❖ THE ART OF ❖

BEOWULF ™

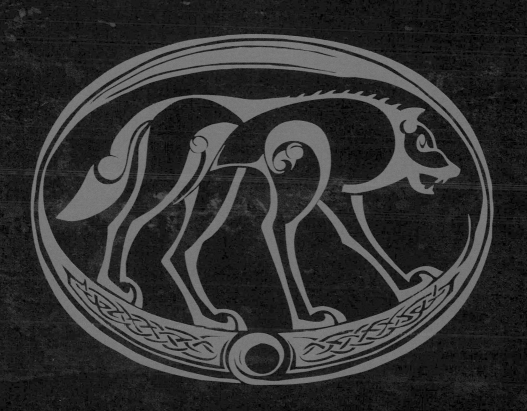

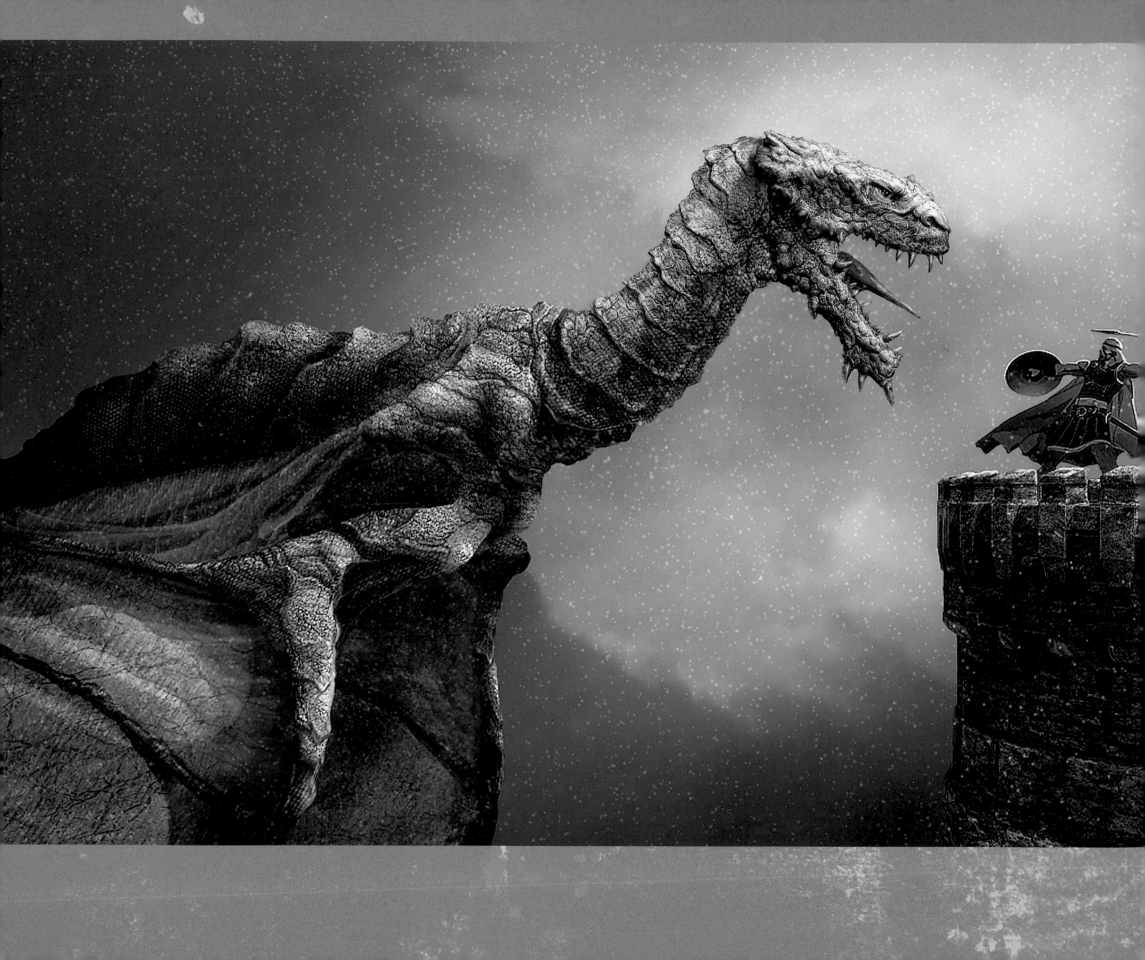

✳ THE ART OF ✳

BEOWULF ™

BY MARK COTTA VAZ & STEVE STARKEY

PREFACE BY ROBERT ZEMECKIS
FOREWORD BY NEIL GAIMAN

CHRONICLE BOOKS
SAN FRANCISCO

LIBRARY OF CONGRESS CATALOGING-IN-PUBLICATION DATA AVAILABLE.

ISBN-10: 0-8118-6038-8
ISBN-13: 978-0-8118-6038-3

MANUFACTURED IN CHINA

DESIGNED BY MARC ENGLISH DESIGN
TYPESETTING BY REVKA ANGLANDER

10 9 8 7 6 5 4 3 2 1

CHRONICLE BOOKS LLC
680 SECOND STREET
SAN FRANCISCO, CALIFORNIA 94107

WWW.CHRONICLEBOOKS.COM

The photograph on page 69 *(left)* is © Museum of National History, University of Oslo, Norway. Photographer: Eirik Ingens Johnsen. Reprinted with permission. The photographs on page 69 *(middle and right)* are © The Museum of National Antiquities, Stockholm, Sweden. Reprinted with permission.

Every effort has been made to trace the ownership of all copyrighted material included in this book. Any errors that may have occurred are inadvertent and will be corrected in subsequent editions, provided that notification is sent to the publisher.

page 1
Beowulf emblem design // MARC GABBANA // digital

pages 2-3
Dragon attack // RANDY GAUL, DERMOT POWER, and ZAC WOLLONS // digital

page 5
Grendel fire // AARON BECKER // digital

page 6
Hrothgar's anteroom // AARON BECKER // digital

page 12
King Beowulf's castle design // KURT KAUFMAN // pencil

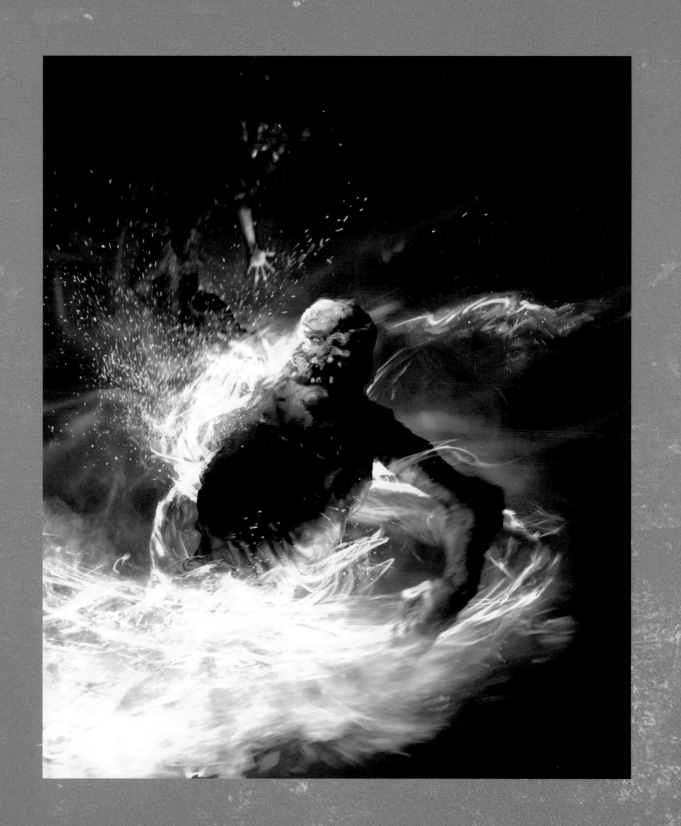

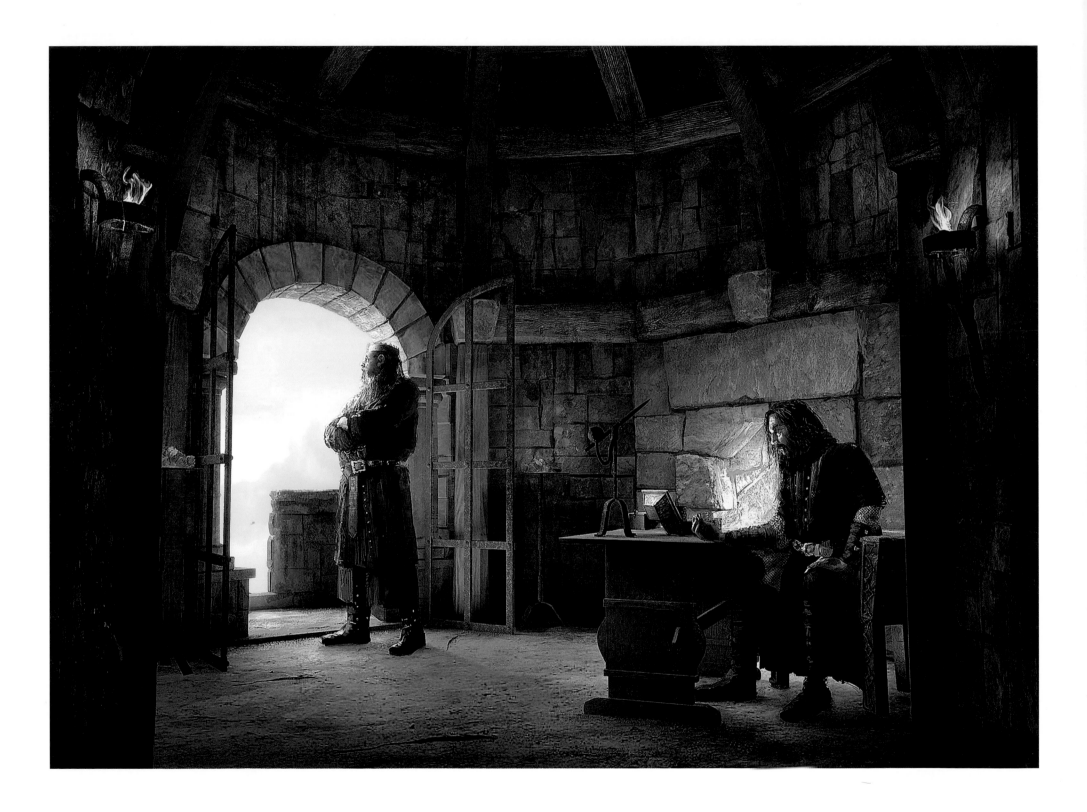

contents

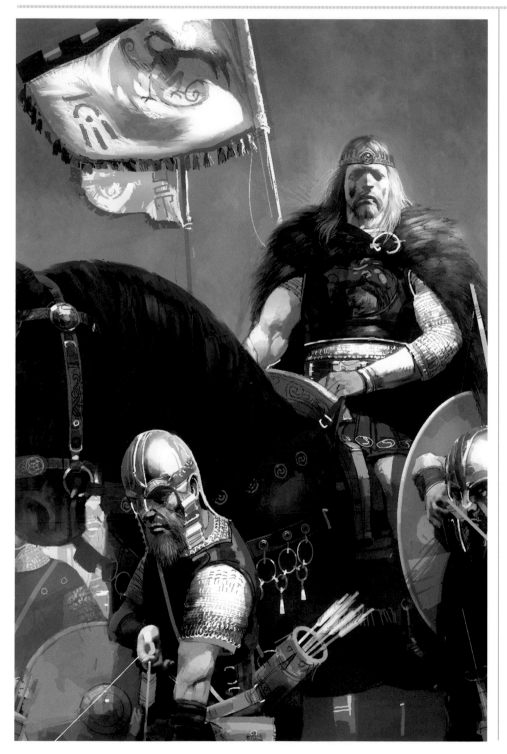

Frisian Battle // DERMOT POWER // digital

When we founded ImageMovers ten years ago, one of the first projects we acquired was *Beowulf*. Screenwriters Roger Avary and Neil Gaiman adapted the Old English poem in a way I'd never seen before. In their words, they put back everything the English monks edited out.

For one reason or another, we were never able to get the movie off the ground. After utilizing performance-capture technology in *The Polar Express*, I realized that *Beowulf* was a perfect candidate for the revolutionary process, and I began to consider directing the project myself.

Doug Chiang and his team of concept artists attacked the next challenge: bringing the world of mighty warriors, noble kings, and evil creatures to life. The artwork they produced stunned me with its epic scale, its lush texture, and its vivid re-creation of an age of heroes that thrived in Northern Denmark, circa 518 A.D.

While the author of the poem is unknown to this day, we wanted to place our own unique stamp on the ancient myth. We focused on the true core of *Beowulf*—facing one's inner demons that are drawn to wealth, the allure of power, and the temptation of pleasures untold.

This book details the process of bringing that grand vision to the screen.

ROBERT ZEMECKIS

When I told people that Roger Avary and I were writing a script for *Beowulf,* they'd say things like "We did that at school. How can you make it into a movie? It's so boring." It was like being told that hot peppers were just too bland, or that exploding volcanoes tended to be a little soporific. I never knew quite what to say.

Beowulf began for me as art, after all, and I didn't know it was meant to be boring. My first real exposure to the story was as a fourteen-year-old, when DC Comics brought out a comic called, if memory serves, *Beowulf: Dragon Slayer.* It was drawn by Ricardo Villamonte, and Beowulf was pictured as an oddly dressed young man with a pair of metal horns on his helmet so wide that he would have had to take off his headgear to go through a door. The story—which made Beowulf into a sort of bargain-basement Conan—still made enough impression on me to make me want to read the original and find out what the real story was. Nobody told me it was classic; I just thought it was something that they'd based a comic on. I found a Penguin modern English translation and I fell in love with it. The oldest story in the English language. A violent meditation on time and our place in the world. A story that was better than I had dreamed. And it was visual, too. Gold glittered in the words. Monsters stalked in the shadows.

So when, in 1997, Roger Avary mentioned he had always wanted to make *Beowulf* into a film, I enthusiastically agreed. I could see it already, in my head.

Of course, in the way of films, it never happened. But we had written a script . . .

I was in Ireland in 2004, finishing a book called *Anansi Boys,* when the call from Robert Zemeckis came through. He wanted to direct *Beowulf* himself. He wanted to use the technology he had begun to explore with *The Polar Express,* but this time use it to make a film for adults.

It was Roger Avary's decision, and it wasn't an easy one. But he trusted Bob, and he trusted him with the script. So March 2005 found the three of us in an empty office a little south of Santa Barbara, putting the final script together—arguing, agreeing, laughing, grumbling, exclaiming. And that was my first exposure to the art of *Beowulf.* Bob had commissioned several pieces of concept art, and even then I was impressed by the richness and color and imagination that the artists had put into it. We discussed many different ways that the film would look—"an animated Frank Frazetta painting" was our first idea—before reality caught up with us.

Bob kept the production art close to his chest. He wanted Roger and I to come up with our own solutions and ideas, unconstrained by anything that anyone else had done. He would only show us designs for sets when we needed them to make sense of a location.

I was on a book-signing tour for *Anansi Boys* in October 2005 when the performances were being recorded, but I got to visit the studio for a couple of days at the end, and watched a strange world. I saw Angelina Jolie and Crispin Glover and Ray Winstone in science-fictional garments, acting in an empty set with wire objects. On one side of the set was a scale model of the world they were in and the set, and pictures on the wall of what was happening, what everything and everyone would look like.

As I write this, ten months before the film will come out, I still don't know how the finished film will look. It only exists inside computers. But, thanks to the artists whose work is represented here, I know what our characters look like. I've walked in the strange cavern beneath the hills where Grendel's mother waits; I've seen the dragon and the sea monsters; I've watched Wealthow go from girl to woman; I've thrilled with delighted revulsion at poor Grendel; and I've smiled and shaken my head and been moved by image after image. I don't know what the film will look like, but I cannot wait to find out. Based on what I've seen so far, it's going to be remarkable, and unlike anything else anyone has done.

This is a new way of making films. I don't believe it will supplant either live action films or animated films: it's a new thing, a different thing, which will, in time, simply become another tool in a filmmaker's toolkit, another way of telling stories. Right now it's the newest one we have.

Which, given that it's being used to retell the oldest story that the English language has, is strangely appropriate.

NEIL GAIMAN

Age of Heroes

"**Through** STORE OF STRUGGLES I STROVE IN YOUTH, MIGHTY FEUDS . . . FOR ALL THAT [MY KING] GAVE ME, MY GLEAMING SWORD REPAID HIM AT WAR—SUCH POWER I WIELDED—FOR LORDLY TREASURE: WITH LAND HE ENTRUSTED ME, HOMESTEAD AND HOUSE. HE HAD NO NEED FROM SWEDISH REALM, OR FROM SPEAR-DANE FOLK, OR FROM MEN OF THE GIFTHS, TO GET HIM HELP— SOME WARRIOR WORSE FOR WAGE TO BUY! EVER I FOUGHT IN THE FRONT OF ALL, SOLE TO THE FORE; AND THIS BLADE SHALL LAST . . ."

❋ Beowulf ❋

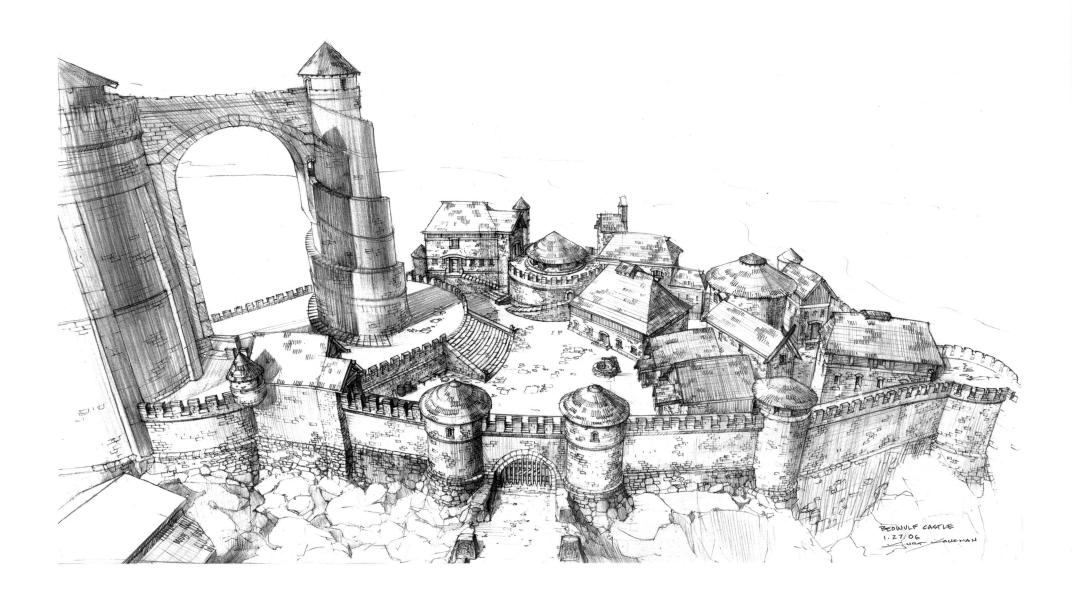

BEOWULF CASTLE
1.27.06
Kurt Coleman

The legend has echoed down the centuries: the song of warrior kings who hacked and hewed their kingdoms from wilderness infested with the fallen sons of Cain—cursed monsters that could not abide humankind. King Hrothgar, ruler of the Danes, built the most glorious mead hall in all the world, only to see it plagued by the bloodthirsty creature Grendel. But from Geatland, across the sea, came Beowulf, a hero who would grapple with Grendel and tear his arm asunder, a hero who would even kill the monster's vengeful mother. Beowulf returned to his home and his lord King Hygelac, crowned with glory, his ship weighted with riches bestowed by grateful Hrothgar. In time, Beowulf ascended the Geat throne and ruled for fifty winters, until a rampaging dragon forced the aged warrior king to put on his mail-shirt, take up sword and shield, and face the last of the monsters.

Beowulf, the epic poem set in Scandinavia and composed in Old English by an unknown author in England, endures in the modern world because of its "mythic potency," argues Nobel Prize–winning poet Seamus Heaney in the introduction to his own acclaimed translation. "We can conceive of it re-presented and transformed in performance in a *bunraku* theatre in Japan, where the puppetry and the poetry are mutually supportive, a mixture of technicolor spectacle and ritual chant," Heaney writes. "Or we can equally envisage it as an animated cartoon . . . full of mutating graphics and minatory stereophonics."

Beowulf has, indeed, exceeded Heaney's conception of coming to life as an "animated cartoon . . . full of mutating graphics." The 2007 Paramount Pictures and Warner Bros. computer graphics (CG) animated feature, directed by Robert Zemeckis, features the latest incarnation of "motion capture," which allows for recording a live actor's performance and applying it to a computer-generated character. Zemeckis and his Imagemovers production company, along with Sony Pictures Imageworks, a leading visual-effects and animation studio, first used the technology in the 2004 release *The Polar Express,* which starred Tom Hanks in an adaptation of Chris Van Allsburg's illustrated book about a boy's magical train trip to Santa's North Pole. The filmmakers next used the technology in the 2006 animated feature *Monster House.* The preferred term might be "performance capture," but by *Beowulf* the technique had evolved to the point that some production principals began calling it something else entirely.

"We started to call this process 'digitally enhanced performance' to try to get people to make a distinction from normal animation, where

an actor's performance is vocal," explained Steve Starkey, longtime Imagemovers producer and partner. "With this process we bring in both an actor's voice *and* physical performance—an actor's character can live in the movie. This is like when sound came in; this is a new form of cinema. Of course, there are growing pains and hurdles and difficulties involved with experimenting with any new form. We stumble as we go, but what we've achieved over three films is phenomenal."

By the time of *Beowulf*, a core group was getting increasingly facile with the complexity of performance capture (the term still generally used, along with "mocap," for motion capture). Key *Beowulf* production principals included production designer Doug Chiang, who had shared production design duties with Rick Carter on *Polar Express* and was concept design supervisor for *Monster House*, and a team of talented, seasoned conceptual artists at Chiang's own studio. Ken Ralston and Jerome Chen, the Sony visual-effects supervisory team on *Polar*, came back for *Beowulf*, with veteran effects guru Ralston giving Chen the opportunity to lead the effort.

The process was a strange new world for a stellar cast that included Ray Winstone as Beowulf, Brendan Gleeson as Beowulf's loyal warrior Wiglaf, Anthony Hopkins as King Hrothgar, Robin Wright Penn as Queen Wealthow, John Malkovich as Unferth, Crispin Glover as Grendel, and Angelina Jolie as the creature's mother. They discovered there were no costumes, no hair and makeup concerns, no sets, not even the bluescreen or greenscreen setups familiar to actors working on effects-filled films. Instead, the *Beowulf* cast donned special body suits, had their faces sprinkled with motion-sensor dots, and stepped under the yawning shell of what Jerome Chen calls "the capture zone," the bare stage area where hundreds of cameras recorded their performances as the data that later animated their computer-generated characters.

> "Bob Zemeckis showed me the process that Tom Hanks went through on *Polar Express*, the dots and everything. I was intrigued, but I was slightly apprehensive. There are no costumes, no sets—you're naked, really. But, we were all going to be fools together!"
>
> ANTHONY HOPKINS

The film's origin was an example of the serendipitous twists

of fate and fortune behind many a Hollywood production. It all began with the fortuitous pairing of writers Neil Gaiman and Roger Avary, but one could say it all started with the Sandman.

Gaiman, a best-selling and award-winning novelist and comic-book writer from England, can retrace his career to the boyhood summer when he was lent a box of American comic books—"a Box of Dreams," he later wrote. Among its wonders was Sandman, a DC Comics character born in the Golden Age of comic book superheroes, who carried a sleeping-gas gun and dressed in a cloak, green suit, fedora, and yellow gas mask. By chance, in late 1987, Gaiman was approached by DC to update Sandman, and began dreaming it up during the blackout that came with the most powerful hurricane to hit the south of England in half a millennium. When electricity was restored, the idea emerged of Sandman as king of a phantasmic land known as the Dreaming. *Sandman*, with its mythic allusions and supernatural storylines, won critical raves and a legion of fans.

By 1998, Gaiman was developing a *Sandman* movie at Warner Bros., with Roger Avary hired to direct. That attempt at a *Sandman* feature failed, but a creative partnership was born and another potential film project beckoned. "Roger and I hit it off; he was barking mad in all the best kinds of ways," Gaiman recalled. "During one of our *Sandman* conversations, Roger asked me, 'What do you think of *Beowulf*?' I said, 'I love *Beowulf*.' He said, 'I've always wanted to make a *Beowulf* movie, but I've never figured out how you get from Act Two to the dragon.' I told him I had an idea. Roger paused, then asked, 'When are you free?'"

Gaiman's idea turned the epic on its head. As he explained to Avary, the accounts of Beowulf's adventures often took the hero at his word. For example, when Grendel's monstrous mother is tracked across the moor to a churning pool, Beowulf alone dives into the murky depths. He is gone for over nine hours, finally emerging to describe how he battled sea creatures, arrived at the airy vault where he killed Grendel's mother with a sword, and then beheaded the corpse of her gruesome son (curiously, Beowulf brings only Grendel's head back to the surface). What if, Gaiman wondered, Beowulf hadn't killed the mother at all—what if he had spent those missing hours having sex with her? "I proposed to Roger a perspective in which when anyone goes offstage and comes back to say, 'This is what I did,' they could be lying. Then, what if, in the last act, the dragon was Beowulf's son? Suddenly, the dragon was part of a whole story. It also became a story of how bad things done in the past can come back to haunt you in the present."

In May of 1998, Gaiman and Avary were bound for Mexico and a vacant house that a friend of Avary's lent them, to work in seclusion on a *Beowulf* screenplay. The house had a swimming pool, but other than refreshing dips in the midday heat, the writers were all business. Even a pool table at the place became part of their work process, with many a story problem cracked over an easy-going game. "One of the important things we discovered was Roger and I were equally bad at pool, which is very important, because if one of us had been good and the other bad, the whole dynamic of the working relationship would have

gone down in a handbasket," Gaiman chuckled. "When we got stuck on something, we could go talk over plot while we played pool."

They wrote *Beowulf* in a "white heat," Gaiman recalled, and by the end of a week were headed back to Los Angeles with a completed first draft script. Gaiman's agent showed it to Robert Zemeckis, who loved it. The wheels of production began turning and Beowulf seemed ready for his close-up.

But the project fell through, and the production principals went their separate ways. By Christmas of 2000, Avary was ready to resurrect *Beowulf* when Zemeckis called. "Bob said he'd never been able to get our *Beowulf* script out of his head," Gaiman recalled, "and he wanted to make it as a performance-capture movie."

By March of 2005, Gaiman and Avary were sequestered with the director and going through their old script line-by-line. Meanwhile, conceptual design for *Beowulf* had already begun in January. The art department came to life in the very building, north of San Francisco in San Rafael, where *Polar Express* had been designed, a studio presided over by Doug Chiang. Over time, its walls filled with iterations of conceptual art, an evolving mosaic of visions of a legendary Viking world. "*Beowulf* was a two-and-a-half-year

King Beowulf's emblem // JOSH VIERS // digital

> "Beowulf is the ultimate mythic hero—that's part of the fun. He's also not as smart as he thinks he is. As a young man, Beowulf *is* a braggart. Admittedly, being a braggart in the Viking world was a survival skill. But there are places in the original poem where he cheerfully leads his men to die without, as far as I can tell, a qualm. Beowulf is not exactly the greatest role model, which I really liked."
>
> NEIL GAIMAN

process," explained art department CG supervisor Pete Billington. "In a traditional live-action production your environments are already there, so an art department will work for three, maybe six months, until principal photography begins. But in a mocap or animation production nothing exists; *everything* has to be thought out, designed, and rendered—sets, characters, props. So, we had to start at the beginning of the production process."

"The boundaries of the various aspects of preproduction and postproduction are blurring," added Doug Chiang. "Even though we had all the traditional production departments—lighting, costume, hair, and makeup—it all filtered through the art department. Our production design encompassed it all; everything was kind of rolled into one. For me, that was appealing because it made the role of production designer a bit more challenging."

Beowulf marked Chiang's debut as a solo production designer, but he declared it "business as usual," a smooth transition from *Polar Express* design duties he had shared with Rick Carter. The *Beowulf* art department numbered some thirty-five people, including a core twenty-person team of conceptual artists who had been on *Polar Express* and would stay to the end. The studio had its own CG department, and most of the flat, two-dimensional paintings and sketches would be done in the computer. Physical model makers John Duncan, Trevor Tuttle, Robert Barnes, and Tony McVey contributed character sculptures and miniature sets. While Chiang's team in San Rafael focused on design, a Los Angeles unit overseen by Chiang and headed up by art director Greg Papalia and supervising art director Norman Newberry (another veteran of *Polar Express* and *Monster House*) translated the designs into physical set pieces and props for the motion- capture stage in Culver City.

> "Bob [Zemeckis] uses technology to tell stories that otherwise couldn't be told. Technology is just another form of illusion. In fact, when audiences watch a film, they don't know how you achieved the images. All they know is they're captivated."
>
> STEVE STARKEY

"The advantage of having the team already assembled was we could ramp up within days," Chiang noted. "After *Polar*, we had all the tools ready and, as one entity, my team covered a wide range of skills, including design and painting, CG modeling, and lighting. We could design 3-D sets and render them with specific camera lenses and lighting built in. Within the first couple of weeks, Bob could actually see images of what his film could be in terms of character and set design, drama, composition, lighting. Bob could then make design decisions in the context of what his film was going to look like, which is one of the great things about designing a film this way. All the output from the art department in terms of 3-D sets was fed into the postproduction pipeline—Sony could take those models, plug them in, and update them with their proprietary software to make it all work. Even late in the schedule, Bob was making design changes, so our art department would get elements back from Sony, modify them, and send them back."

Beowulf would be both a bold foray into an emerging technological medium and a dramatic interpretation of the epic story. This book collects samples of the artwork that fed the production and formed the template for the final look of the film. Beowulf and his contemporaries would doubtless look at this whole business and declare it the work of sorcerers—and they would not be far from wrong. This is the stuff of movie magic.

Production designer Doug Chiang asked Josh Viers to come up with a dragon icon for the production that would be representative of the movie, and Viers explored Celtic art for inspiration. "There was so much, from metalwork to carvings in stone and wood. What was interesting is they were a smart people, but they had a barbaric, even primitive, nature. Celtic art was not literal—it dealt in graphic symbols. There is an inimitable style to everything they created, a lot of very complicated braided shapes and stark lines."

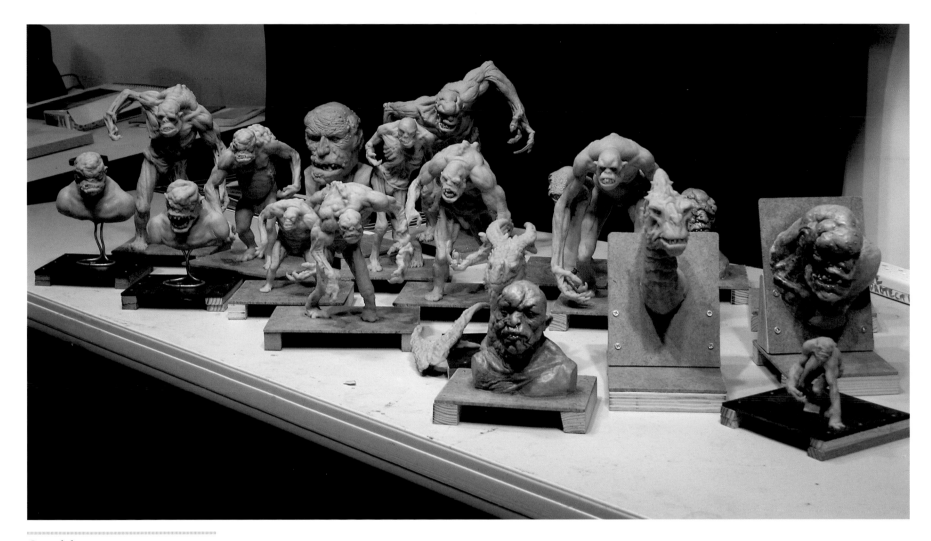

Grendel // TONY MCVEY // sculptures

McVey, a veteran movie sculptor, generally
worked in Super Sculpey, a vinyl-based
modeling compound that can be baked in an
oven for the mold-making stage.

CHAPTER

1

Horror from the Moors

"**There** CAME UNHIDDEN TIDINGS TRUE TO THE TRIBES OF MEN, IN SORROWFUL SONGS, HOW CEASELESSLY GRENDEL HARASSED HROTHGAR, WHAT HATE HE BORE HIM, WHAT MURDER AND MASSACRE, MANY A YEAR, FEUD UNFADING . . . THE EVIL ONE AMBUSHED OLD AND YOUNG DEATH-SHADOW DARK, AND DOGGED THEM STILL, LURED, OR LURKED IN THE LIVELONG NIGHT OF MISTY MOORLANDS . . . SUCH HEAPING OF HORRORS THE HATER OF MEN, LONELY ROAMER, WROUGHT UNCEASING, HARASSINGS HEAVY. O'ER HEOROT HE LORDED, GOLD-BRIGHT HALL, IN GLOOMY NIGHTS. . . .

THIS HEARD IN HIS HOME HYGELAC'S THANE, GREAT AMONG GEATS, OF GRENDEL'S DOINGS. HE WAS THE MIGHTIEST MAN OF VALOR . . . A STOUT WAVE-WALKER HE BADE MAKE READY. YON BATTLE-KING, SAID HE, FAR O'ER THE SWAN-ROAD HE FAIN WOULD SEEK, THE NOBLE MONARCH WHO NEEDED MEN!"

✳ Beowulf ✳

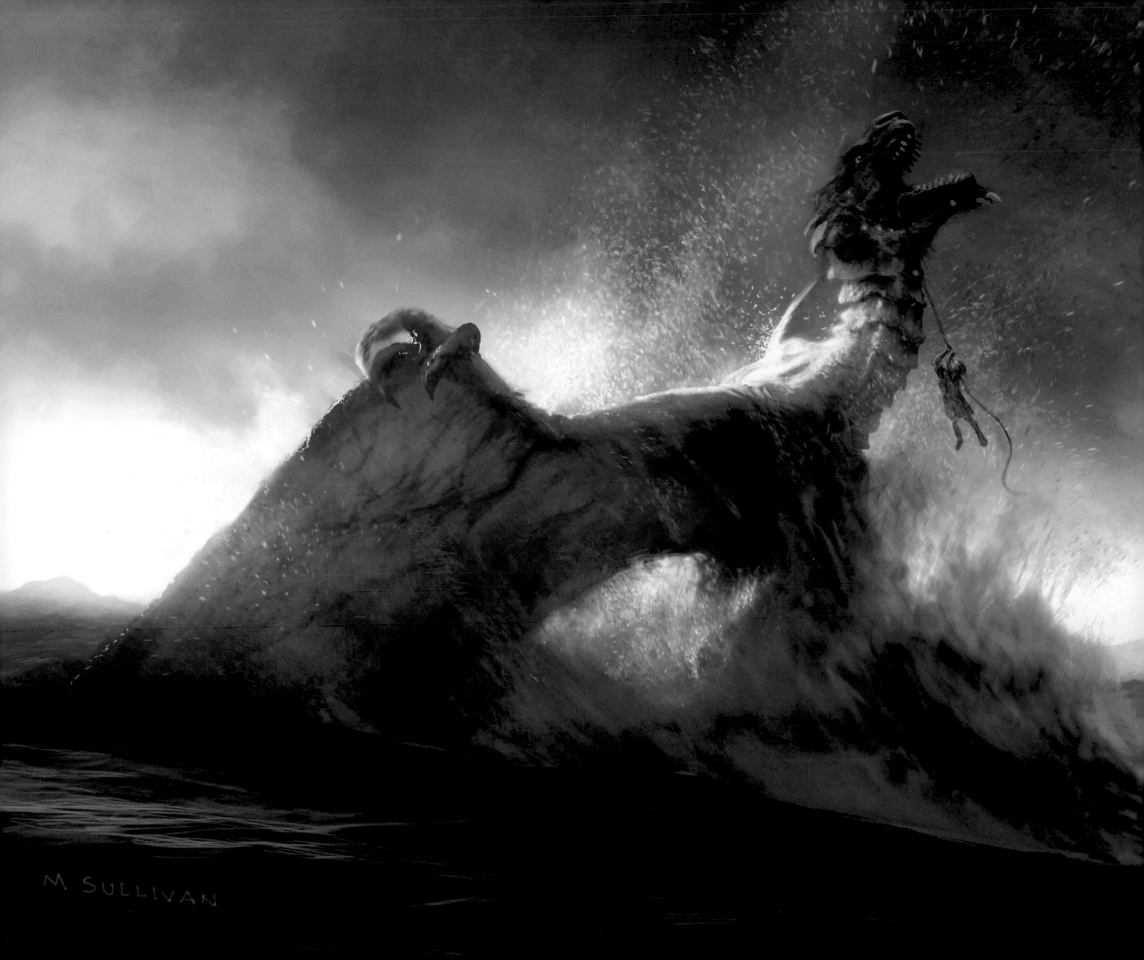

Beowulf has a ring of truth—Hygelac, king of the Geats in the epic, can be traced to A.D. 600, when his death during a raid was recorded. "That historic event, recorded by a Frankish chronicler, is the one dateable event we have for the poem," noted Karl Hagen, *Beowulf* expert and former professor at Mount St. Mary's College in Los Angeles, who served as a consultant for Zemeckis's production. "The sixth century is when the poem is set, but my own best guess is its actual composition was in the early eighth century."

Although *Beowulf* is today an icon of world literature, it is only by luck or providence that the poem made it across the sea of time to our century. "*Beowulf*, like all Anglo-Saxon literature, was essentially forgotten; there is no continuous tradition of telling *Beowulf*," Hagen explained. "The poem survives in one manuscript, written around the year 1000, and we're damn lucky it survived."

In 1731 that millennial manuscript, the only existing copy, was among a collection of bound medieval codices in a private library in Britain, when a fire swept through—reportedly, desperate librarians were tossing burning books out windows. The close call for *Beowulf* can be seen in the manuscript's singed edges (*Beowulf* today is safely archived at the British Library). That excitement aside, the poem was largely ignored until about 1815, and then studied as a historical and linguistic artifact. *Beowulf* began to be taken seriously as literature in 1936, when Oxford scholar and teacher J.R.R. Tolkien published a paper, "*Beowulf*: The Monsters and the Critics." *Beowulf* had an obvious influence on *The Lord of the Rings* and other literary works from the man Hagen calls "the great author of modern epic fantasy."

Hagen himself was attracted to studying *Beowulf* in its original Old English while a student at Princeton. Within that rich and inscrutable meter he found secrets of a lost world. "There are obvious Germanic elements that go back to the ancestors of the Anglo-Saxons and reflect pagan ideals of heroism, but the writer of the poem was, unquestionably, a Christian. So, there's this radical tension. The poem captures a society caught at this moment of transition, when it is looking back at its Germanic pagan past. The pagan elements are actually what appeal to most people these days, the aspects of heroism and battles with monsters. Beowulf has the strength of thirty men, and then you have Grendel, this superhuman monster Beowulf battles. It's all larger than life. In some ways, Beowulf is the original comic book superhero!"

Mythical elements and historical reality informed the design of an elemental world and Herot, the seat of Hrothgar's kingdom and the mead hall around which so many pivotal events revolve. For the art department, the creative journey began with research archivist Greg Bossert helping

gather photographic reference and other materials that explored the Viking culture of A.D. 600. "My past work has, typically, been future-oriented, so *Beowulf* was a different film for me," said Chiang, a former director of the art department at Industrial Light + Magic (ILM) and a design leader on the first two *Star Wars* prequels. "But I love to research different time periods, so that was one of the great things about this project. Going to the past opened up a whole new world for me in terms of material, texture, and form."

But there were limits in the Beowulf era. The production design became "evolutionary," Chiang noted, as period reality did not translate into the spectacle one might assume went with sword-wielding warriors, monsters, and dragons. "The tendency is to go big and design things like grand castles," Chiang explained, "but what I discovered was a sixth-century Viking village was simple and small, that a mead hall was essentially a giant barn. That didn't lend itself to the dramatic appeal of what Hrothgar's Herot could be. We wanted something visually appealing that would support the story Bob was going to tell and still be faithful to the timeline, so we expanded the window from A.D. 600 to 1100. For the mead hall, we incorporated elements of medieval architecture, using stone and more wood. We basically created our own alternate world."

There were two basic phases to the art department's work. The first established the look of the film. The second was a post–performance capture director's "layout" stage, during which Zemeckis supervised creation of a low-resolution computer-graphics version of the entire movie, from which the art department selected key frames and created final paintings, the look of which Sony Imageworks had to match in its high-resolution computer-generated imagery.

Chiang's art department used tools familiar to modern filmmakers. For two-dimensional painting in the computer, the production favored Photoshop and Painter, both popular off-the-shelf software packages. The CG department did its 3-D modeling work in Maya, another commercial software program. Norm Newberry's L.A. art department used traditional Computer Aided Design (CAD) technology to design props to the exacting specifications needed for the performance-capture stage. But what was unusual was the department's teamwork and facility with the tools, their impact on all aspects of production, and their involvement from beginning to end. Many artists used words like "fluid" and "dynamic" to describe a process that accelerated conceptual art to final designs.

"Instead of the traditional way to design, with artists using markers and pencils to show a director rough sketches *suggesting* what something might look like, we were leaping to paintings to show right away what the final, finished look might be on screen," artist Randy Gaul noted. "Some artists spend six months to a year exploring what a look will be like, and I'm all for exploration. But given the experience level of the artists here [Chiang's studio], we all know what gets up on the screen. In a sense, we threw away the traditional tools because we now had this new toolbox and new skills."

There was a learning curve for artists accustomed to the traditional "blue sky" preproduction conceptual design period. *Polar Express* veteran Marc Gabbana likened the experience to the end-zone sprint of post-production. "For design work on other shows, we'd work in black-and-white and worry about things like color, tone, and mood way, way down the line. But on *Beowulf* we were attempting to combine design, mood, and lighting

very early in the production. It was *very* challenging, when you're used to drawing conceptual designs from scratch, to have to go for a photoreal quality and pull photographic textures into the designs, to be working on, like, the third angle of a room. I don't know any other [art department] that's worked like this, so we prided ourselves on that. It really reinvented us as artists. We were getting approvals from the director so quickly, we had to keep moving forward."

The *Beowulf* art department was geared up to

getting into 3-D designs quickly because 3-D was the world of the final animated film. The process included what CG supervisor Pete Billington calls "fabricated 2-D," with simple, gray-shaded 3-D computer imagery forming the template for detailed two-dimensional paintings. "Our fabricated 2-D was the secret to being able to have a still image to show Bob two years before the film [was scheduled for release]," Billington added. "Character design might be painted over a photograph or as a straight-up painting, but every set and prop was a 3-D model created by three or four of us. When we had that model in 3-D, we could move the [virtual] camera around. Our painters would then give it textures and light qualities. When the gray-shaded model was painted, we would print out hard copies of the image that went to Sony and the director. If it wasn't what the director wanted, we would go back and start the process again. But when approved, it became the Holy Grail for that particular scene and the look of props, lighting and staging, the texture."

There were layers and layers to the process and constant collaboration between 2-D painters and sketch artists, 3-D modelers, and practical sculptors. "Whatever you have to use, you use it," was how painter Brian Flora summed it up. "If we had nothing, we painted from scratch. If,

say, a Grendel design was done in sculpture, we would take photos of that, scan them into the computer, and paint on top to get into color and lighting issues. If there was a 3-D model built, we had a nice render to work with. As more stuff was thought out and designed, there was more and more reference to work with."

Beowulf was also a quantum leap for Sony Pictures Imageworks, compared to their seminal work on *Polar Express*. "With *Beowulf* there's a grander scope. With more main characters, the performances had to be more subtle," said visual-effects supervisor Jerome Chen. "The magnitude of detail got down to the fuzz on people's faces. This was the hardest thing I've ever done, but also the most exciting."

The *Beowulf* performance capture was created at Culver Studios, across the street from Imageworks' own studio in Culver City. The work represented a "technological leap forward in terms of the zone," Chen added. The capture zone, or "volume," of area that could be captured at one time on the mocap stage grew from a 10-by-10-foot area on *Polar* to 25 by 25 feet on *Beowulf*—625 square feet, a sixfold increase, by Chen's estimates. *Polar* used 64 to 72 mocap cameras, but *Beowulf* had some 250 infrared cameras mounted on a 40-by-40-foot steel shell over the capture zone, which Chen likened to a rock-and-roll concert stage truss. The stage also had eight camera operators handling high-definition video cameras for reference.

Norm Newberry, along with art director Greg Papalia, headed up the seventeen-person L.A. design team charged with the day-to-day work on the mocap stage. "They say film is the most collaborative art form, and mocap is even more collaborative," Newberry laughed. "For example, the art department got much more involved in the lighting issues that normally belong exclusively to the cinematographer. But you have to be involved in those issues, because you have to show the director how

a scene will cut together. Even among our three groups—Doug's studio developing designs, the L.A. group supervising physical things on stage, Sony Imageworks having to realize everything in CG—there was a blending of talents and disciplines. Doug and I worked on developing the set spaces in the computer and, even though we were separated by hundreds of miles, we could send 3-D files back and forth. We developed the designs that allowed us to get the set pieces pinned down for the mocap stage."

Newberry noted that the designs from Chiang's studio set "the mood and feeling and design," while the L.A. group addressed reality issues ranging from making sure mead hall benches were the right scale for six-foot Vikings to, much like a real live-action set, making sure set design was efficient and would serve the story and the director's vision.

The motion-capture stage work always began with the director showing the actors the art department's paintings and miniature foamcore sets that were appropriate to the scenes on the day's schedule. "Bob used these paintings and models to explain the scenes to the actors, to help make this abstract space seem more real," Newberry added.

"From the starting point of Doug's artwork, we stepped across a weird line into a strange reality that this particular technique had never done before," Ken Ralston mused. "With the earliest tests, we felt like we were looking at an actor's performance, not some bizarre concoction inside a computer. Also, for this movie to work, it couldn't look real. If you look at Doug's artwork, it's realistic, but beautifully stylized. This isn't some lighthearted piece. *Beowulf* is *insane*. There's a mythic, emotional, and spiritual nature to it."

Map of Herot // JOSH VIERS // design

This map oriented the production to the geography of the story, from the beach on the coastline where Beowulf's ship arrives to the peninsula where Hrothgar's walled city sits upon a sheer cliff. Herot, the name of the mead hall in the poem, was the name the production used to describe the entire walled complex (the spelling changed from "Heorot" in the poem, a liberty the screenplay took with a few of the more antiquated spellings). Inland lies the moorland and Grendel's cave, which is at the foot of a mountain range. The cave is miles from Herot, Viers noted, but Grendel can quickly close the distance at "monster speed."

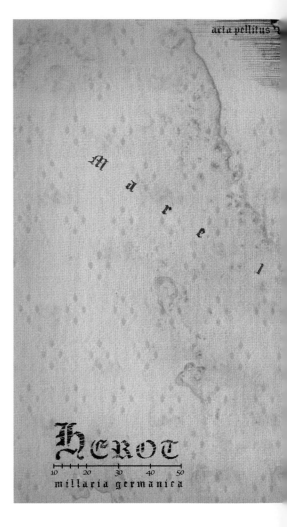

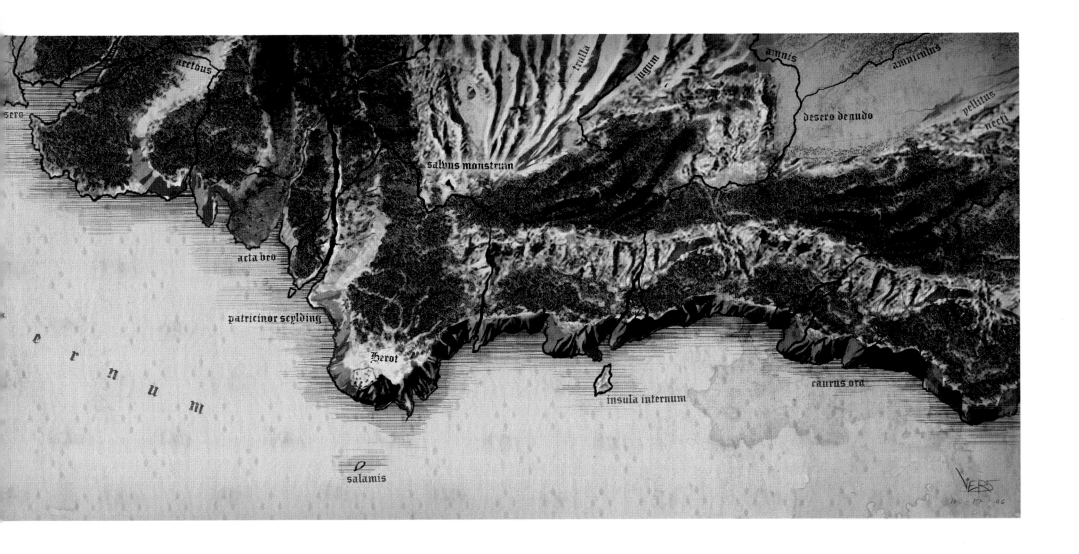

26

When Robert Zemeckis
sat down with Gaiman and Avary to work on
the screenplay, a major story point the director
added was to stage the entire story in the land
of the Danes. Beowulf would not return to
his homeland, as in the poem, but inherit
King Hrothgar's throne at Herot. The story
encompassed more than thirty years, from
the twilight of Hrothgar's rule to what the
production called "the Beowulf era."

To help conjure the world of *Beowulf*,
Chiang often called upon Brian Flora, a veteran
matte painter accustomed to creating wide
establishing shots and landscape scenes,
who worked with Chiang on *The Phantom
Menace*, the first *Star Wars* prequel. "The
reason Doug probably included me [in the
Beowulf art department] is because my focus
is on mood and lighting," Flora mused.
"There are a lot of dreary environments in
Beowulf, so the proper mood helps make
the landscapes look interesting and move the
story along."

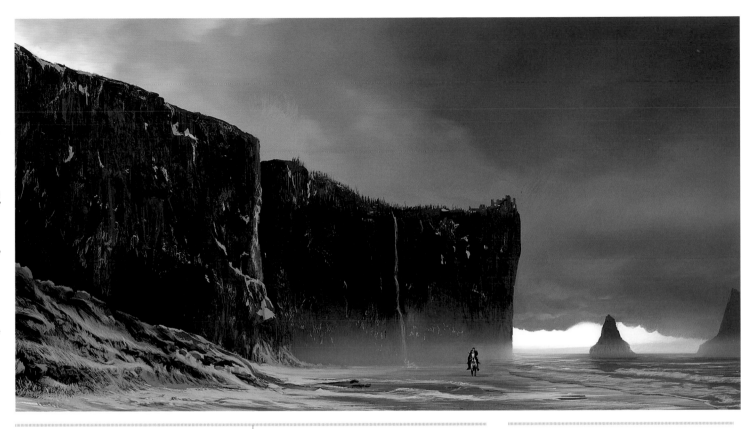

"The landscapes in *Beowulf* struck a chord
with me. To me this land is the opposite of
Paradise. That gave an edge to the designs.
Dark, harsh, and foreboding—
that's the world we're in."

RANDY GAUL

"The biggest design challenge was this land
had to have a sense of history. We had to
get across the idea that Beowulf succeeds
Hrothgar as ruler and make those two eras
separate, but we also had to make clear that
the land has been settled for thousands of
years. That concept of time and how the
land has been affected by time, the idea
that there are layers of history, was crucial.
That is seen everywhere, throughout
all the designs."

PETE BILLINGTON

Coastal cliffs and beach // BRIAN FLORA //
concept painting

The distant rider is the coastal watchman
Scylding, who has taken a trail down from
the cliffs to meet Beowulf and his men, whose
boat has just landed. This landscape is revisited
in a scene, set years later, when King Beowulf
watches from the cliffs as his army sets aflame
the invading ships of the Frisians.

opposite
Forest path to Grendel's lair //
AARON BECKER // painting

The road to Herot // MARK SULLIVAN // painting

To get to Herot, one crosses the King's Road Bridge and passes looming monoliths that mark a road built of shale stones ("perhaps recycled tombstones," the screenplay notes).

The following images illustrate the dramatic changes in Herot that occur from Hrothgar's time to Beowulf's rule.

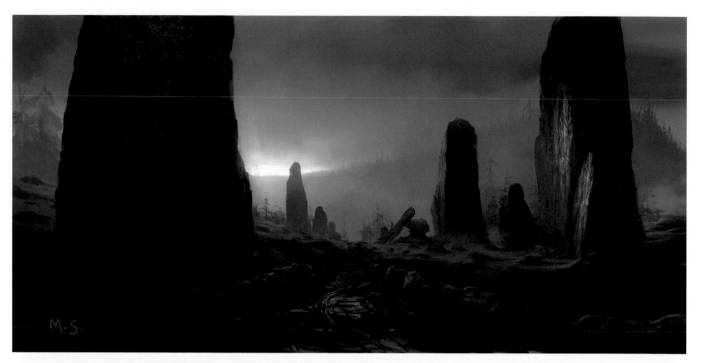

The King's Road Bridge, Hrothgar's era // MARC GABBANA and BRIAN FLORA // painting

This rustic, rickety-looking bridge would become a quaint memory compared with the elegance and superior engineering of the renovated bridge in King Beowulf's time.

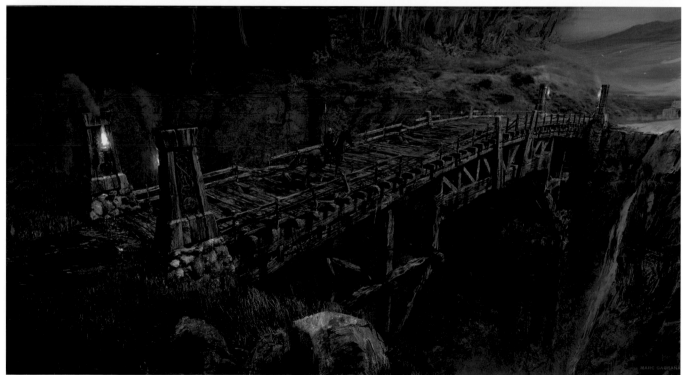

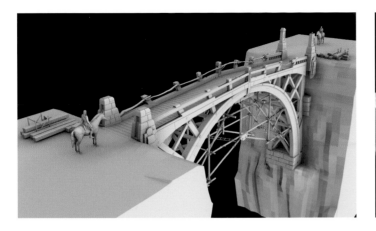

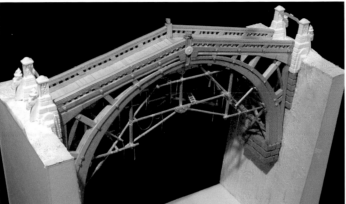

left

King's Road Bridge, Beowulf era //
ZAC WOLLONS, CG DEPARTMENT // 3-D model

The template for the final design of Beowulf's bridge was this simple, three-dimensional grayscale model. "Our goal was a painterly image that captured the look of what the film could look like," explained Pete Billington. "Our CG department took 2-D images and provided a primitive grayscale rendering that artists could paint on top of. We didn't have to think of things like perspective—the computer had done that for us."

right

King's Road Bridge, Beowulf era //
JOHN DUNCAN // model

Concepts for the renovated bridge included this physical model featuring a peak in the middle. It was redesigned when it became apparent the peak was too steep, preventing a CG character and the virtual camera from seeing from one end to the other.

King's Road Bridge, Beowulf era //
AARON BECKER // painting

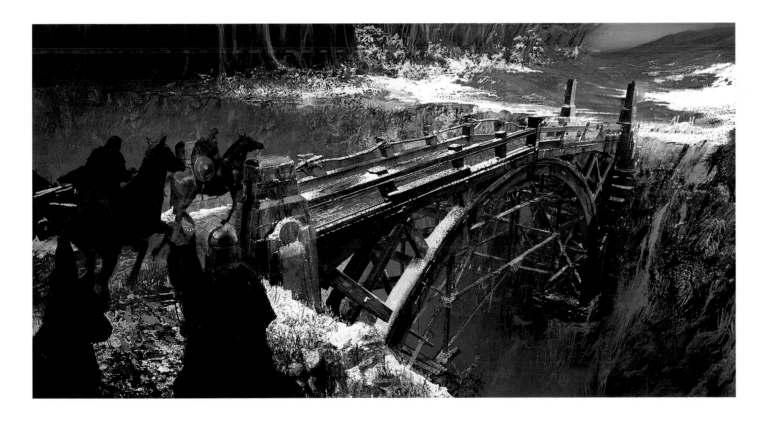

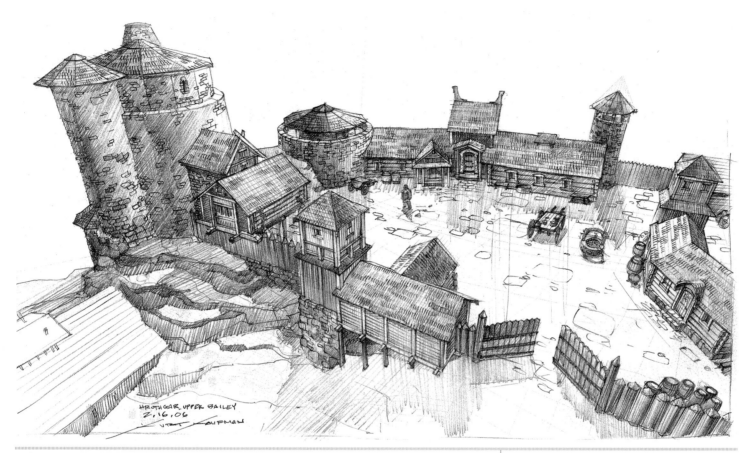

Hrothgar's Herot, exterior //
KURT KAUFMAN // pencil sketch

An example of Kaufman's approach of building a rough 3-D model in the computer and drawing over a hard-copy printout. Note the tower of Hrothgar's castle at far left and, below, the mead hall that is built onto a natural rock formation.

Herot // MARC GABBANA // painting

This aerial view gives Herot the appearance of a peasant village (note the cheerful fire-lit glow from the mead hall, center of social life).

𝕱𝖔𝖗 𝖆𝖗𝖈𝖍𝖎𝖙𝖊𝖈𝖙𝖚𝖗𝖆𝖑 𝖉𝖊𝖘𝖎𝖌𝖓 𝖜𝖔𝖗𝖐, Chiang called on Kurt Kaufman, an artist who had studied industrial design and was a veteran of *Polar Express* and *Monster House*. For *Beowulf*, Kaufman decided to make a bold move into the digital realm and was the only artist in Chiang's studio to work in 3-D and 2-D simultaneously. Typically, 2-D artists first created a pencil sketch they could scan into a computer to work on with their 2-D painting tools, but Kaufman began by creating a rough 3-D model. He could then draw over it, adding intricate detailing in his pencil sketch. With a 3-D model, he could also create fresh camera angles and draw new sketches from different perspectives. "I worked with Doug on *Star Wars,* and we would have to do these incredibly detailed line drawings to figure out perspective. But by modeling in 3-D the perspective is all done for you. I could give my drawing and model to our CG guys and they had an accurate model. I was essentially previsualizing in 3-D."

"Early on, our paintings set the mood for all the settings and we got pretty detailed as to even what time of day it was. We wanted the castle to be moody and dark in Hrothgar's era. In Beowulf's era it's a bit lighter, but the sun still hardly shines in this environment. Herot is a walled city which, in Hrothgar's time, is surrounded by a wooden fence and the castle tower is shorter and stubbier than it will look in Beowulf's time."

MARC GABBANA

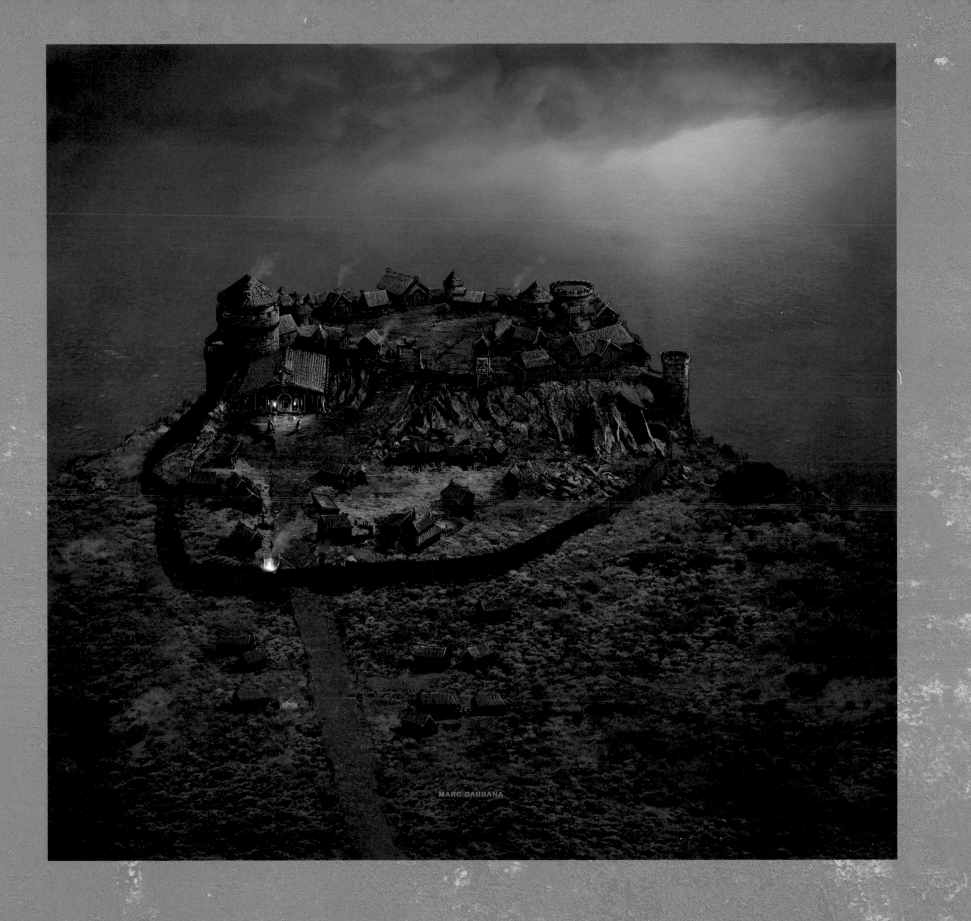

MARC GABBANA

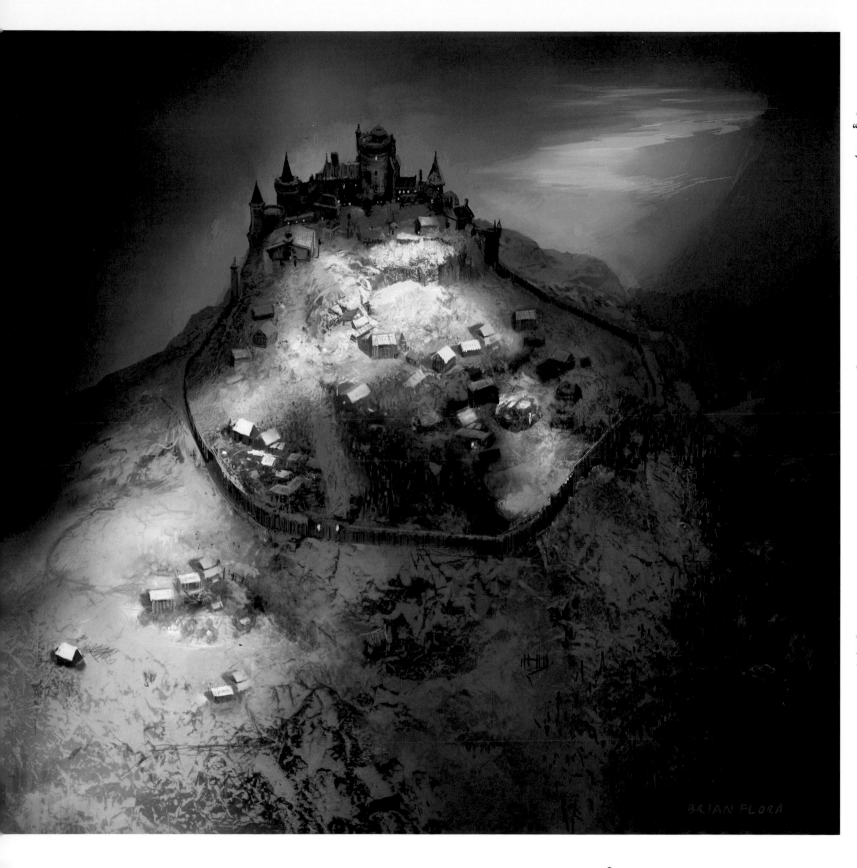

"I started conceptualizing in 3-D on my own, which no one else here was doing. Working in 3-D is complicated and time-consuming. I taught myself Maya, which is a huge program and like learning another language, one that, as an artist, you don't really need to know. For an illustrator, computer graphics software is a whole other ballgame. It's intimidating and technical. But for me, it just seemed natural, the way this [performance-capture] process was going. This 3-D/2-D approach is a great design tool."

KURT KAUFMAN

Hrothgar castle design // BRIAN FLORA //
digital

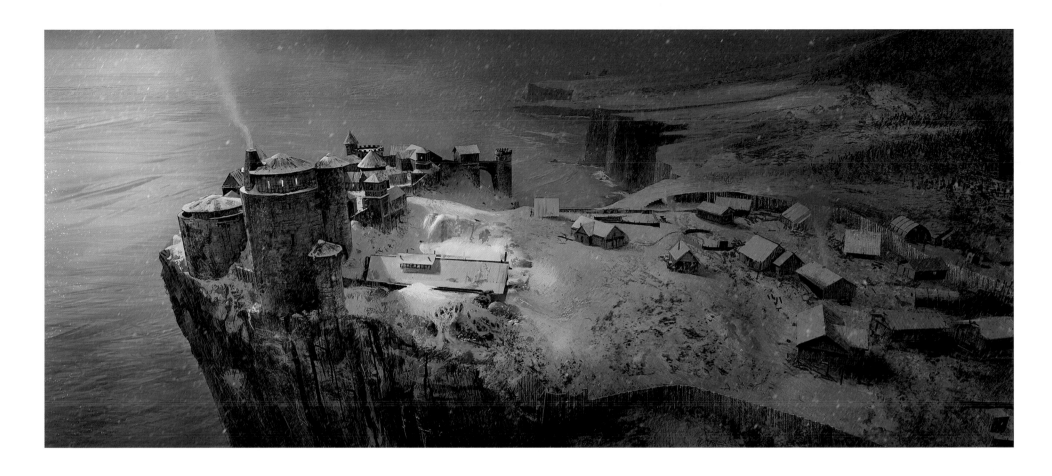

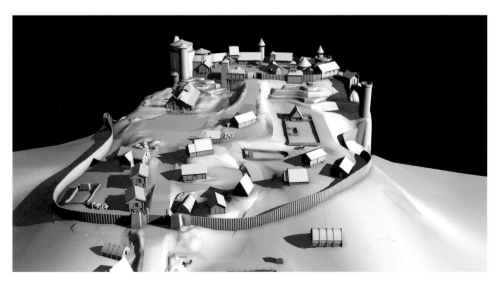

Hrothgar castle, exterior // BRIAN FLORA //
painting

This painting reveals Herot as, literally, on the
edge. "Part of the concern and challenge for this
painting was to make it moody and mysterious,
but clear," Flora explained. "We needed to see
the cliff and ocean."

Herot // ZAC WOLLONS, CG DEPARTMENT //
art department 3-D model

Brian Flora's final design painting of the exterior
of Hrothgar's castle began with this 3-D layout as
a foundation.

"*Beowulf* had to look like it came out of a specific period, even though it's not. It had to have a Viking style, although they never would have done something like put horns on the mead hall roof, as we did. Doug described the mead hall to me as carved out of rock—the rock is basically the back wall, with a stream running through that becomes their 'piss pit.'"

KURT KAUFMAN

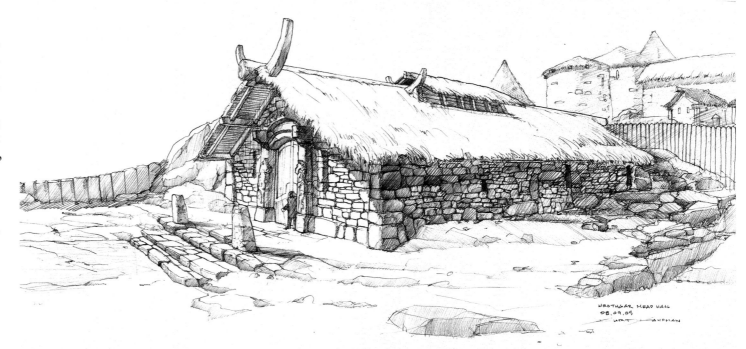

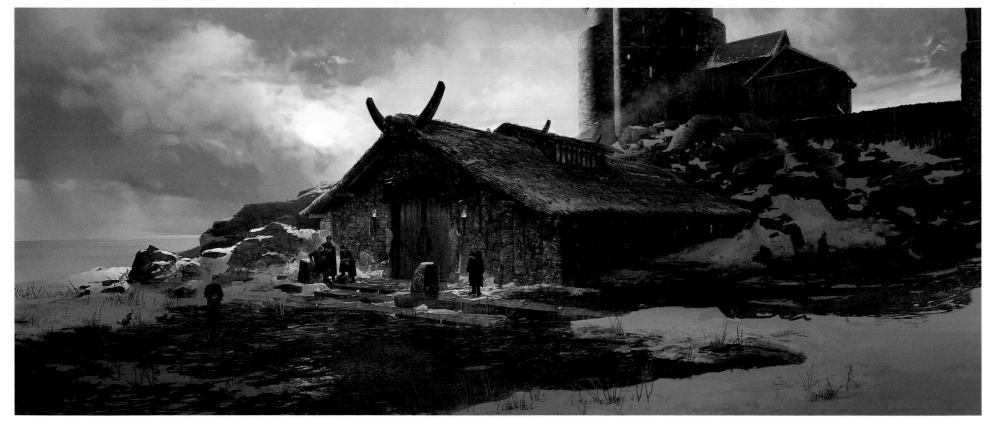

𝕿𝖍𝖊𝖗𝖊 𝖜𝖊𝖗𝖊 𝖗𝖔𝖚𝖌𝖍𝖑𝖞 fourteen major sets in the film, Chiang estimated, but that number actually almost doubled, given the major makeovers many sets required for the distinct look of the Beowulf era. The mead hall was one of the most pivotal sets, the setting for the introduction of a hard-drinking Hrothgar, Grendel's bloody rampage, and the creature's epic face-off with Beowulf.

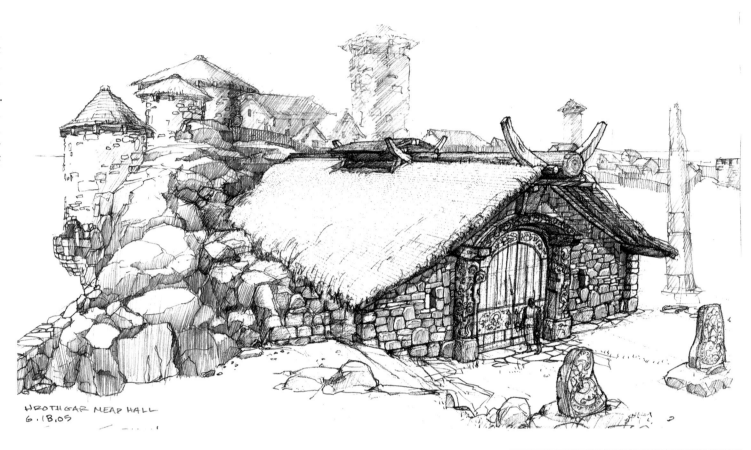

HROTHGAR MEAD HALL
6.18.05

opposite, top
Hrothgar's mead hall, exterior //
KURT KAUFMAN // pencil sketch

opposite, bottom
Hrothgar's mead hall, exterior, night of the Beowulf/Grendel fight //
AARON BECKER // painting

An example of the production's second design phase—taking individual unfinished frames from the final cut of the film and adding color and light—it is this sunset exterior that sets the mood for Beowulf's battle with Grendel that night. This level of key-frame art represented the final look of the film itself.

above
Hrothgar mead hall, exterior //
KURT KAUFMAN // 3-D-based drawing

right
Norse architecture // reference photo

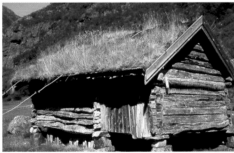

"It's a very narrow focus, this time in history in which *Beowulf* takes place, and we took a lot of liberties. But with monsters and a dragon, we also got to infuse our imagination. Being reality-based and also incorporating the fantastic, but without crossing the line into the whimsical, was our task."

MARC GABBANA

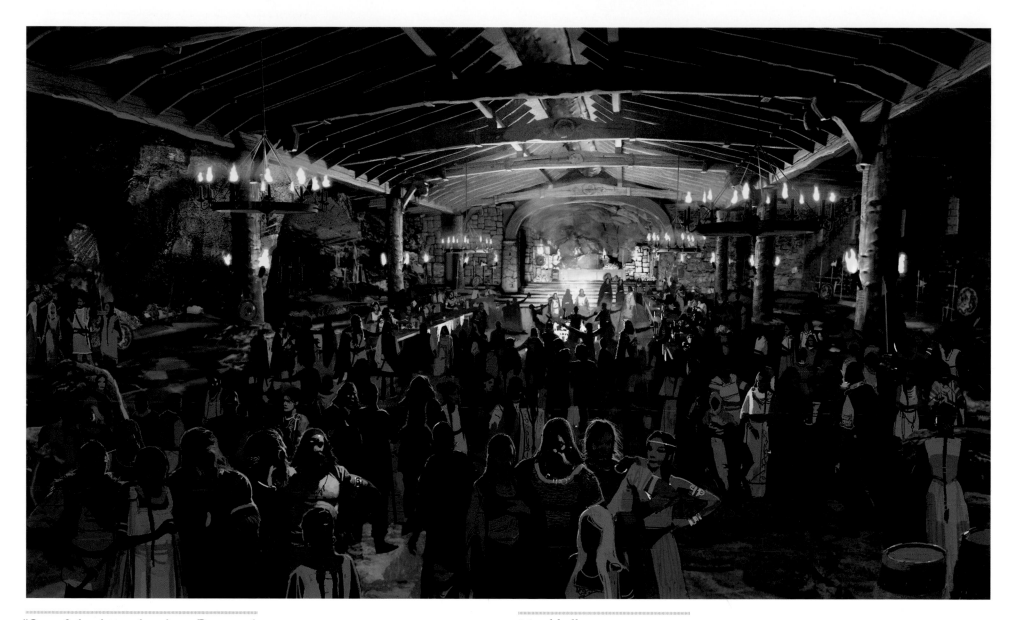

"One of the things that drove Roger and me when we were writing the *Beowulf* screenplay was the idea of this weird historical feeling seen in movies like *Monty Python and the Holy Grail,* a past in which things were dirty, where people had sex and pissed and swore and got drunk—a lot like *us.*"

NEIL GAIMAN

Mead hall party scene // BILL MATHER and DERMOT POWER // painting

"I was *in* the mead hall," laughed Bill Mather, a veteran matte painter who started his career at Matte World and ILM. "Hrothgar's mead hall is rustic, kind of rowdy. The fun part of painting the mead hall was imagining myself there. It just seemed a cool place, with one side built into this natural rock where there's a spring and waterfall that form a sort of latrine area where they go to piss and throw up. Things will look more organized when Beowulf takes over, because although they're all Vikings, Beowulf and his men are more disciplined warriors."

Hrothgar's mead hall interior //
BILL MATHER // painting

This after-party appearance featured a "cooler look," noted Bill Mather. Working on 2-D imagery in the computer allowed the production to go from a "clean" image to one full of characters. For scenes of a crowded hall, Mather teamed with Dermot Power, a British comics artist whose film design experience included working with Doug Chiang on *Attack of the Clones*. "For the mead hall, I would give Dermot a painting of an empty hall, with tables and everything, and he would take it in the computer and paint his figures over it," Mather explained. "Dermot is really good, so it was fun to see him populate a scene and make my painting come to life."

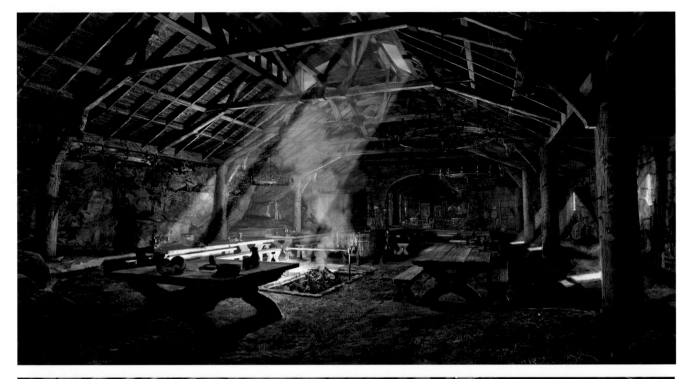

Mead hall party scene // BILL MATHER
and DERMOT POWER // painting

Mather noted this was a final for the look of the lighting and fire pit, the door, and stone walls.

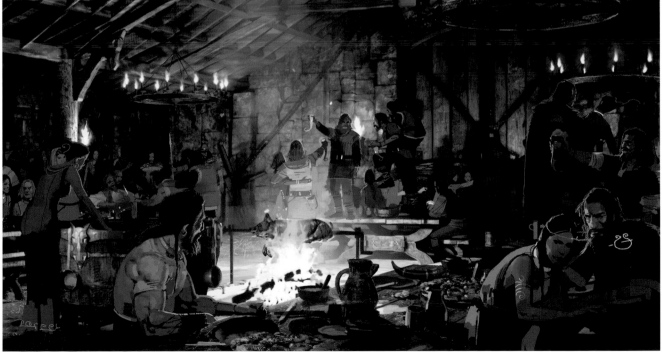

As the conceptual art was adapted for its purposes by Sony, everything had to be defined, right down to the cups and silverware on a mead hall table. "We had to determine things like how shiny a cup should be," Jerome Chen noted. "Or we might need to break off the shutters of a window because it would be allowing in too much light, so, it would go back to the art department to redesign. That's why Doug [and the art department] had to be involved throughout the entire production."

A major story point was how the mead hall door was reinforced to keep Grendel out. "When we worked on details such as how to reinforce the mead hall door, we had to keep in mind the Viking mentality," Chiang noted. "How would they reinforce it, given the materials they had to work with?"

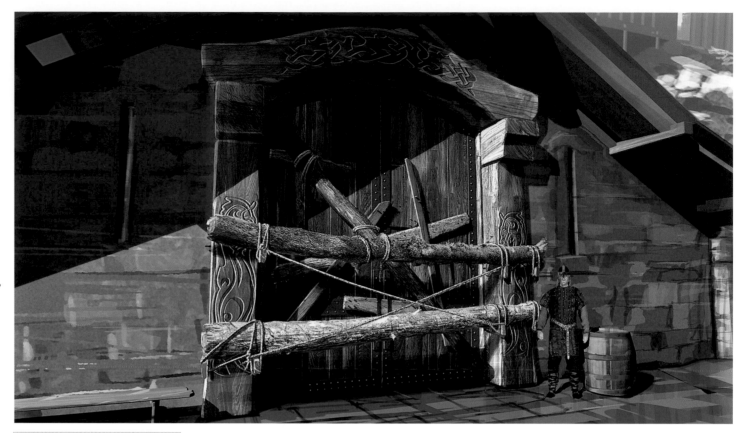

Barricaded mead hall door, exterior //
KURT KAUFMAN // painting

This image shows the mead hall door locked up and off-limits to Viking revelers after Grendel's deadly rampage.

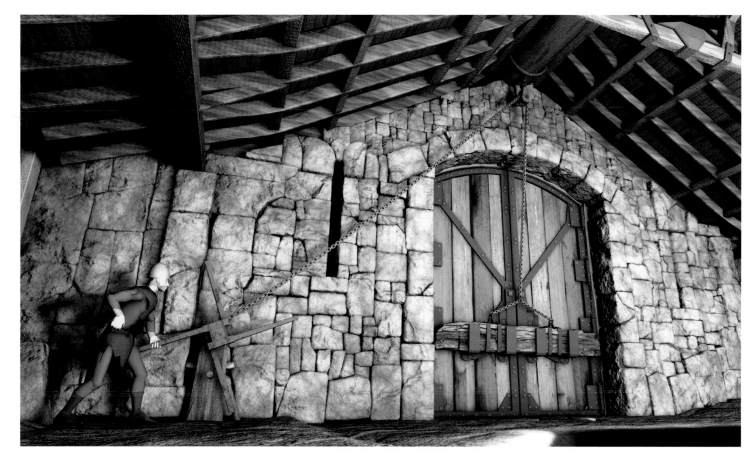

"One of the unique aspects of how we designed *Beowulf* was we rarely designed elements outside of the context of the film. In other films you might design specific props and sets without taking into account things like the characters who would be there, or how a scene would be seen in terms of cameras and lenses. In this process, we did it all at once."

DOUG CHIANG

Mead hall door reinforcement //
PETE BILLINGTON // CG model

Mead hall door reinforcement //
KURT KAUFMAN, CG DEPARTMENT //
pencil sketch

Mead hall door wrench //
PETE BILLINGTON // CG model

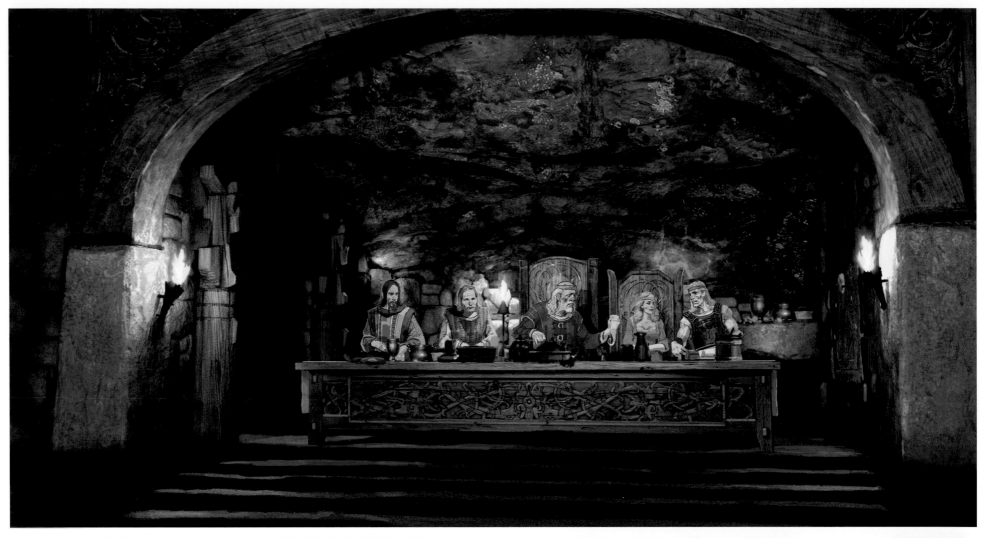

Mead hall, Hrothgar throne area //
BILL MATHER and DERMOT POWER // painting

This "Last Supper" pose shows the rough
quality of Hrothgar's mead hall, with bare
rock overhanging the royal table. In addition
to Dermot Power's figures, the painting
incorporated elements of the Kaufman design.

Ray Winstone and Geat actors in mead hall //
GREG PAPALIA // photograph

At the Sony mocap stage, some "troupe players," as the
production called performers who served in small roles or
as extras, gather with Beowulf for a mead-hall banquet
scene (the motion sensor suits making them look like
characters from the pioneering 1982 computer-effects
film *Tron*).

The infrared motion-capture cameras couldn't see
through solid objects, so all props that actors needed to
interact with—swords, eating utensils, chairs, Hrothgar's
throne—were built of chicken wire and welded steel. "The
props had to be structurally strong, but transparent to the
motion-capture process," Billington explained. "The full
team, our group in Northern California and the CAD team
in L.A., designed the specs for all the props, which then
went to the fabrication department to be built, and then
went on set."

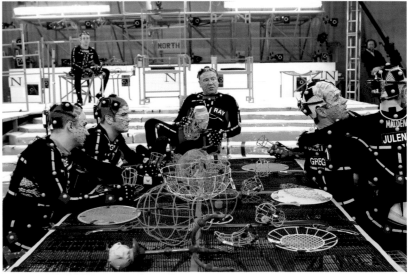

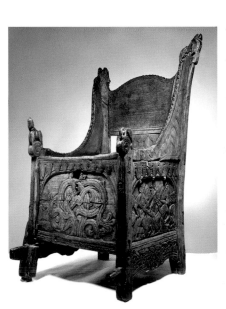

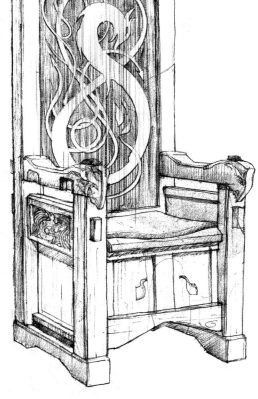

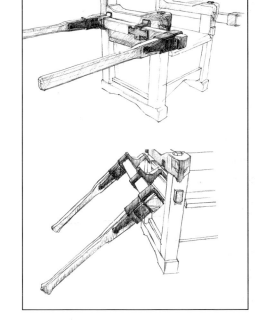

far left
Throne // reference photo

left
Hrothgar's throne // KURT KAUFMAN //
3-D-based drawing

right
Hrothgar's throne carrier // KURT
KAUFMAN // pencil

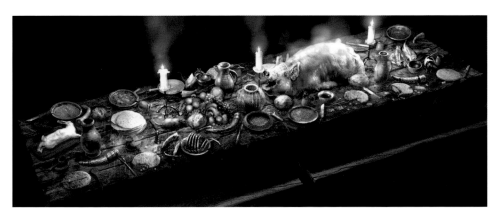

left
Typical table setup // RANDY GAUL //
digital painting

right
Tableware // reference photo

"The main difference between doing a traditional film and one of this style is that instead of building sets on a real location or soundstage, you're building them all in the computer. That's the first thing you have to do—design the entire film and then construct it in three dimensions in the computer. After that, you translate the performance information for the actors. But you have to design everything in advance because the actors need to physically know where they are in the spaces of the film. So, if you're in the king's quarters, you need to know things like where the entrance to the room is and where the bed is, so you know how to move around in that space."

STEVE STARKEY

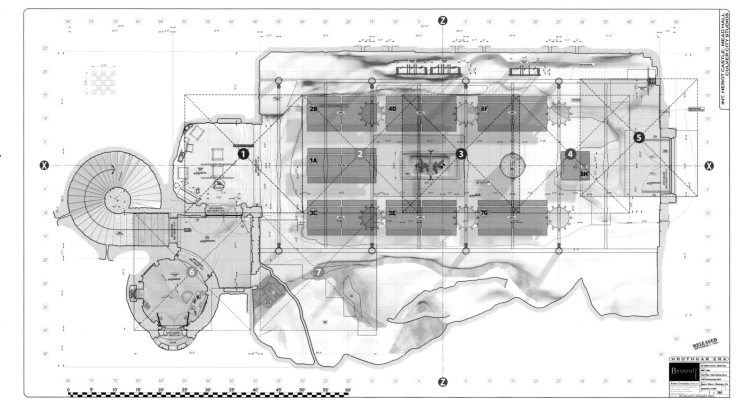

To nail down the volume on the motion-capture stage, CAD set designer Todd Cherniawsky would figure out the actual dimensions of the sets the designers were developing in Northern California.

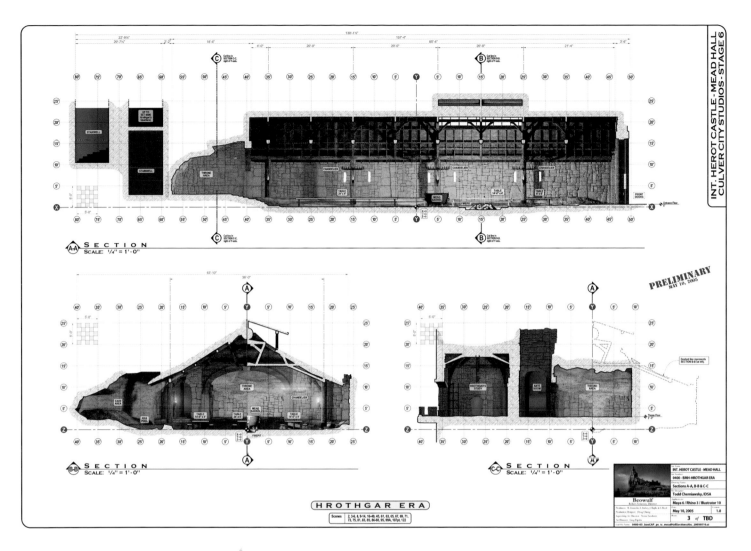

A-A **SECTION**
SCALE: ¼" = 1'-0"

PRELIMINARY
MAY 10, 2005

B-B **SECTION**
SCALE: ¼" = 1'-0"

C-C **SECTION**
SCALE: ¼" = 1'-0"

HROTHGAR ERA

Scenes 2, 3-6, 8, 9-14, 16-40, 45, 61, 63, 65, 67, 69, 71, 73, 75, 81, 83, 85, 86-90, 95, 99A, 107pt, 122

INT. HEROT CASTLE · MEAD HALL
0400 · BMH·HROTHGAR ERA
Sections A-A, B-B & C-C
Todd Cherniawsky, IDSA
Beowulf
Robert Zemeckis, Director
Maya 6 / Rhino 3 / Illustrator 10
May 10, 2005 1.0
3 of TBD

opposite and top left
Herot Castle mead hall //
TODD CHERNIAWSKY // CAD set drawing

Rough set models, dubbed "Maya models"
after the 3-D modeling program, informed
the director's layout. "This is a simple model,
because it takes less computer memory,"
Newberry noted. "Actually, it's not that
different from a [live-action] movie, where
you want designs locked in before you start
shooting. Our set models had to be even more
accurate, but they also kept getting developed.
Depending on what happened on the mocap
stage, we could also fix a model, shift things
around, refine it later."

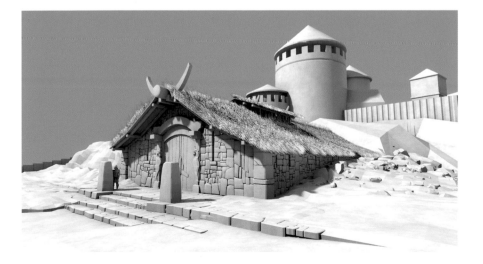

left
Hrothgar's mead hall, exterior //
YOUNG DUK CHO // CG model

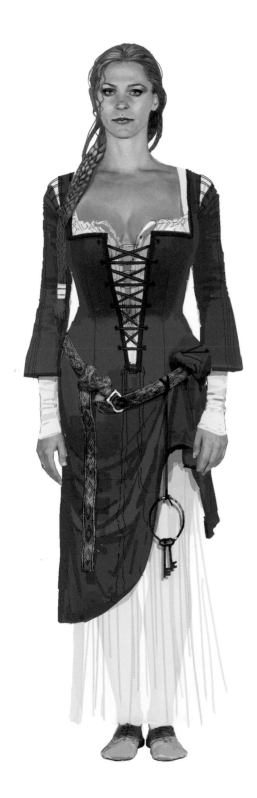

What's a bawdy mead hall without a sexy serving wench? At Herot, there's the flirtatious Yrsa, played by Robert Zemeckis's actress wife, Leslie.

left
Yrsa, final costume design //
DERMOT POWER // painting

After Fix finished his portrait and costume designer Gabriella Pescucci completed the costume design, Power painted this full-figure image of Yrsa, incorporating photographic elements.

right
Yrsa, final character design //
COLIN FIX // portrait

"It's a cheap trick, but I made sure there was extra contrast in her face and shoulders, to guide [the viewer's eye] to her breasts," Fix laughed. "Yrsa is a seductress and I wanted people to go, '*That's* a sexy vixen!'"

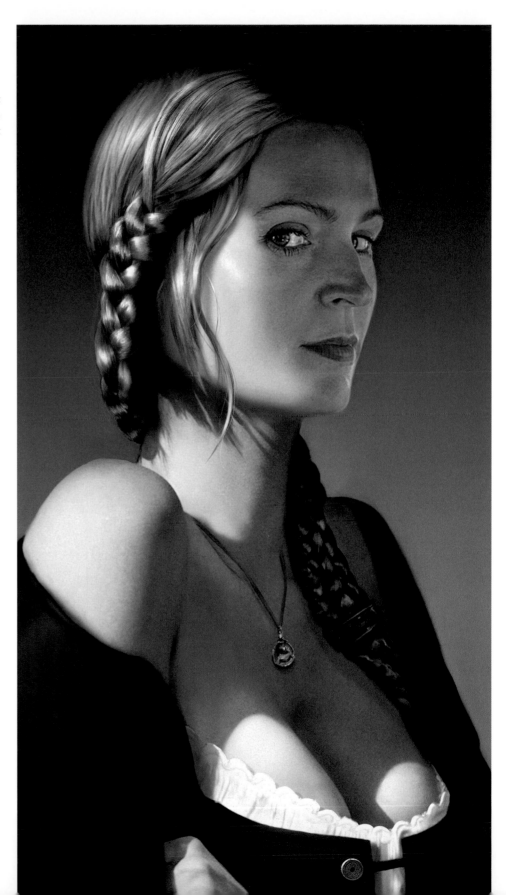

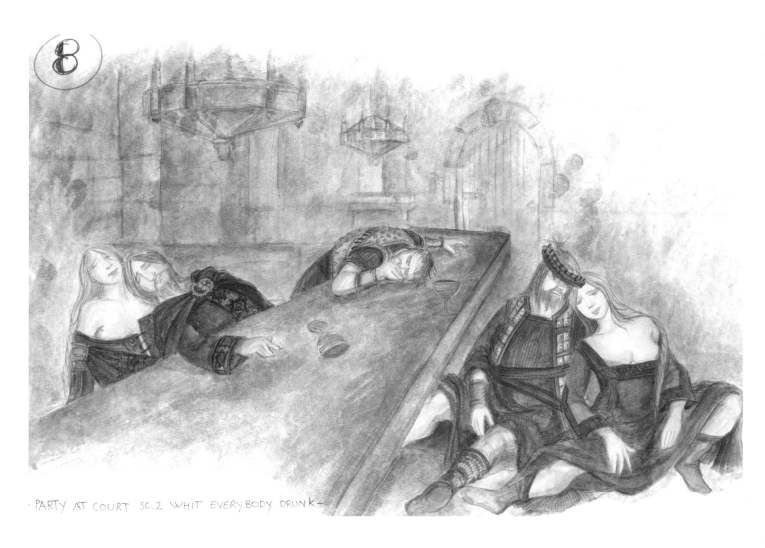

- PARTY AT COURT SC. 2 WHIT EVERYBODY DRUN k-

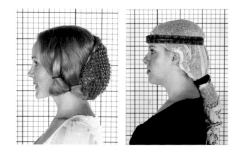

Hair reference photo shoot // SONY
PICTURES IMAGEWORKS // photographs

"Sample of hairstyle" for Herot village
women // GABRIELLA PESCUCCI // concept art

SAMPLE S OF HAIR-STYLE

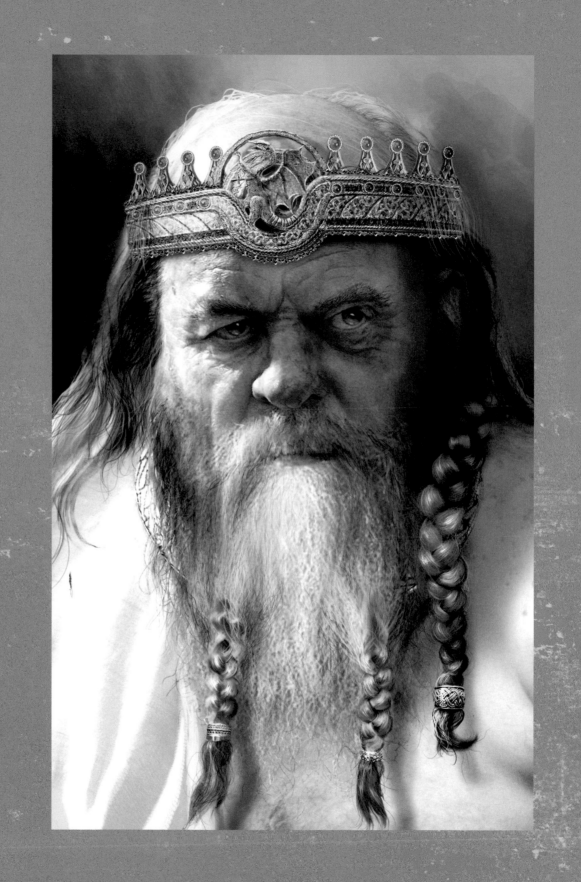

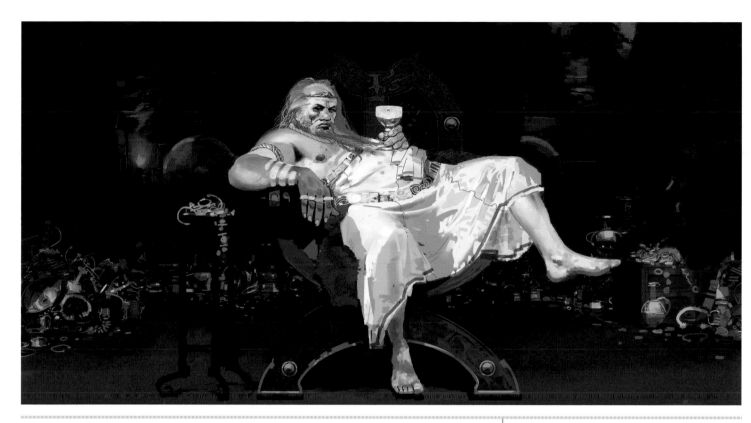

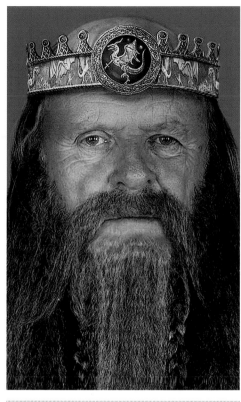

𝕮𝖍𝖎𝖆𝖓𝖌'𝖘 𝖉𝖊𝖕𝖆𝖗𝖙𝖒𝖊𝖓𝖙 𝖉𝖎𝖉𝖓'𝖙 take on the hugely complex task of building three-dimensional character models, but its character designs did establish the director's vision for each character. Before final casting, the art department explored potential character designs, but it was difficult doing that from scratch, Chiang noted. "What made the difference was when casting started. That's when characters started to come to life, because we started to model and design them with the likenesses of the actors."

Leading the character design and portrait work were Colin Fix, Dermot Power, and Bill Mather. Before costume designer Gabriella Pescucci joined the production, Fix and Power worked on costume designs, which Power had done on *Attack of the Clones*. The portraits had to have a photorealistic quality because, generally, the CG characters were modeled in the likeness of the actors, such as Hopkins as King Hrothgar, or designed to incorporate physical aspects of an actor, such as Crispin Glover's facial features that informed the final design of Grendel.

In the poem, fortunes of war have blessed Hrothgar and he builds his mead hall to be a wonder of the world and testament to his glorious reign. In the film, Hrothgar is a shadow of that storied ruler, a man burdened by secrets and whose reign is cursed. He's a heavy drinker and so overweight he must be carried around on a portable throne (Anthony Hopkins referred to his character as "legless"). The king also suffers the indignity of seeing his queen attracted to Beowulf.

King Hrothgar // DERMOT POWER // painting

"One description around the [art department] for Hrothgar's body type was that he was a retired football player," Fix recalled. "He's now broken down, overweight, but you could still see that he had been a powerful man in his youth."

opposite
King Hrothgar character and crown development // COLIN FIX and RANDY GAUL // digital painting

Hrothgar make test photo shoot with crown // RANDY GAUL // digital painting

"I was told that when Anthony Hopkins was shown this final portrait he asked to take it home," Fix noted.

"This film has a realistic look; it's not stylized like the usual animated film. So the production needed a sense of the final look of a character, what the digital costume, hair, and makeup would be. A lot of our guys can paint photorealistic images, but that can take months. So you have to scan and incorporate photographic elements to quickly get to the level of realism you need. It's like making a photocollage and painting over it to mend the seams and change color, mood, and texture."

COLIN FIX

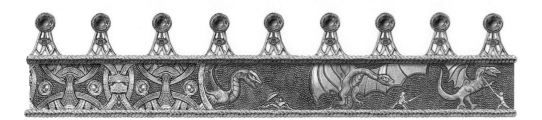

Detail of crown design depicting Hrothgar's slaying of the dragon Fafnir //
RANDY GAUL // digital

above

Hrothgar costume designs //
GABRIELLA PESCUCCI // concept art

right

Full Hrothgar figure and costume design //
DERMOT POWER // painting

far right

Hrothgar grid reference photo // SONY
PICTURES IMAGEWORKS // photograph

To help gather as much information as possible
for Sony's CG characters, the production
photographed actors and "body doubles" against
grids, which allowed reference marks for Sony
modelers and art department artists. This iteration
of Hrothgar was used as a costume reference, with
Hopkins' face pasted on a body double.

"At the beginning, I played Hrothgar as
the rip-roaring drunk he's described as in
his first scene in the script. That was fun,
but then I was going through the script
and found some darker elements. After
all, this was the king of a kingdom. He's
not just a drunk, but a man with great
irony. He knows what's going on between
his wife and Beowulf and it saddens him.
His kingdom becomes worthless to him,
like a shadow, which leads him to kill
himself, and pass on his
curse to Beowulf."

ANTHONY HOPKINS

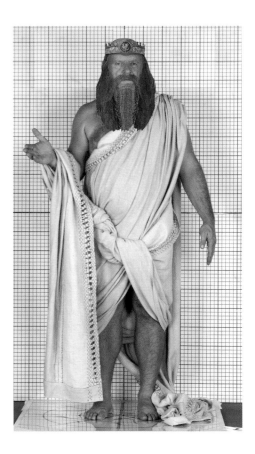

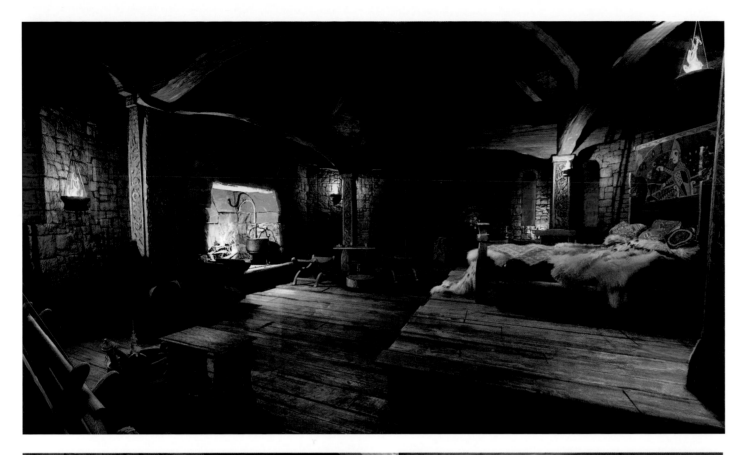

Hrothgar's quarters // BILL MATHER //
painting

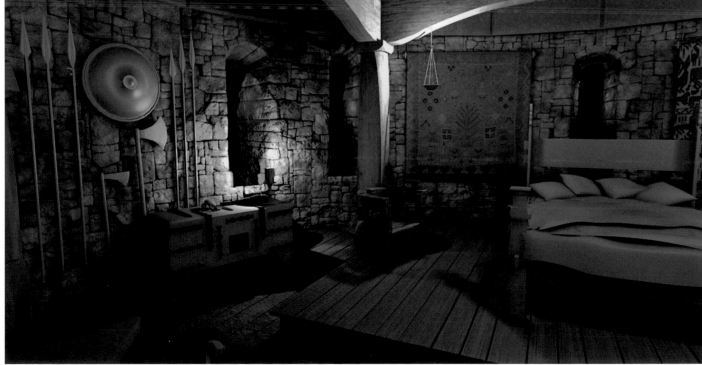

Hrothgar's quarters // ZAC WOLLONS, MATT
DOUGAN, and YOUNG DUK CHO //
3-D renders

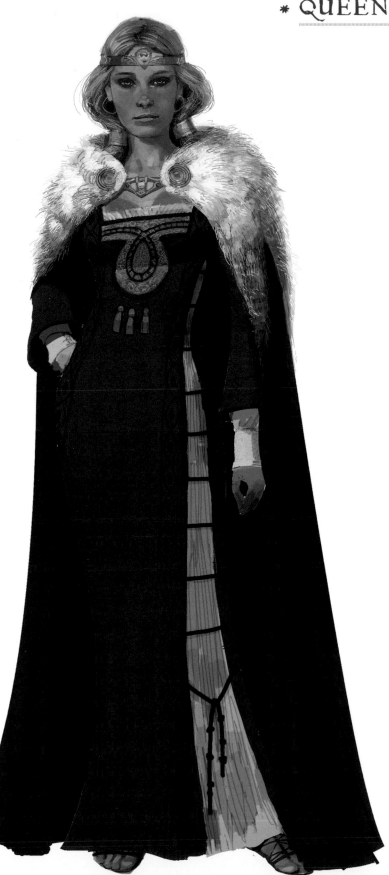

The honor of painting the portrait of the queen was given to Bill Mather, who specialized in painting beautiful women. "When I was a matte painter at Matte World and ILM, I spent the day painting landscapes and buildings, so when I went home and wanted to paint for myself, what's better than painting a beautiful woman? I think painting women is more challenging than painting men. A man's face is more angular; you can get away with more. But a woman's face has a delicacy and smoothness that requires more finesse with a brushstroke—the wrong mark and you can age someone ten years, or completely change an expression."

YOUNG QUEEN

above, left
Queen Wealthow // RANDY GAUL and BILL MATHER // early portrait design

In this early painting, the queen was imagined as being around seventeen to eighteen years old. By the time of her final portrait sitting, Wealthow was around twenty-one.

above, right
Queen Wealthow // GABRIELLA PESCUCCI // costume design

left
Queen Wealthow // DERMOT POWER // digital

opposite
Queen Wealthow // RANDY GAUL and BILL MATHER // final portrait

The queen, as Mather understood her, was a beautiful young woman trying to uphold her grace and dignity in the face of a boorish husband. "She can't leave him because he's the king, so she has to put up with his behavior. But she also likes being in a position of power."

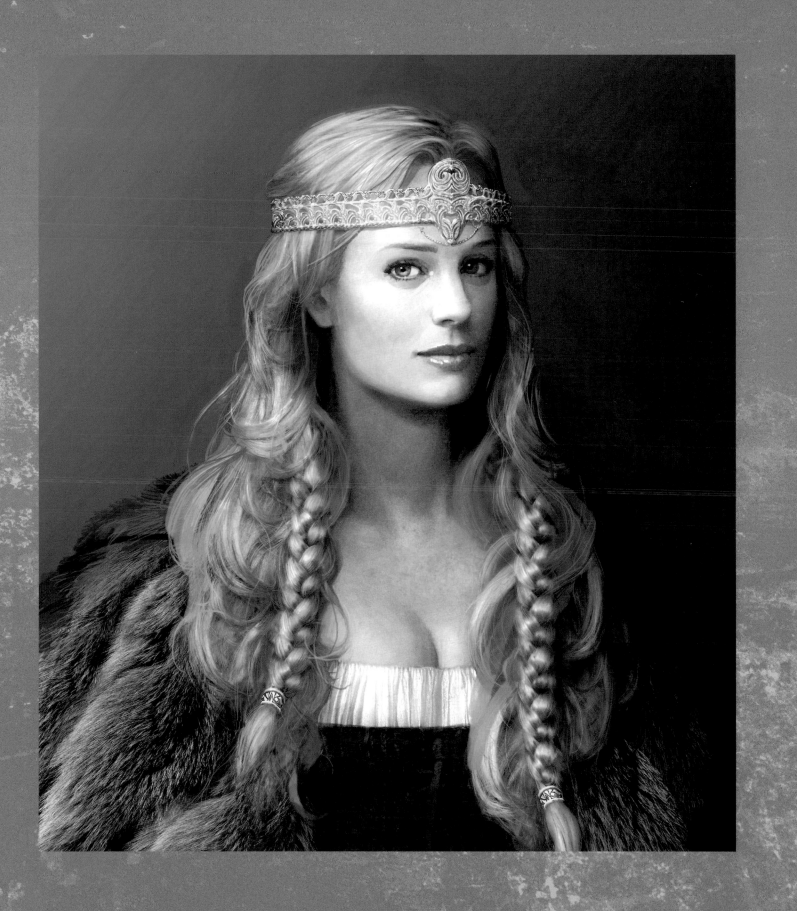

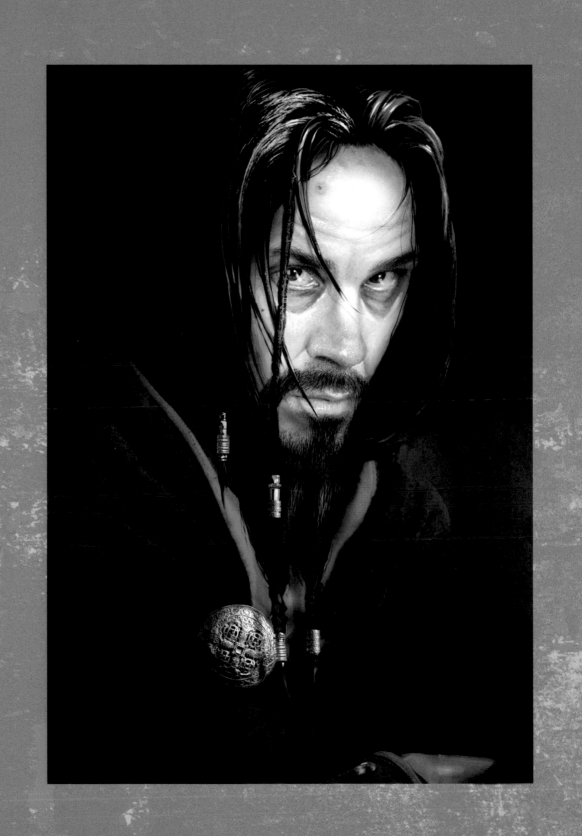

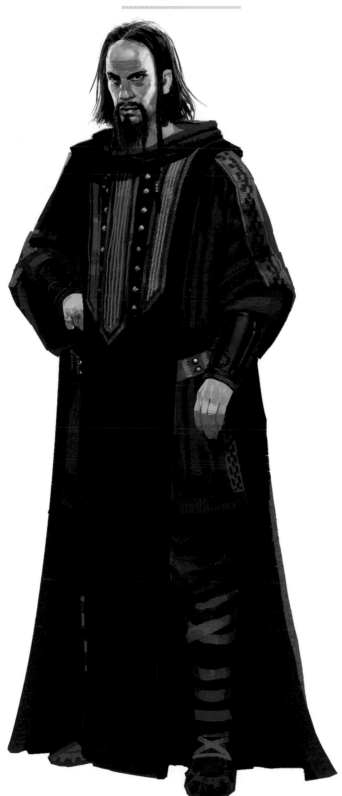

"Young Unferth," as the production called him, is Hrothgar's closest advisor, a political schemer and insider. "Doug asked me to give young Unferth a sleazy, smarmy look," Fix explained. "I would get a portrait to a point and Doug helped guide me to the final design."

opposite

Young Unferth // COLIN FIX // final character design portrait

Young Unferth // DERMOT POWER // final character and costume design

The early costume design work of Fix and Power was reevaluated when costume designer Gabriella Pescucci joined the production. "Bob was happy with some of the costumes Dermot and I had done," Fix noted, "so some elements stayed with the characters. Others went away completely, as Gabriella redesigned them. I had done a full body of the young Unferth, Gabriella tweaked the design, and Dermot then did this final art based on what Gabriella had done. This is an example of a more finished character piece, where the proportions were very specific to provide a precise guide for Sony's modelers."

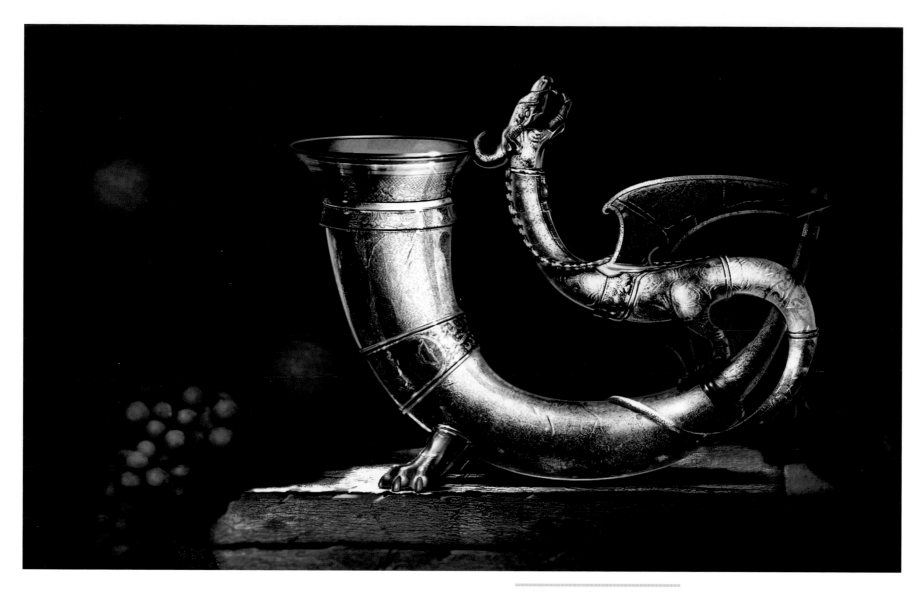

Golden mead horn final design //
JOSH VIERS // painting

This final design inspired Sony Imageworks'
computer-generated model. The dragon motif
that forms the handle includes a red ruby on the
neck, a symbol of the Achilles' heel of the golden
dragon Beowulf battles near the end of the story.

The icon of the film is a golden mead horn that King Hrothgar presents to Beowulf. For Beowulf, it will ultimately mean supreme power—and a curse. "The horn symbolizes the treaty and power that goes with the deal they make with Grendel's mother," explained Josh Viers, who took the lead in the golden horn's design. "When Hrothgar gives the golden horn to Beowulf, he's actually handing over the curse."

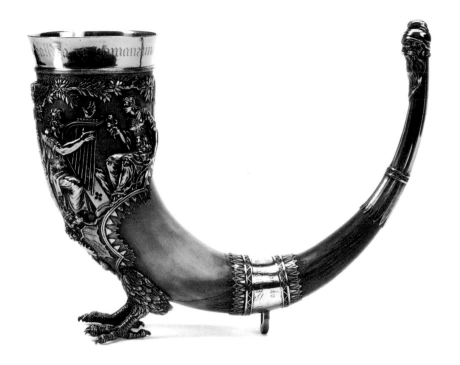

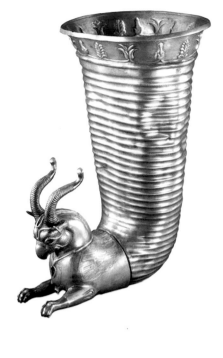

Mead horn // reference photos

For inspiration for what Viers calls "the ultimate symbol of these tough Vikings," he looked at photographic references of mead horns ranging from the sixth to the fifteenth century. References included one with sculpted feet, which appealed to the director and were featured in the final design. "Those little sculpted feet allow you to set the horn down on a table and are mead horns of royalty—only Hrothgar and Beowulf drink from this type," Viers explained. "The thing is, a mead horn is just a hollowed out horn—once you've filled it with mead, you can't set it down! So, when these Vikings started to drink they couldn't stop and would get out-of-control drunk. Greg Bossert, our research archivist, told us that mead, which is fermented honey, was pretty powerful."

Golden mead horn presentation design //
AARON BECKER // painting

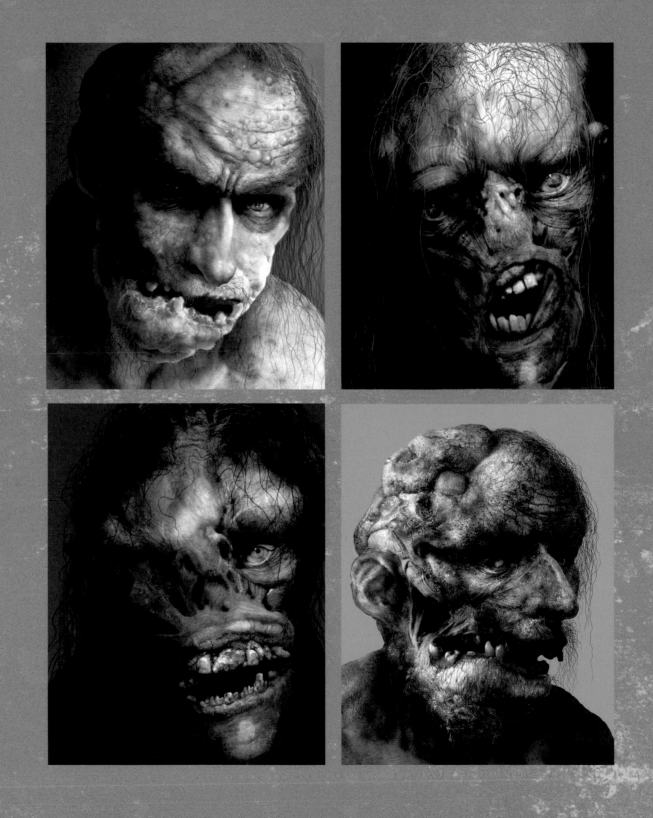

✳ GRENDEL ✳

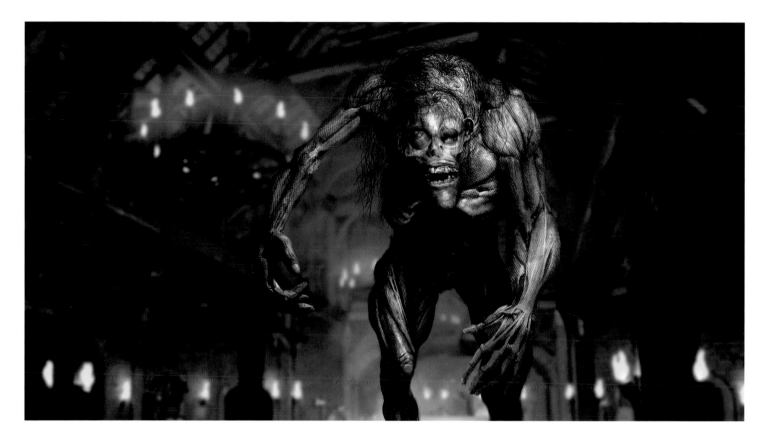

left
Grendel design development //
DOUG CHIANG // digital

> "Grendel is the embodiment of pain."
>
> ROBERT ZEMECKIS

𝕮𝖍𝖎𝖆𝖓𝖌 𝖗𝖊𝖈𝖆𝖑𝖑𝖘 that the director's description of Grendel as "the embodiment of pain" was a breakthrough for the character's design. "Bob's description was a story point that dictated what Grendel became. Grendel is deformed, has open sores—you understand how painful it must be to be Grendel. I loved the twist that Grendel was not so much a monster as a tormented child. You can sympathize with his agony; he's no longer a monster for monster's sake. And then there was Crispin Glover's performance, which brought in nuances and subtleties. The character designs were constantly evolving because an actor can bring so much more to a character than a visual designer like myself. For example, in our original design, Grendel's forehead was deformed and covered with boils, but Bob realized that so much of Crispin's performance used his forehead. So, the finished design became a synthesis that reflected Crispin's acting."

right
Grendel's agony // RANDY GAUL // paintings

Grendel tears his flesh, driven mad by the raucous merrymaking drifting across the moor from Hrothgar's mead hall.

opposite
Grendel head design development //
RANDY GAUL // digital

"Early on, we went down some crazy paths. Grendel was a hairy, demonic monster, but came back to recognizably human attributes in his eyes, expression, and facial structure. This was done so audiences could identify with him, which is a hard thing to do. Most alien or monster designs are one-dimensional—they're the 'bad guys' that need to be killed. In this film, there's a thread between creatures and humans that knits everything together."

RANDY GAUL

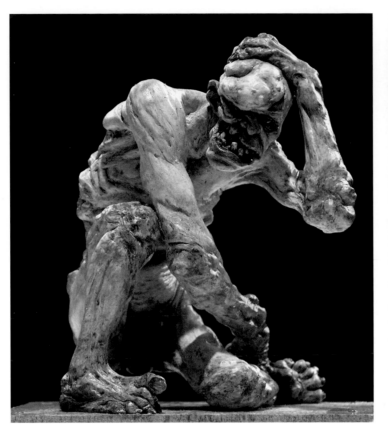 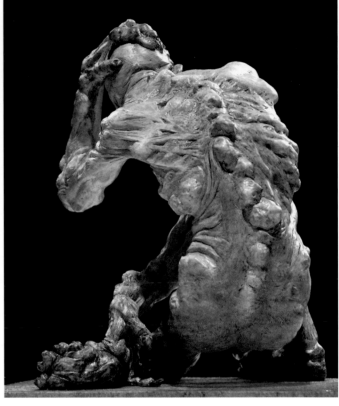

Painted Grendel sculpture, front and back views // TONY MCVEY // sculpture

"During the design process, the idea was always to make Grendel sympathetic," McVey recalled. "He's this tortured thing, really a deformed child. He's sensitive to noise, and all the racket coming from the mead hall drives him crazy. In some ways, it's Beowulf who's the unpleasant character. He's a schemer, because if he kills Grendel he wins fame and glory. At least, that's my take."

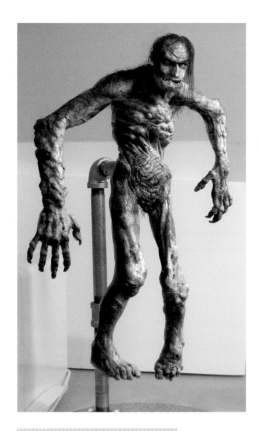

Grendel // RANDY GAUL // painting over Tony McVey sculpt

This painting, based on the McVey sculpt, took the design into color and incorporated Crispin Glover's facial features into Grendel's face (note the pipe rig from the original scan).

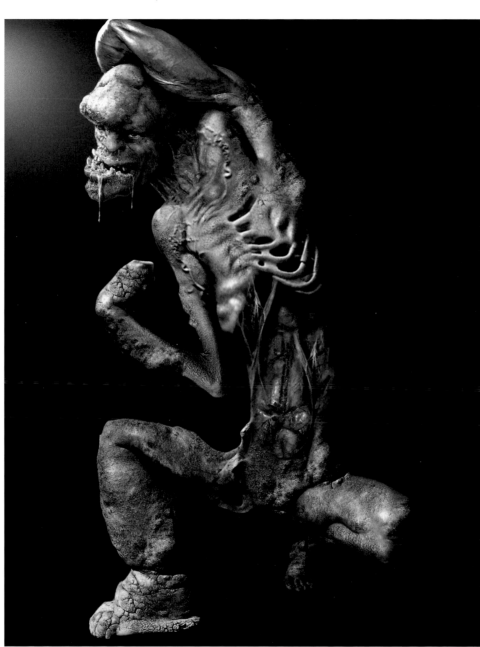

Grendel design development // VLAD TODOROV // digital

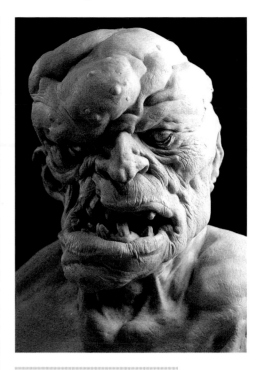

Grendel design head sculpt // TONY MCVEY // practical clay sculpt

This sculpt from the summer of 2005 was an early approved design (for scale, it's three to four inches from chin to the top of the head). This design changed, however, when Zemeckis requested that Grendel's face become more recognizably that of actor Crispin Glover. Zemeckis's overall concept, McVey noted, was partly inspired by *Fighter*, a painting by Austrian artist Egon Schiele. "That painting had a figure covered with bruises and bloody red marks," said McVey. "Zemeckis wanted that look for Grendel, but more battered and deformed."

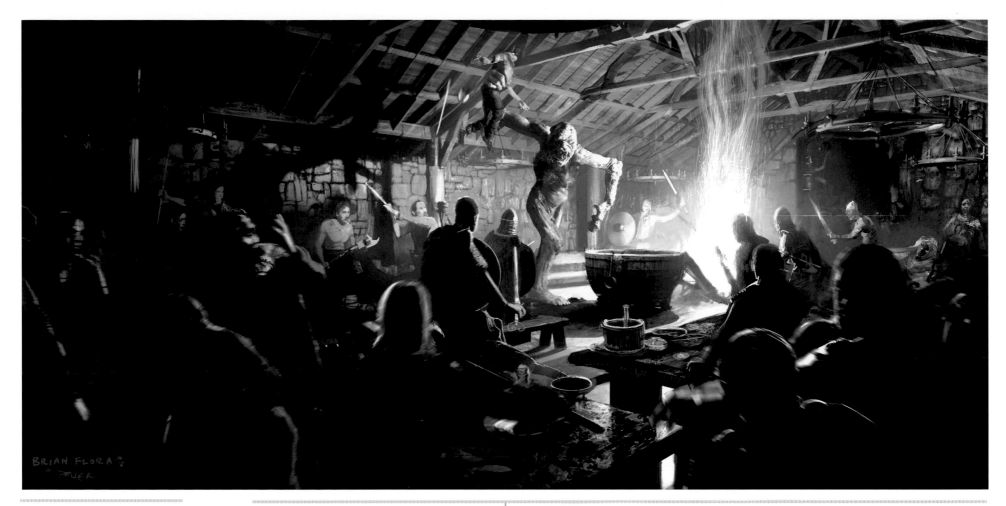

Grendel attack // BRIAN FLORA and
DERMOT POWER // painting

"In the Anglo-Saxon world, 'comfort' was the hall, the idea of being inside some place warm and safe from the outside world, which was dark and harsh, where famine was always on the horizon, the ocean gray and threatening. The idea of a place that's safe and warm from this scary exterior world works as reality and allegory and is a motif throughout Old English literature. Grendel invading Hrothgar's Hall is a fearful thing that upends the social order. To the Anglo-Saxons it's hitting them where they live—it's terrorism coming home to roost."

KARL HAGEN

𝕬 concern was how far the production could go in depicting the violence inherent in *Beowulf*, particularly since the film was also planned as a 3-D release. "Bob's marching orders were not to worry about the violence, that we'd determine later how to tone things down," Chiang said. "That was liberating, because it is a very violent story. We had to show that, to be faithful to what was written. But it was a big concern, how graphic to be."

The production experimented with classic techniques of implying horror through shadow and silhouette. "Bob also came up with a brilliant idea," Chiang added, "that when Grendel attacks, the fire pit in the middle of the mead hall turns into white and blue phosphorus, a surreal, mythical element that causes a stroboscopic effect and desaturates the scene. That allowed us to turn everything monochromatic, to make the blood deep black as opposed to bright red."

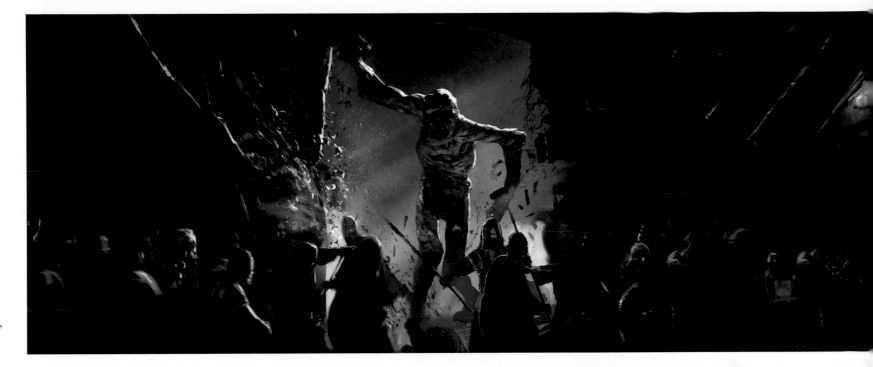

Grendel attack // BRIAN FLORA and DERMOT POWER // painting

"These were fun to work on," Flora concluded. "The work had to strike that balance between hiding certain things to be suggestive and scary, yet read visually. The dark scenes are like that. You want some mystery in the shot."

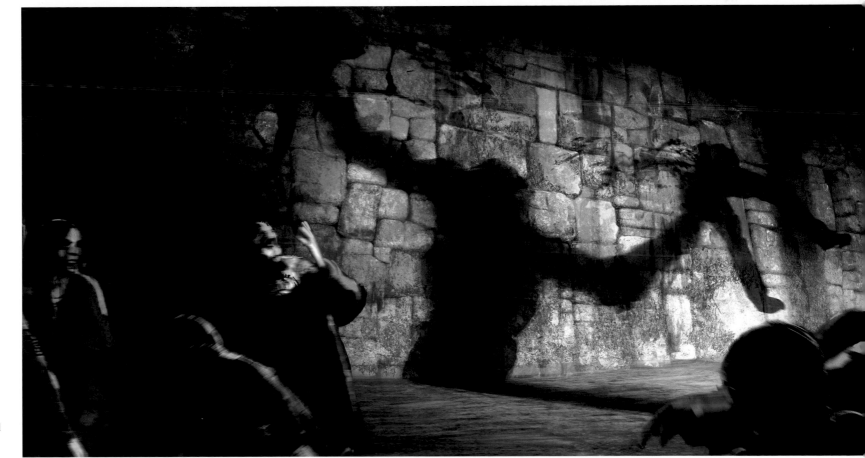

Grendel attack // BRIAN FLORA // painting

The first in a series of three Flora paintings was dubbed "the shadow on the wall," and followed Zemeckis' direction to come up with a shadow image of Grendel ripping a man in two.

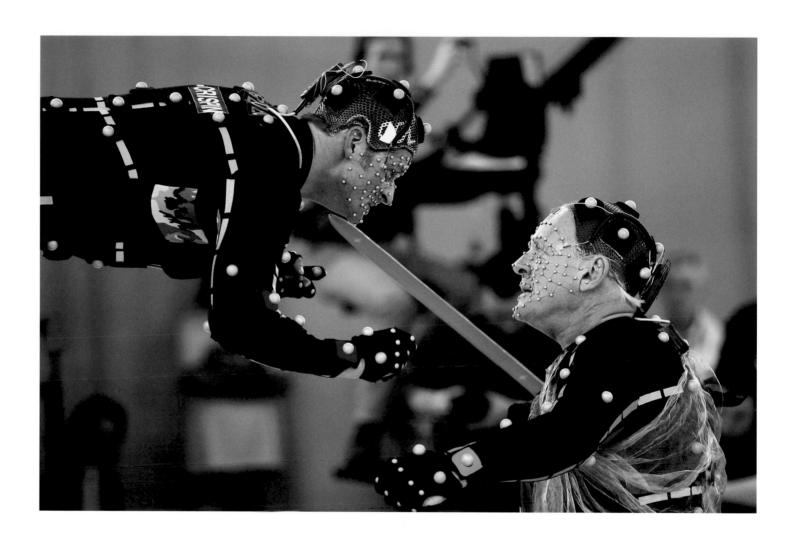

Motion-capture stage action //
GREG PAPALIA // photograph

Crispin Glover is in full-on Grendel mode as
Anthony Hopkins' Hrothgar confronts the
monster. Their performance data would be
applied to the CG characters, with Glover's
performance scaled up to the full dimensions of
the towering creature.

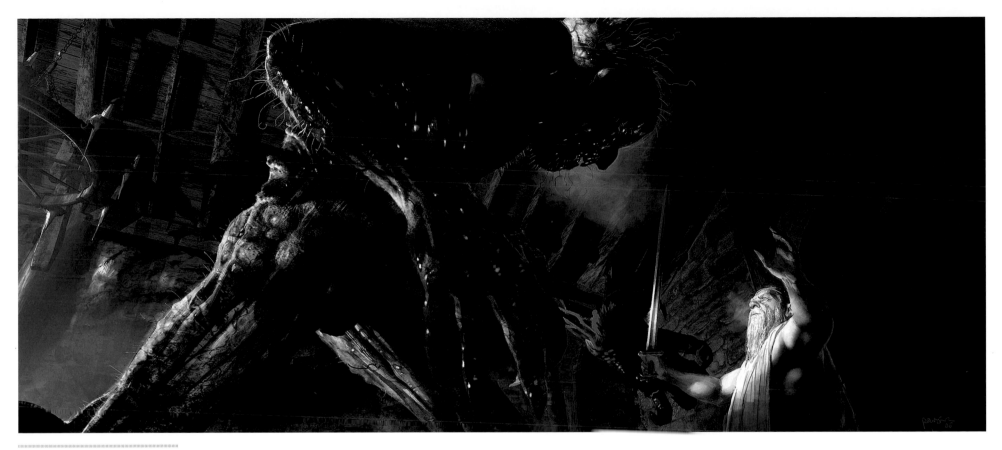

Hrothgar faces Grendel in the mead hall
// DERMOT POWER // key-frame painting

Grendel attack sculpture, front and back views // TONY MCVEY // sculpture

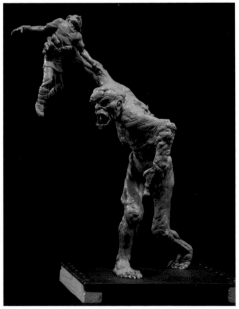

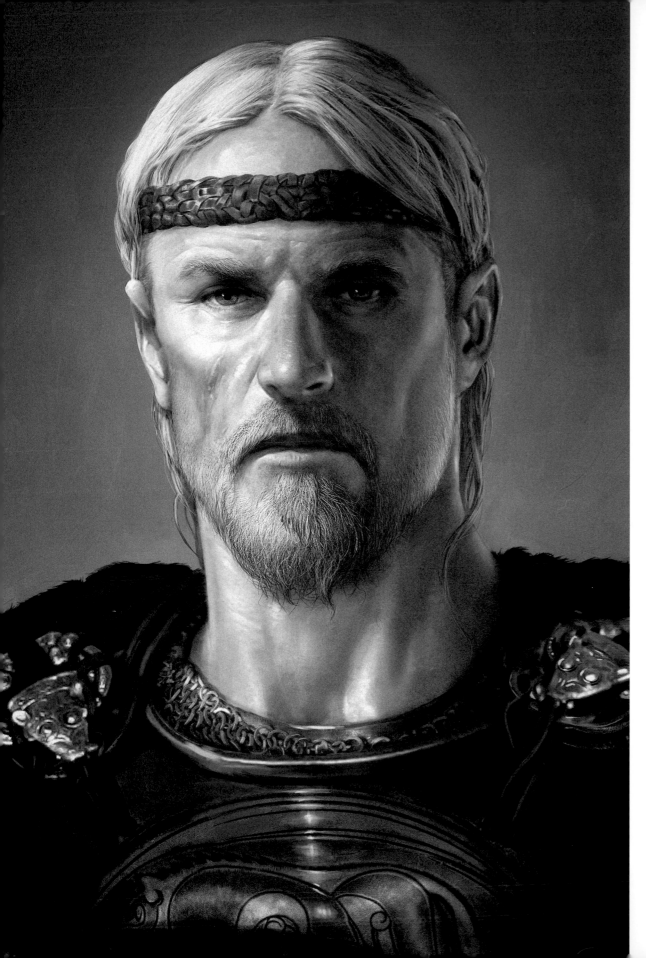

✳ BEOWULF ✳

Robert Zemeckis's vision of Beowulf was that of "an iconic superhero," Chiang recalls. The final CG character would stand, for all practical purposes, an imposing six feet, six inches, and be in his twenties. Beowulf also had to be perfectly integrated with CG characters who would look exactly like the actors who played them on the mocap stage. "It was the same issue we had on *Polar Express,* where there were characters created out of thin air performing against characters that looked like the actual actor who played them," Chiang recalled. "If, in contrast, you're off by a tiny percentage—if, say, the nose is slightly off—audiences will pick it up. They may not know why, but they'll know it looks wrong. People are so attuned to faces that even the slightest variation will be disconcerting. Beowulf is our only synthetic/human character; he doesn't really exist. If it's a stylized film, you can get away with it, because every character is stylized. With Beowulf we had to be more real than real."

A breakthrough came when Zemeckis proposed the intriguing idea that Beowulf look like the holy card image of Jesus Christ. "So, we imagined what Jesus would look like as a superhero, with a bit of Clint Eastwood intensity in his eyes," Chiang noted. "The goal was to create the ultimate, iconic hero. That's the beauty of this process: we can create the perfect character to fit the story. Casting is no longer a limitation."

above
Beowulf's wolf symbol // MARC GABBANA AND RANDY GAUL // digital, from a design by Kurt Kaufman

left
Young Beowulf // COLIN FIX // final portrait painting

The concept art of Beowulf with Winstone's eyes (facing page) was the template upon which Colin Fix created this final portrait (note the wolf design on the breastplate, Beowulf's personal symbol).

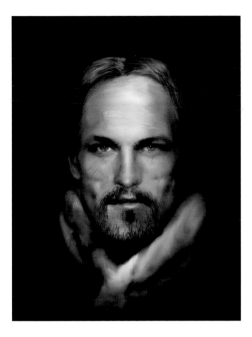 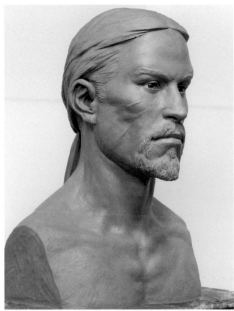 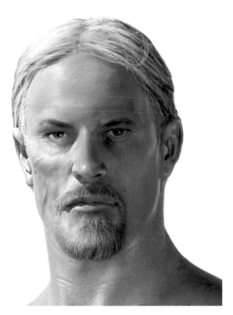 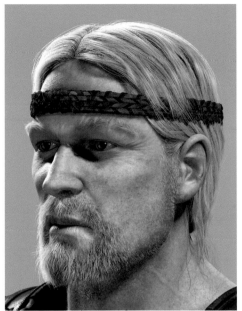

Young Beowulf // AARON BECKER // concept portrait

above right
Young Beowulf // TONY MCVEY // sculpture

As Beowulf designs got closer to what the director envisioned, McVey took the concepts into the physical three-dimensions of a sculpture. "We did the large Beowulf heads in oil-based clay," McVey said. "The point of that is clay doesn't dry out—it's infinitely adjustable."

above left
Young Beowulf // COLIN FIX // concept art

A photo of the McVey sculpt was the foundation for final iterations of Beowulf's portrait design. Colin Fix then went to the Internet to get photographic elements of actor Ray Winstone's eyes. "[The production] felt it important to have his eyes in the final design, so his performance capture and video references would come through in the final model," Fix explained.

above right
Young Beowulf // SONY IMAGEWORKS // final portrait, Imageworks' CG model render

top
*Beowulf costume undergarment and
loincloth design* // DERMOT POWER // digital

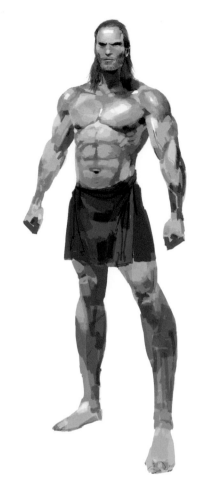

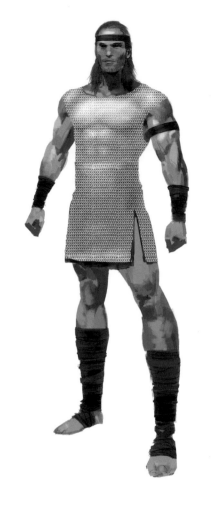

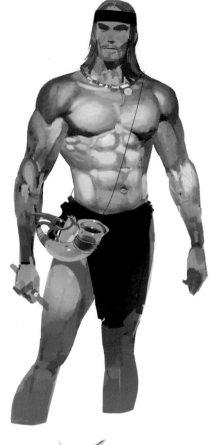

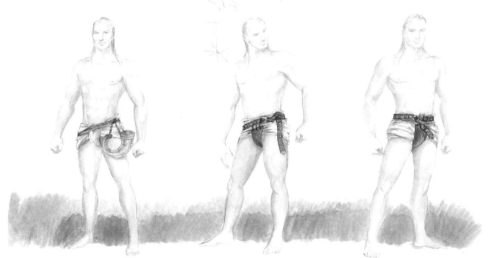

BEOWULF

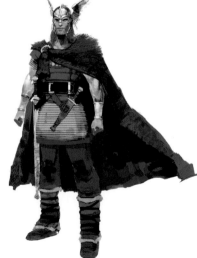

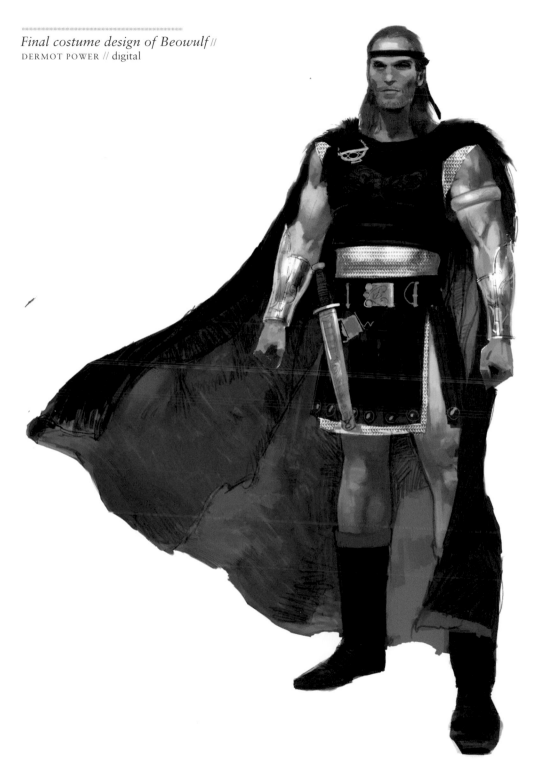
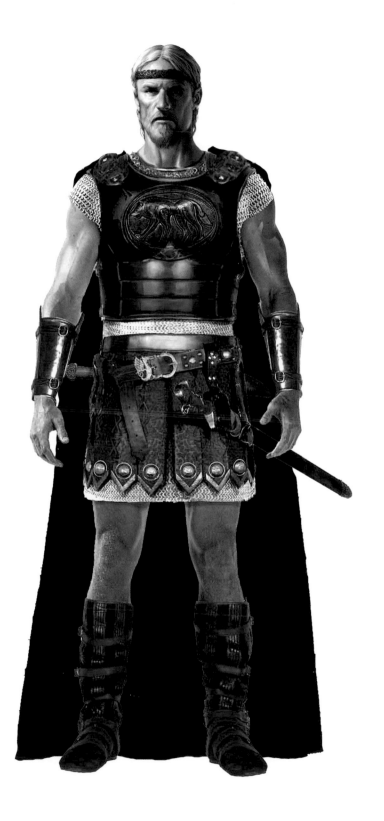

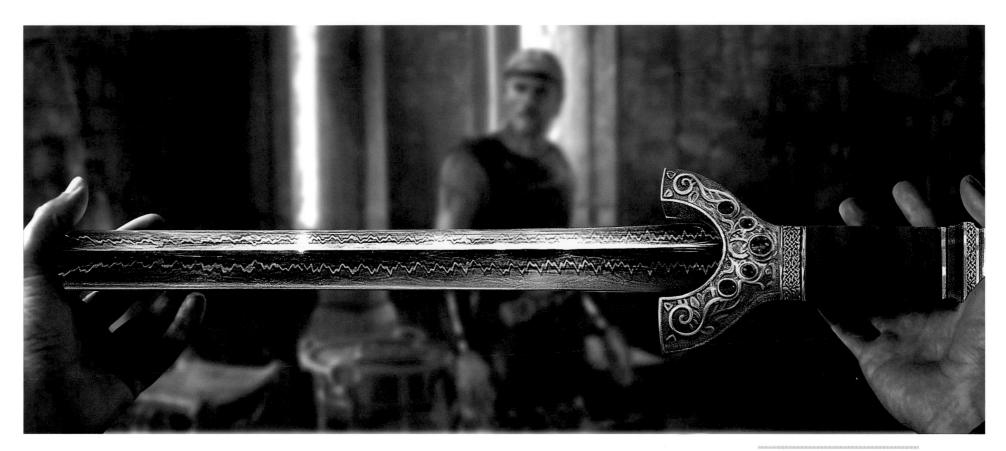

Hrunting sword // RANDY GAUL and BILL MATHER // cutaway

Before Beowulf sets off to battle Grendel's mother, Unferth presents him with the mighty Hrunting sword. Gaul painted the sword, while Mather painted Beowulf and the background, which was thrown out of focus.

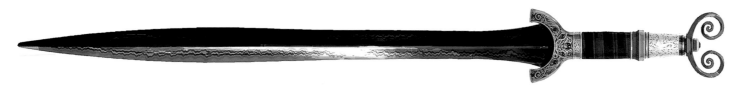

Final Hrunting sword design // DERMOT POWER // digital

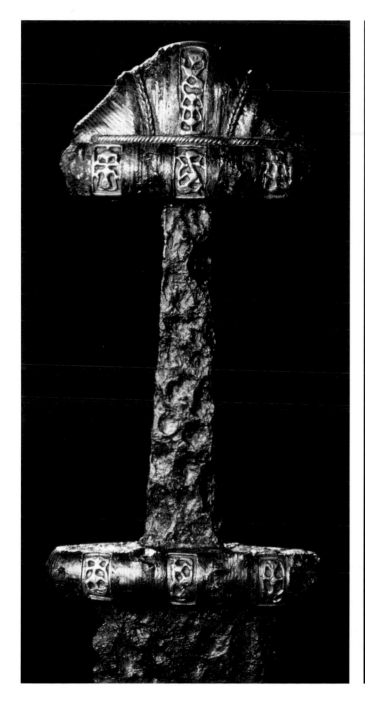

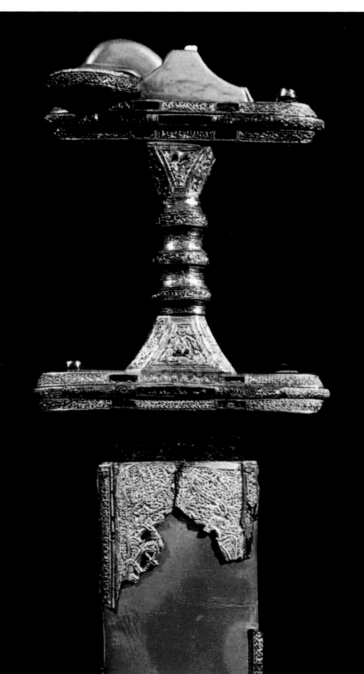

Historic swords that inspired the filmmakers // reference photos

CHAPTER

2

The Hero & the Demons

"**Grendel** spied in hall the hero-band, kin and clansmen clustered asleep, hardy liegemen. Then laughed his heart; for the monster was minded, ere morn should dawn, savage, to sever the soul of each, life from body, since lusty banquet waited his will!... Straightway he seized a sleeping warrior for the first, and tore him fiercely asunder, the bone-frame bit, drank blood in streams, swallowed him piecemeal: swiftly thus the lifeless corse was clear devoured, even feet and hands. Then further he hied, for the hardy hero with hand he grasped, felt for the foe with fiendish claw, for the hero reclining — who clutched it boldly, prompt to answer....

"Wonder it was the wine-hall firm in the strain of their struggle stood... though they crashed from sill many a mead bench — men have told me — gay with gold, where the grim foes wrestled."

✷ Beowulf ✷

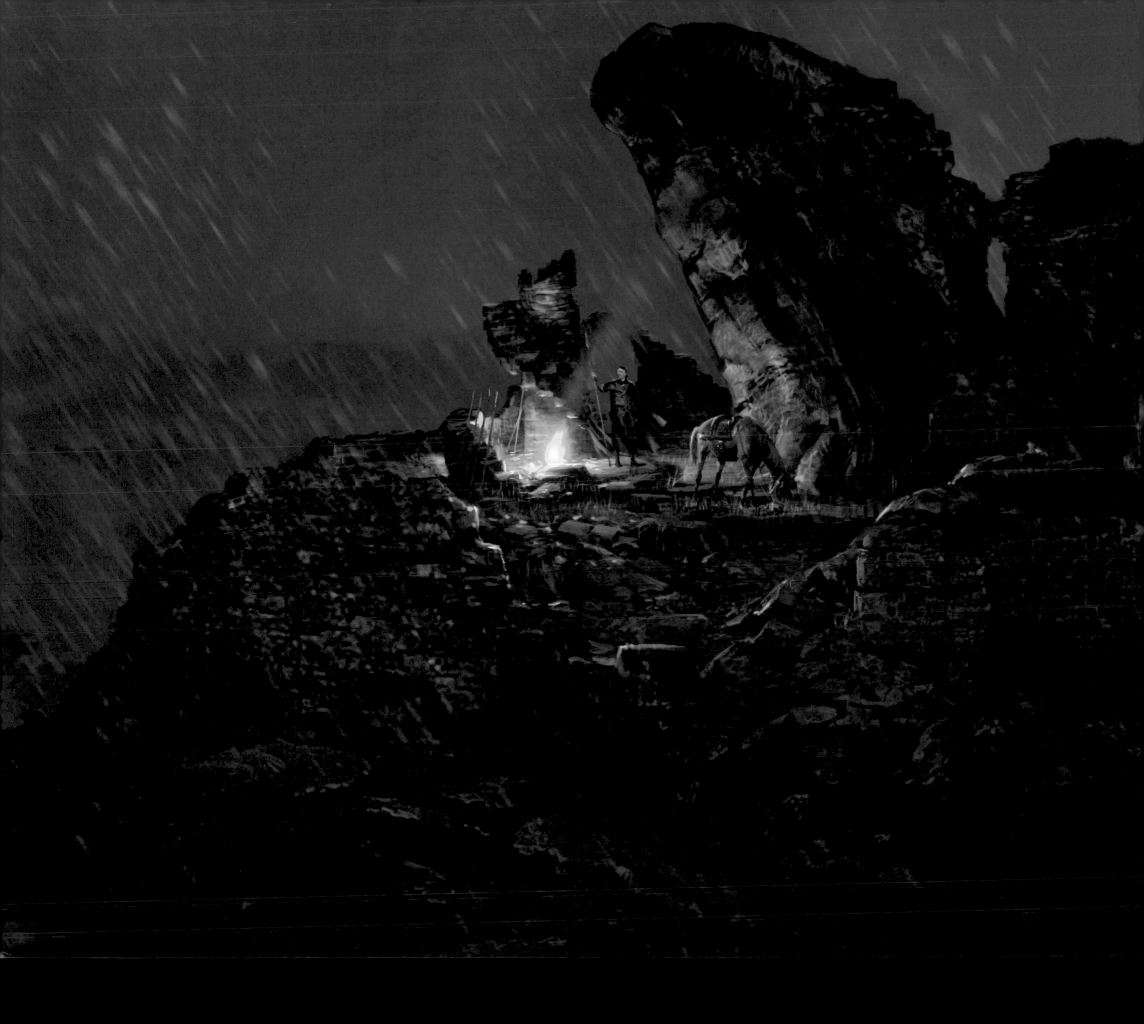

When Robert Zemeckis's production company ImageMovers began gearing up for *Beowulf,* there was a thought of incorporating the poem's Anglo-Saxon roots and casting only English actors with English accents. When the film was finally cast, a few actors were hired as a result of casting sessions in London, while others were hired and underwent dialogue coaching. Producer Steve Starkey also considered going to London to stage a "pre-capture" session, with actors performing rough motion capture that would be used to lay out a story reel. The resulting animation reel would be a precise guide for the official performance-capture work.

What Starkey quickly discovered was that this "simple" mocap session would be hugely expensive and a waste of time. He then had an epiphany—why not just *start* with the performance capture of the real actors? "Other than action sequences and scenes requiring creature models that had to be animated, such as Grendel's mead-hall rampage and Beowulf's battle with Grendel and the fire-breathing dragon, we never did a story reel," Starkey said. "We just accelerated the motion capture and began in the fall of 2005. We picked up four months [on the schedule]."

After *Polar Express* and *Monster House,* the filmmakers had also become more comfortable with the vagaries of performance capture and could appreciate the freedom of pure space. "When you walk onto the performance-capture stage, it seems like a lot of hardware, with computers working, and there are dots all over the faces and bodies of the actors," Starkey explained. "But all that boils down to getting the essence of a human performance that will drive the model you create in the computer. So, after a while, the technology goes away, and it strips down to just the performers acting on stage, very much like a play."

"You get inside these silly suits and have all the dots on your face, but you do feel free," Anthony Hopkins said. "It was interesting working with no sets, and because Robert Zemeckis is a free and easy director, but also strong—he knows what he wants. And the [process] is so fast—you get big scenes in takes that would take days on a conventional film set."

Angelina Jolie, conversant with this kind of movie magic after having performed against bluescreen for the 2004 effects-filled fantasy *Sky Captain and the World of Tomorrow,* also found the process a revelation. "I think the amazing thing about this technology is you can make bold,

"There's a form of theater called 'black box theater,' where there is no set—only the performance. So, actors catch on that the mocap stage is like black box theater, and some of the actors just do without some props altogether. Tom Hanks was one of the best at miming without props, as was Anthony Hopkins—he would lift up his mead horn, and sweep his robes like he was a drunken king in a real mead hall. There was another advantage of mocap animation that I heard mentioned by Ray Winstone: 'I've always wanted to be a six-foot blond Viking —this is *wonderful!*'"

NORM NEWBERRY

Scylding's watch design painting //
MARC GABBANA // digital

epic choices for the look, characters, and scenes that would take 200 million dollars to shoot [in traditional live-action] and you'd *still* lose the focus of the work. It was a full-on, crazy process. I didn't know how intense it was going to be. I first had to get a full head-cast, and then they photographed me and took digital pictures—I didn't even know what they were doing half the time. They had my whole body and facial expression mapped out [to get] something that would take ten hours in prosthetics. It was layers and layers of insane things, the suit and dots on the face. But there was something about having the dots all over your face, where you feel part of the equipment! I loved it; there was something freeing about it. It strips down all this other stuff and you're just performing. The nicest thing about this process is every crew member is important, is equally in the moment."

Jolie noted that at one point Tom Hanks visited the set and was amazed and chagrined at the technological improvements since his work on *Polar Express*. "I bet if I check back in three years it'll be even easier—one dot," Jolie said.

For *Beowulf*, Ken Ralston focused on the creative side of Sony's work. "This is really Jerome Chen's movie—he's on the front lines and I'm the general back in the safety of my comfy office," Ralston smiled.

From his long experience as a visual-effects supervisor, Ken Ralston appreciated the advantages of the mocap stage. "You're not waiting on all the traditional stuff of filmmaking that takes *forever*, like having to set up cameras and relight for every new angle of a scene. Bob could just work with his actors and later [at his ImageMovers production office] take his virtual camera and create all the different camera angles. Once he had that, he could

start cutting on the Avid editing machine, and the production then took the shape of a live-action process."

In the post–motion capture phase, Zemeckis transitioned to the "Director's Layout," or "DLO," as the production called their low-resolution CG template. Zemeckis, cinematographer Robert Presley, and the DLO team could take any performance and then—using low-resolution footage, simple lighting, and video game–like figures—apply whatever camera move the director desired. After creating what Chen called "the cinematic point of view," the sequence moved to the editor to cut together.

By November of 2006, the director was putting the finishing touches on a DLO version of the movie. But before Sony could create the high-resolution final animation, Chiang's department had to select key frames from every scene in the DLO and paint the final images that, once approved by the director, guided Sony's work. "The big difference in the process at this point was that the scenes we worked on earlier had random points of view, but the DLO gave us the kind of camera lens the director wanted to use, very specific parameters," Marc Gabbana noted. "Doug would select the key image, which served as the underlying composition for our finished painting on top. Bob had to sign off on them and we had to make any revisions. As things went on, our key frames got more and more accurate. For each image we knew the time of day, how much snowfall might be on the ground, the final look of everything from costumes to the landscapes. Our approved key-frame paintings looked like the final movie—those images become the Bible."

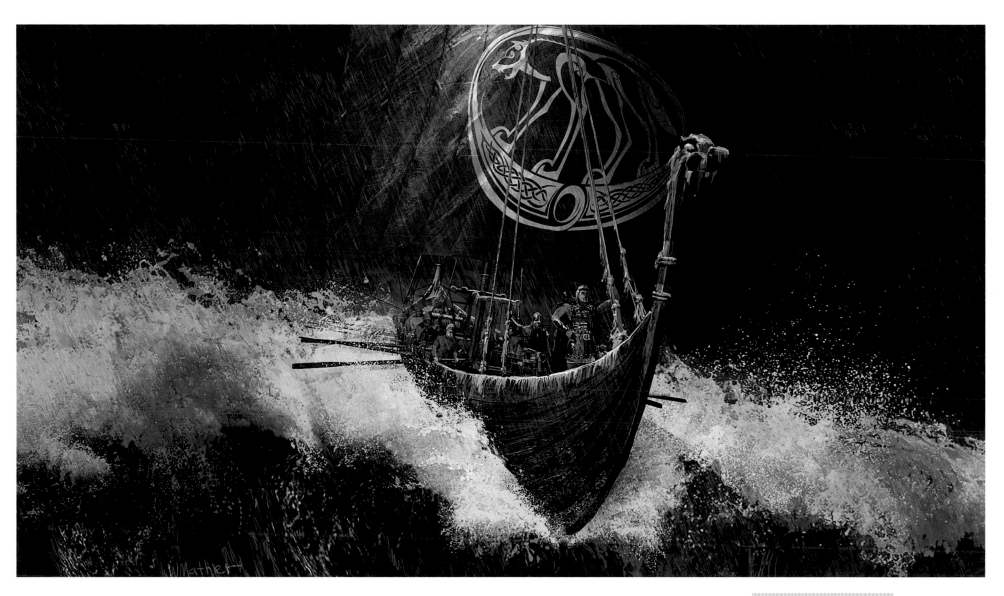

Beowulf's ship at sea, projection mapped // BILL MATHER // painting

This shot, which made the production's promotional "sizzle reel," took advantage of Mather's experience as a matte painter capable of tricking out a painting with a dimensional quality. "I built the wave in four or five layers, so there would be a parallax shift and a sense of splashing and froth," Mather said. "This image is basically Beowulf coming to the rescue."

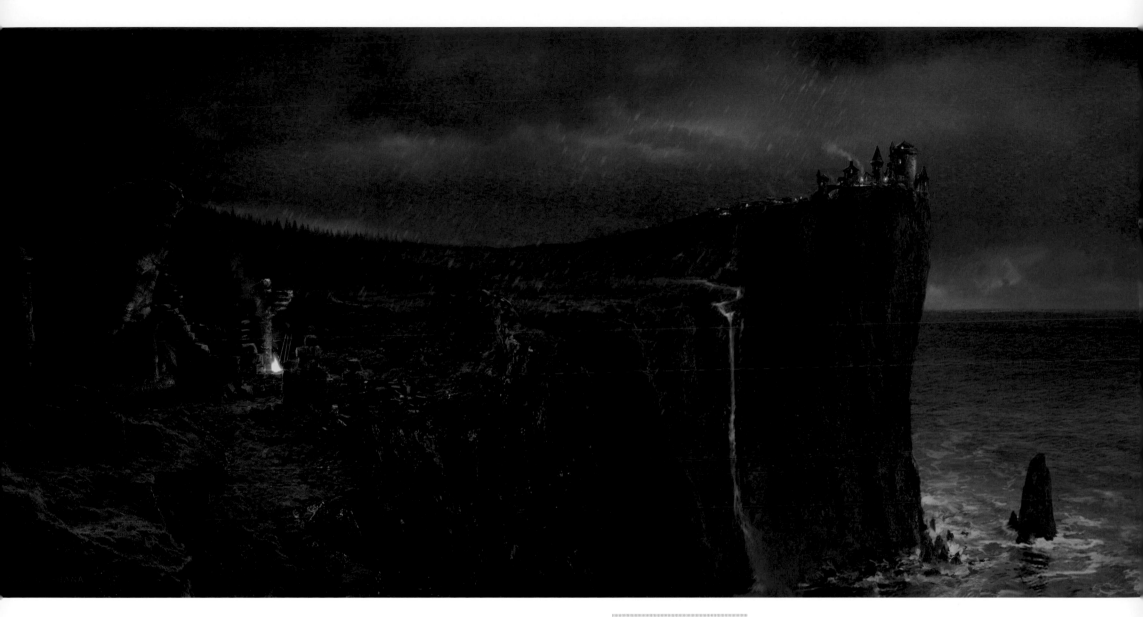

Landscape // MARC GABBANA //
concept painting

In this early concept, Scylding, the coast guard, keeps his lonely watch with only a solitary fire to cheer him. In the distance are the lights of Herot.

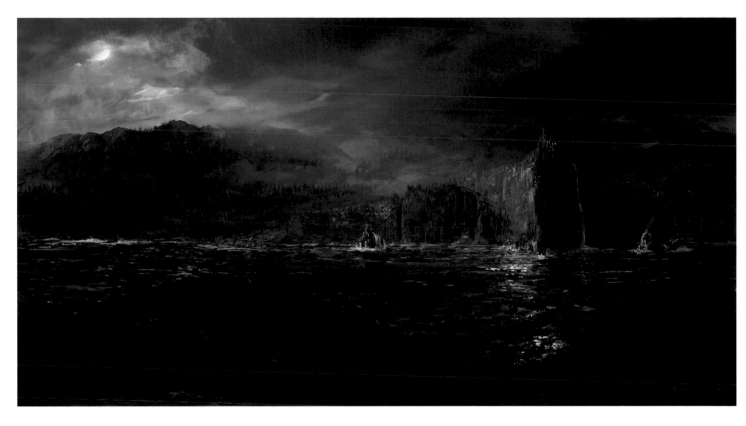

When the news of Grendel's reign of terror reaches the land of the Geats, Beowulf sees a chance for fortune and glory. Beowulf takes leave of King Hygelac and, with fourteen strapping warriors, sails for the land of the Danes. In both the poem and the movie, Beowulf is met by the coast guard, who is amazed at the brazenness of this alien ship that has landed on the shore of his homeland.

Coastline landscape // AARON BECKER // concept painting

This very early concept shows the coastline and lights of Hrothgar's castle as seen from Beowulf's approaching ship. The artists had to get shots to finals quickly, but this was an early opportunity to do a rougher, less photoreal mood and lighting piece. "This was one of the first paintings I did, and it was fun, because there were no constraints," Becker said. "Beowulf's ship is coming in, there's a strong sea and thick fog, and the reflection of the castle lights is like a lighthouse effect."

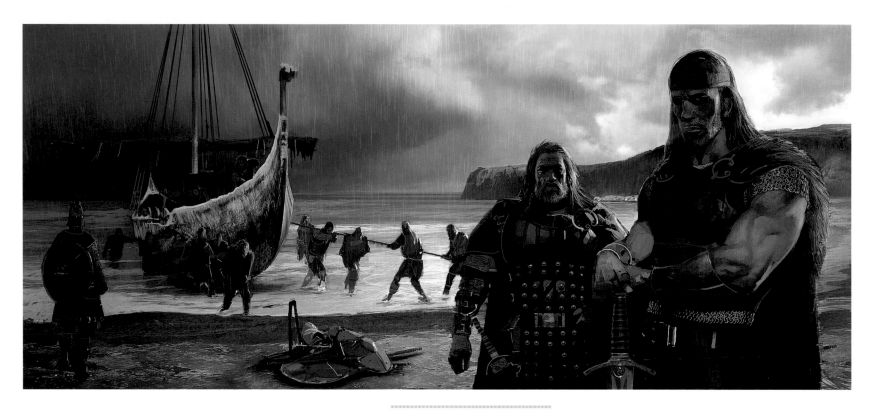

Beowulf and the Geats ashore // BRIAN FLORA and DERMOT POWER // painting

"When I'm painting a scene, I'll get an emotional reaction—a little something inside me will go, 'That's right.' It's a dramatic feeling that's hard to describe. I have this habit where I'll cup my hand and look through it like a telescope, blocking everything out to 'see' the image and imagine I'm really there. I get the same kind of rush as if I'm hiking or traveling in a beautiful place and go, 'Wow.' I used to do that as a kid; I'd look at a real landscape and imagine I was in a fantastic scene. That's what has drawn me to this type of work, my love for nature and light."

BRIAN FLORA

Beowulf's arrival at the gates of Herot's stockade // BRIAN FLORA and DERMOT POWER // painting

For this wide, establishing shot, Flora focused on mood and background, while Power painted the characters and costumes. "At one point this shot was going to be overcast, then darker and cooler," Flora recalled. "Finally, we heard that Bob Zemeckis wanted this to be the first time we see sunlight. What made this shot extra special was this was the first time I worked with Dermot and he did such a great job on the characters."

Revised stockade gate layout // PETE BILLINGTON and ZAC WOLLONS // CG model

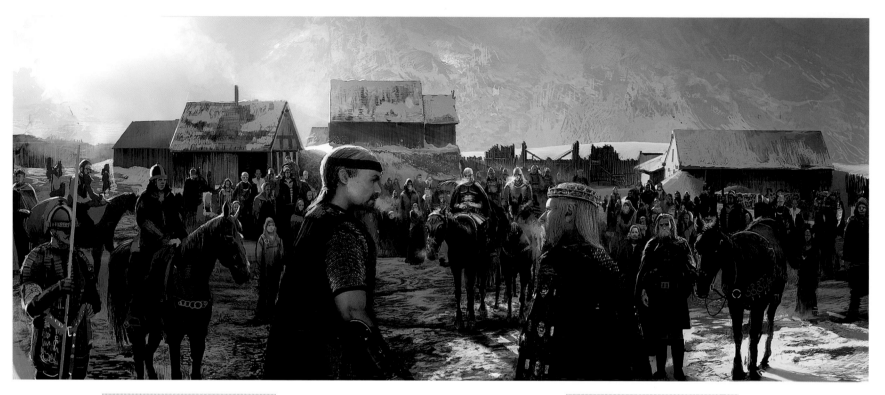

above
Beowulf's arrival // BRIAN FLORA and
DERMOT POWER // key-frame painting

below
Hrothgar's shield design development //
MARC GABBANA // digital

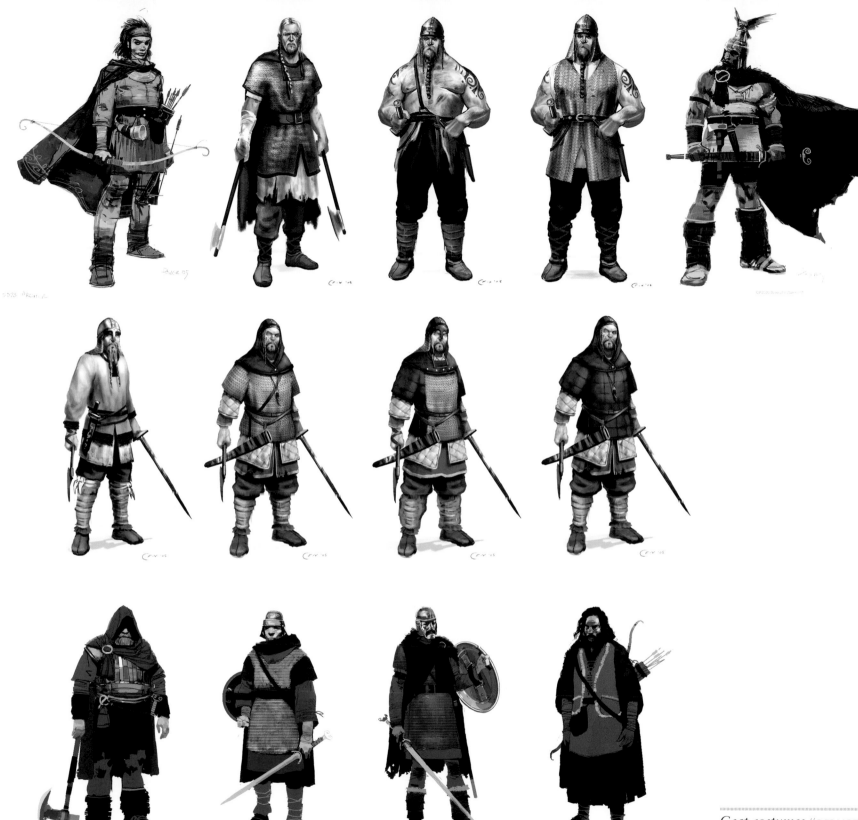

Geat costumes // DERMOT POWER (top row, bottom row) and COLIN FIX (middle row) // concept designs

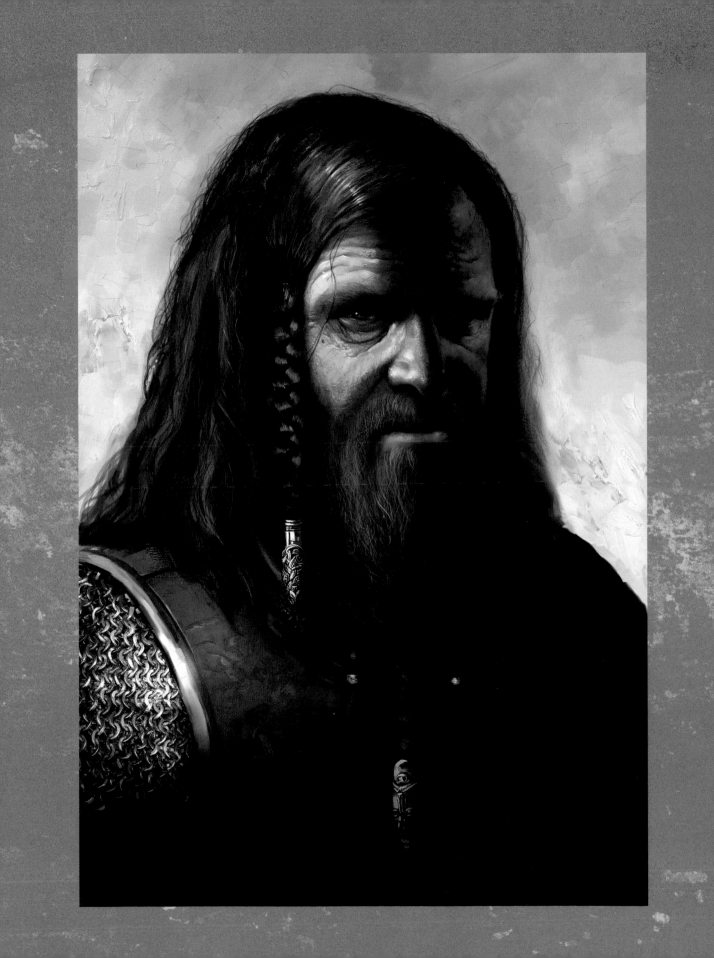

𝕴𝖓 𝖙𝖍𝖊 𝖕𝖔𝖊𝖒, a young Wiglaf is the only warrior who stands by Beowulf's side when the old warrior king fights a fire-breathing dragon. In the film, Wiglaf is with Beowulf from the start and among the group that has sailed with him to Hrothgar's land.

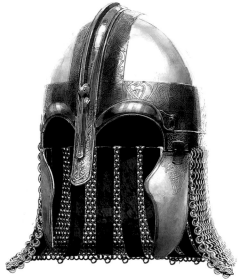

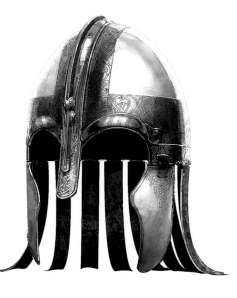

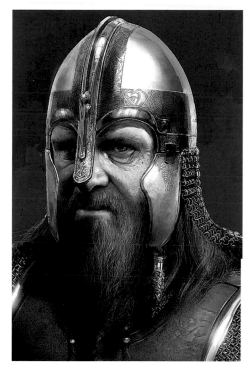

this page
Wiglaf helmet design // DERMOT POWER // helmet design

Power used Fix's "hero" portrait (facing page) of Wiglaf to display his helmet design. Doug Chiang had told his artists that Zemeckis wanted to see designs in context, so instead of displaying the helmet against a neutral background, Power put the helmet on Wiglaf to display it to best effect.

opposite
Wiglaf // COLIN FIX // final portrait

Wiglaf was originally imagined with a shaved head, until Zemeckis asked that he be given a fiery mane of red hair.

When a swaggering

Beowulf is feted at the mead hall, he boasts that he will defeat Grendel. Unferth challenges him about the famed swimming match Beowulf once had against a young athlete named Brecca—a race Beowulf lost. In the poem, Beowulf dismisses Unferth's insult by describing a superhuman race in frigid, stormy seas that lasts five nights, until swelling waves separate them and Beowulf, swimming all the while with sword and armor, is attacked by sea serpents and slays nine of them. The contest reads like a classic tall tale and meets screenwriter Gaiman's criteria that whenever a character relates an "offstage" incident, he might be lying.

opposite
Brecca // COLIN FIX // portrait

right
Final Brecca body marking and hair design // COLIN FIX // digital

right
Beowulf stabs a sea monster //
DERMOT POWER // painting

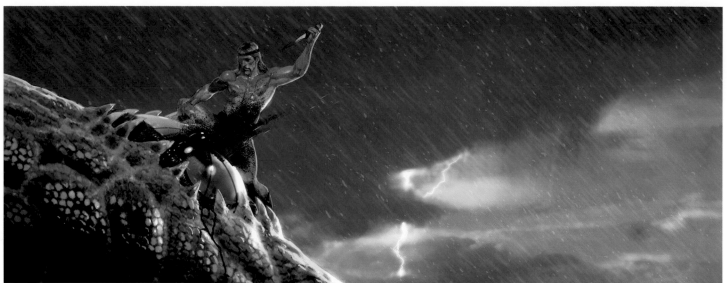

above
Beowulf during Brecca race //
RANDY GAUL // painting

Unlike in the poem, our movie hero doesn't need his body armor to tackle the attacking sea monsters.

right
Brecca race, underwater sea serpent scene // BRIAN FLORA // painting

Flora's assignment was to visually describe underwater mood and lighting conditions. "I started with [a scan] of an unpainted creature sculpt and painted on that and created the water landscape. Sometimes, I get inspired by a painting and just nail a look. But then I might get to a point where I have questions, like, what do bubbles look like underwater, really? I still find it necessary and inspiring to look at reference. For this image, the book I referenced the most was on underwater shipwrecks. It was really moody and creepy, the way blue tones faded off into a greenish gray. I was definitely influenced by that."

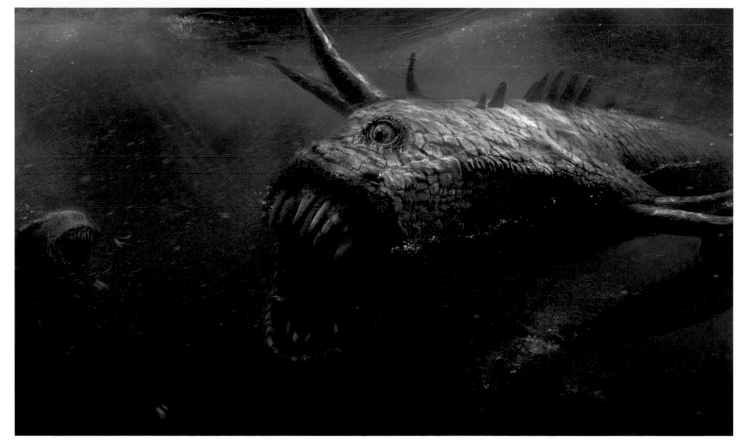

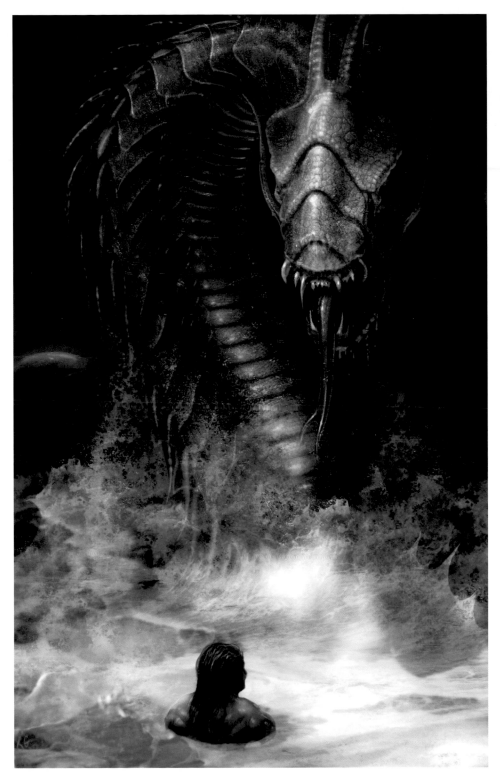

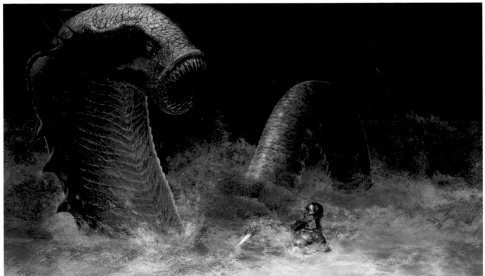

Early sea serpent designs //
RANDY GAUL and DERMOT POWER // painting

Sea serpent final color and texture //
RANDY GAUL // digital

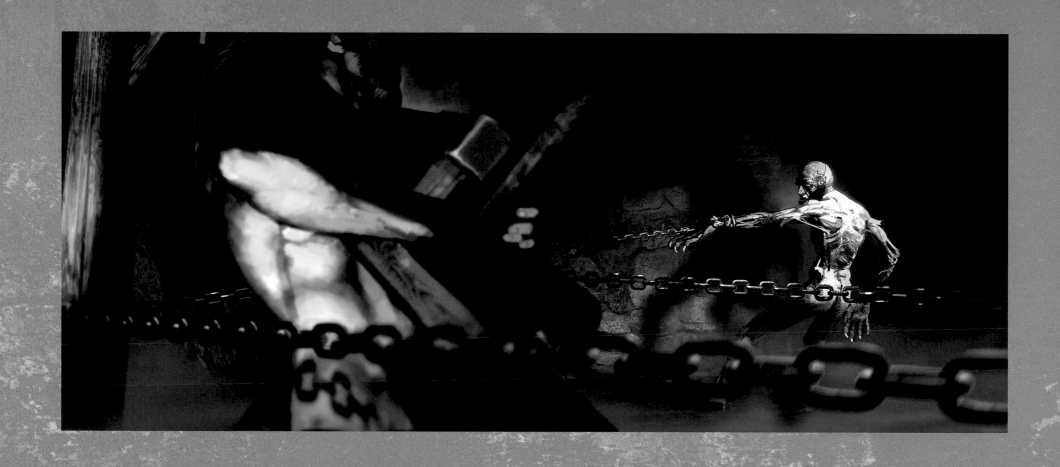

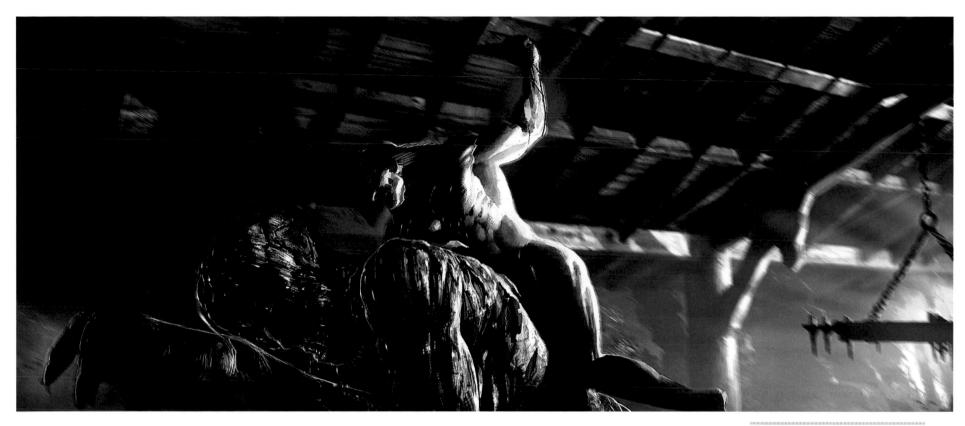

above and left
Beowulf fights Grendel //
DERMOT POWER // digital

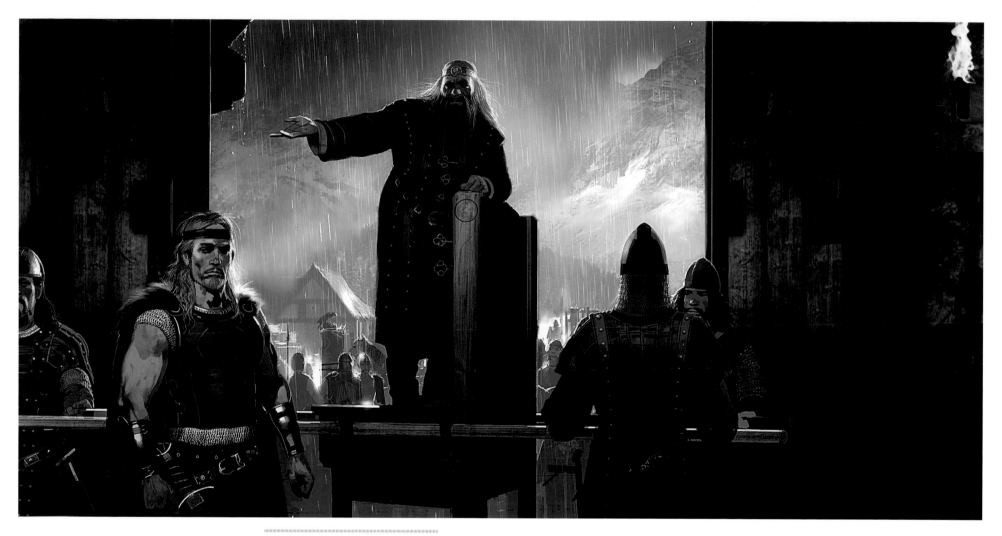

Hrothgar introduces Beowulf //
DERMOT POWER // key-frame painting

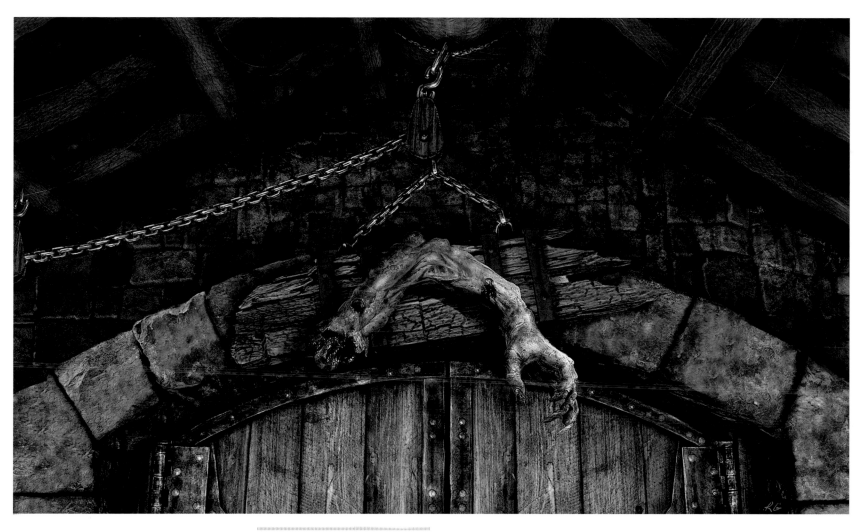

Grendel's arm // RANDY GAUL // painting

The grisly trophy of Beowulf's victory
displayed in the mead hall.

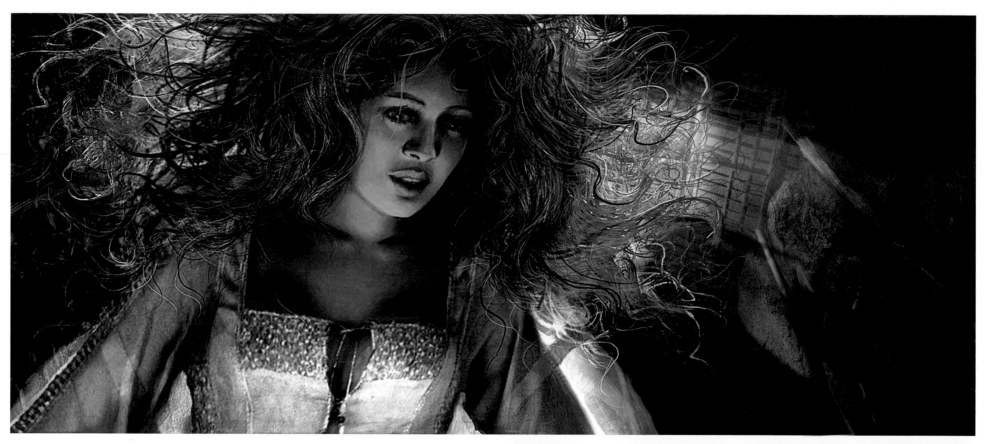

Grendel's mother, dream sequence //
BILL MATHER // key-frame painting

The art department's CG group provided a three-dimensional effect to the ceiling and Randy Gaul worked on the hair. In the image, Queen Wealthow seems to be seductively hovering above Beowulf, but it's a dream that's about to become a nightmare as the vengeful changeling that is Grendel's mother takes her true, monstrous form.

 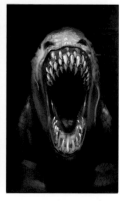

"Mother Morph" sequence // COLIN FIX //
paintings

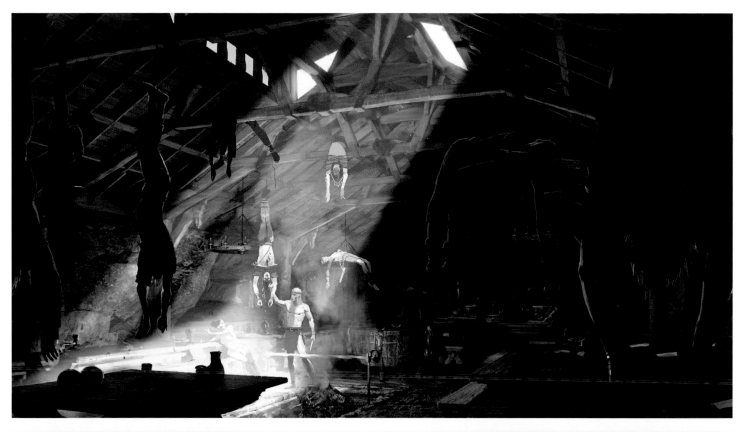

Grendel's mother's attack aftermath //
DERMOT POWER // painting

Grendel's mother's attack aftermath //
AARON BECKER // key-frame painting

This final key-frame image, based on the
director's layout, was inspired by Power's
painting from almost exactly a year before. "I
even added red color to the mead bucket in the
foreground, as if Grendel's mother had drained
some of the blood into it."

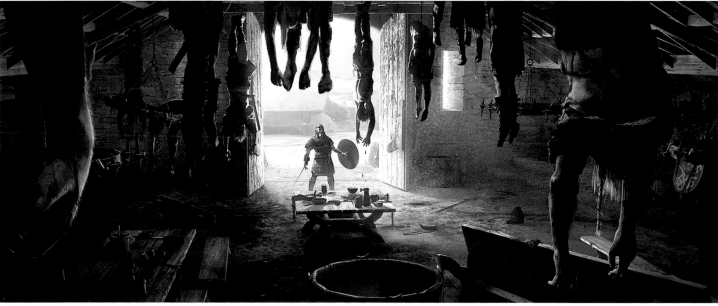

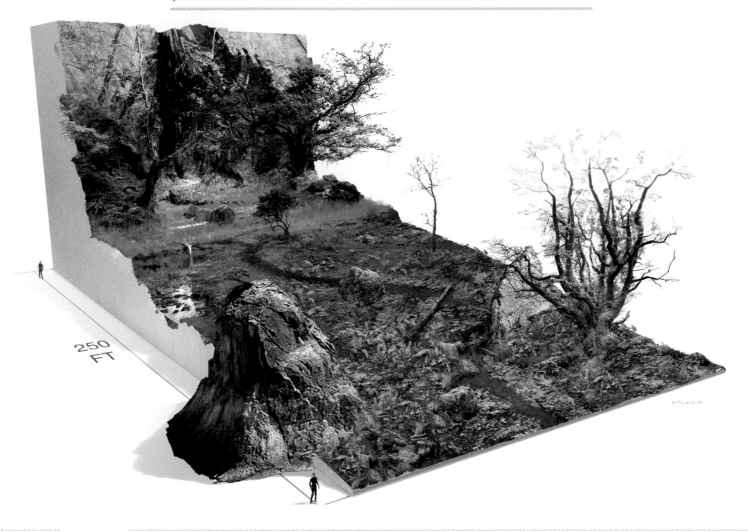

250 FT

Cave entrance // AARON BECKER *// cutaway*

𝕲𝖗𝖊𝖓𝖉𝖊𝖑'𝖘 𝖈𝖆𝖛𝖊 is an example of the layers of ancient history that inform the world of *Beowulf* and an eerie, unusual cave concept. "We have seen so many cave ideas, and I wanted to combine a lot of different aspects of what the cave should be," Chiang noted. "One idea I thought would work for us was to have a cave that was a petrified, unknown beast of gigantic proportions. When you're inside the cave, you're actually inside the rib cage of the beast, so instead of stalactites you see gigantic rib formations—the cave is literally anthropomorphic; we follow Beowulf into the different areas of the body. We pass the intestines, enter the esophagus, and come out into the brain area, which is Grendel's mother's lair. There we put in some very strong skull icons, so you know you're in the brain of the beast."

"Grendel's cave was created in prehistoric times when a large creature got caught in tar. The creature died and the organic material rotted away and became petrified rock, which created the cave. You see the remnants of the creature, such as the rib cage coming down. Taking it a step further, maybe a thousand years before Beowulf comes to this ancient cave, a civilization had inhabited it. Maybe this race [is represented by Grendel's mother], who's the last of her race."

PETE BILLINGTON

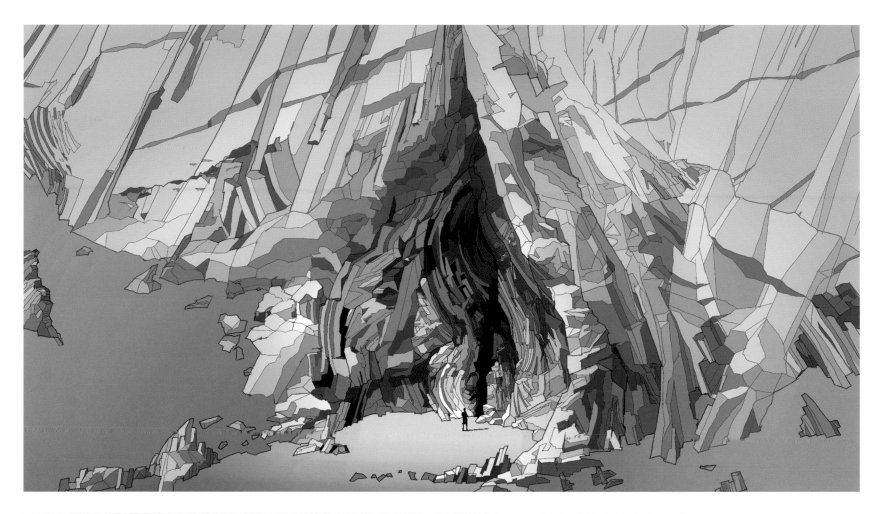

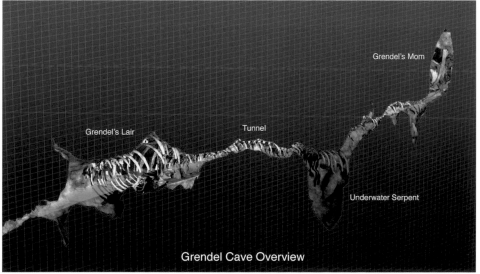

Grendel's Mom

Grendel's Lair

Tunnel

Underwater Serpent

Grendel Cave Overview

above

above

Cave entrance // AARON BECKER //
concept art

The motif of a cave as the petrified remains
of a gigantic ancient creature began with this
vagina-like opening into the "womb" of the beast
(note the standing figure for scale). "It's all subtle
elements—or not-so-subtle," Chiang explained.

Grendel cave overview // PETE BILLINGTON //
CG model

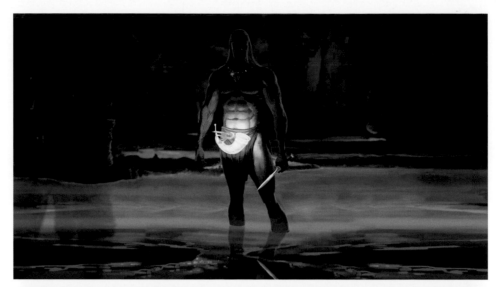

"I love to reference nature, but when the subject is more fantastical, I go inward and let that guide me. Inspiration might come from an arbitrary source—a surface texture of wood grain, a knot on a tree, a combination of shapes and colors. For Grendel's cave there were lots of references for caves and natural forms, but you go back and forth between reference and things you wouldn't see in a cave, so it becomes a surprise as you go beyond the constraints of nature. This cave is lit by luminous gold trinkets, bioluminescence, and a magical light. You have to rely more on your imagination to fuel that."

RANDY GAUL

Beowulf enters Mother's lair // DERMOT POWER and RANDY GAUL // painting

This Power painting of Beowulf highlights the golden horn, which will become symbolic of an unholy pact with Grendel's mother (Gaul painted the background).

Mother's lair // BRIAN FLORA // concept painting

Flora's inspiration for the riblike cave structure, evidence of the petrified remains of an ancient monster, came from his research into the look of whalebones.

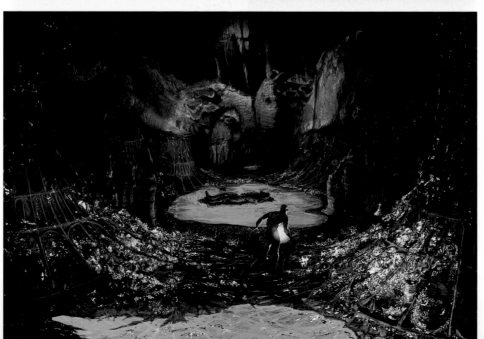

Mother's lair // BRIAN FLORA // early concept painting

"If you look at this image, it's like a nasal cavity and there are two eyes [sockets]—it's like Beowulf is inside the skull of this fossilized skeleton," Flora noted. "In this painting, I was also going for an underlit green-and-blue glow from the water cascading at the back of the cave. The final design stage was Randy Gaul's painting, which featured the gold a lot more."

opposite
Mother's lair // RANDY GAUL // painting

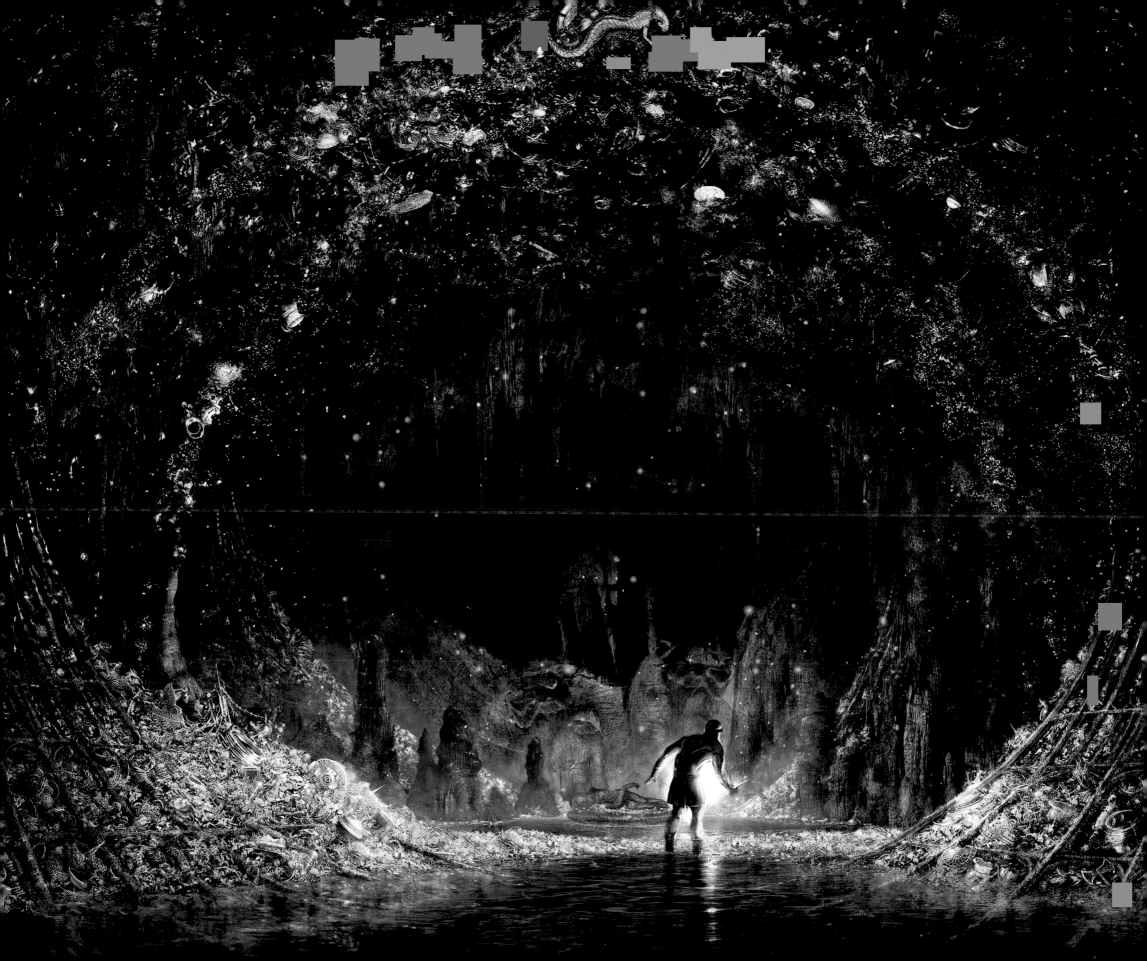

Funeral pyre // BRIAN FLORA // digital

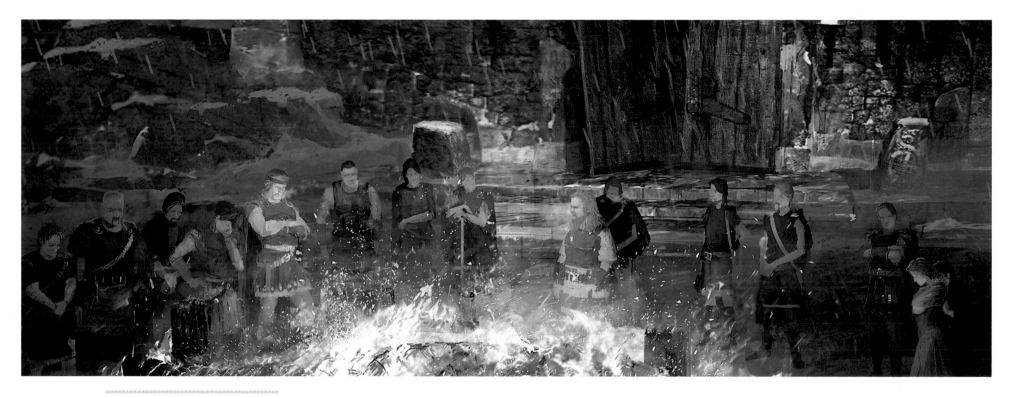

Funeral pyre // AARON BECKER // digital

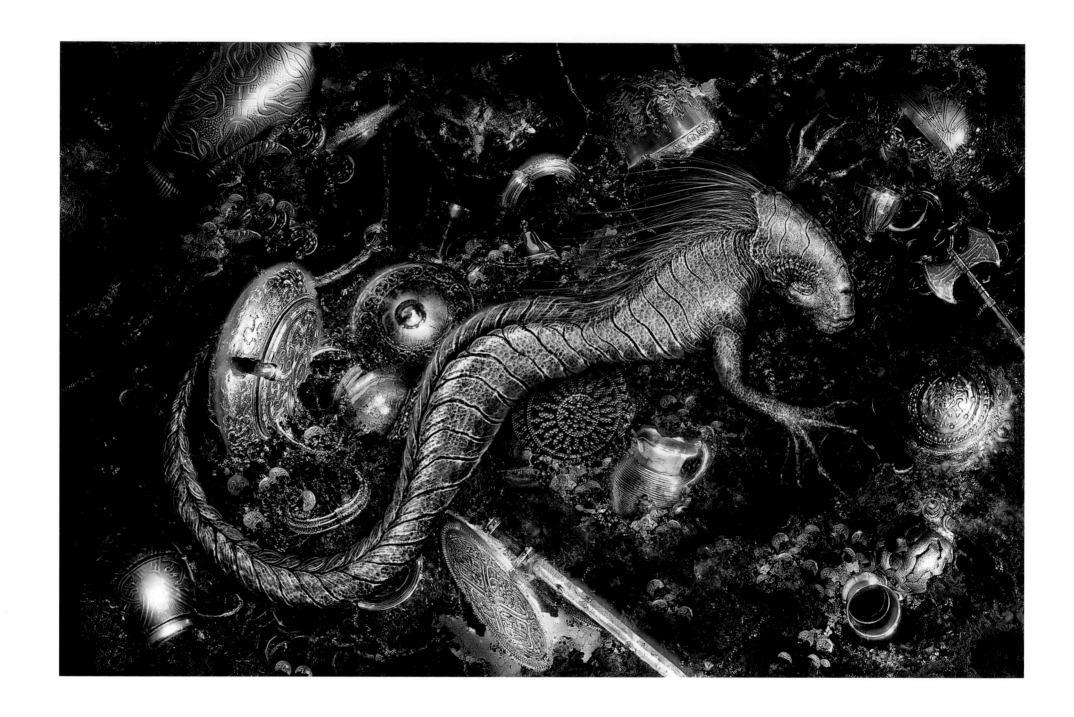

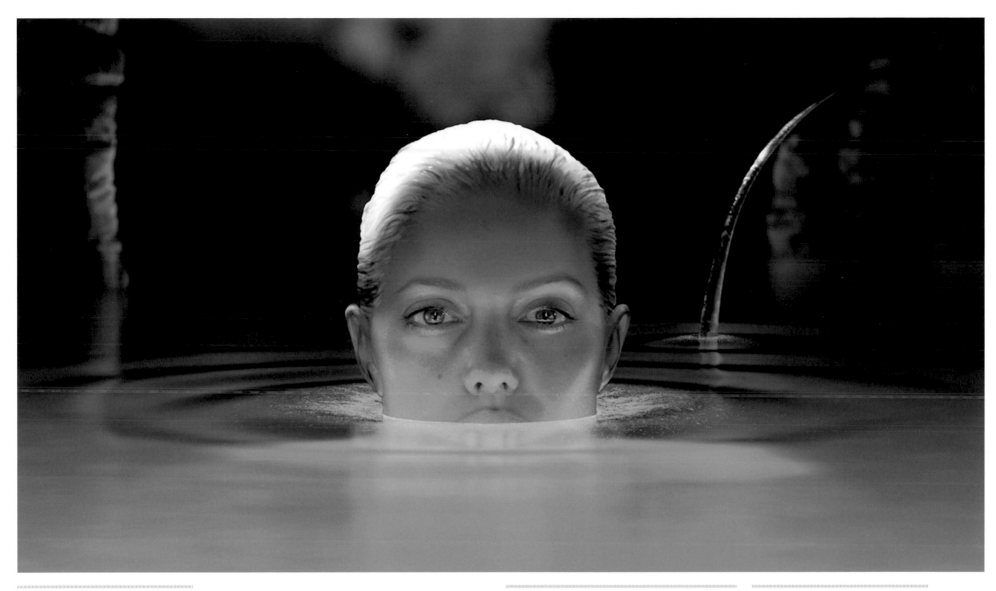

𝕲𝖗𝖊𝖓𝖉𝖊𝖑'𝖘 𝖒𝖔𝖙𝖍𝖊𝖗 can transform
from a reptilian creature into a beautiful
woman. The production affectionately called
the shape-shifter "Mom."

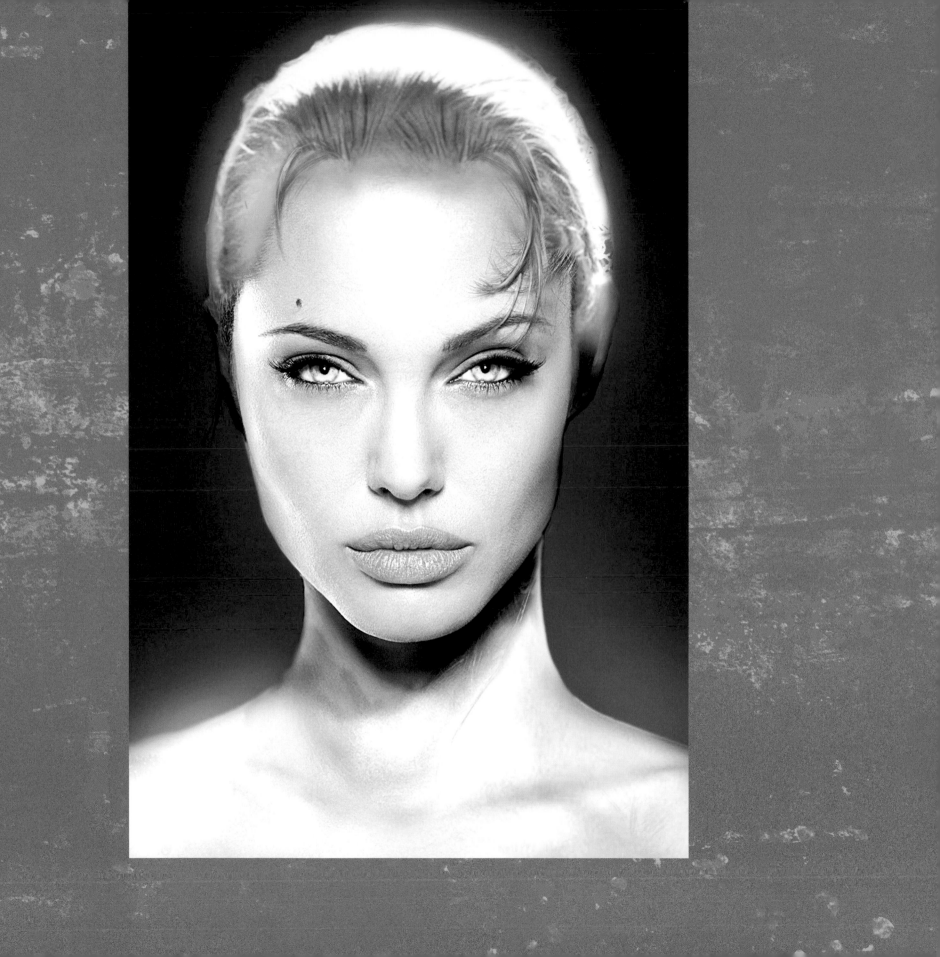

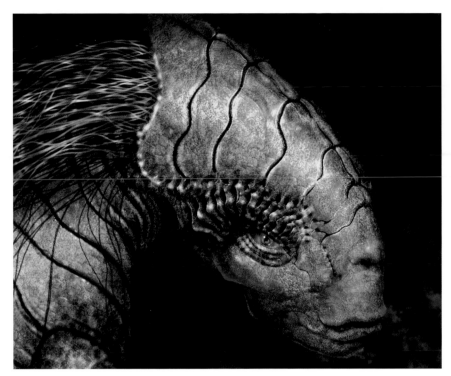

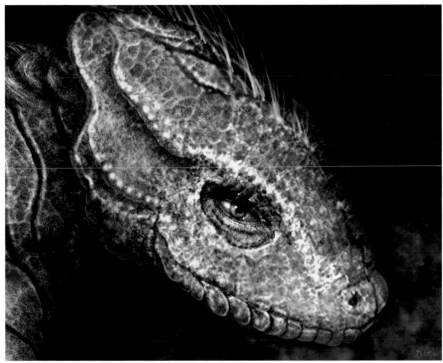

"I loved [Grendel's mom] because I'm a mom. Yes, she's a monster, but she's a mom at heart. Grendel is full-grown, but there's something childlike about him. You can love him as a son, and if somebody hurt your child you would avenge your child. I approached it that way—I didn't think about good or evil, right or wrong. Crispin also made some strong choices as [Grendel]; he opened himself up in this really sweet way that allowed me to feel more maternal."

ANGELINA JOLIE

opposite
Grendel's mother // COLIN FIX // painting

This painting clearly incorporates the likeness of actress Angelina Jolie.

above
Grendel's mother, demonic form //
RANDY GAUL // paintings

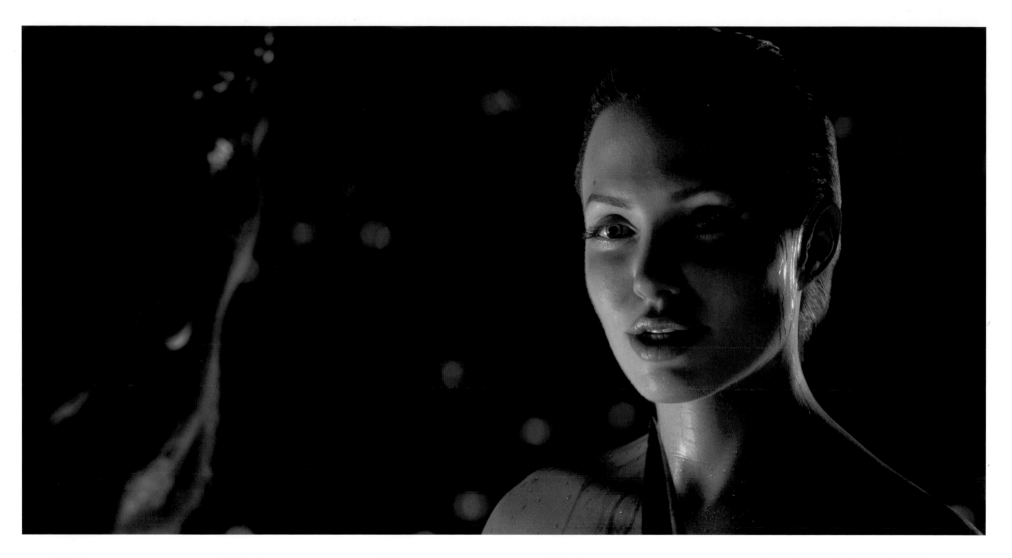

"When Grendel's mother takes her human form, she still retains aspects of her beastly quality, such as her snakelike ponytail and feet that are weirdly shaped like stiletto-heel shoes," Doug Chiang said. "If you noticed those details you'd be repulsed, but there's just enough to give a [subtle] unnerving feeling."

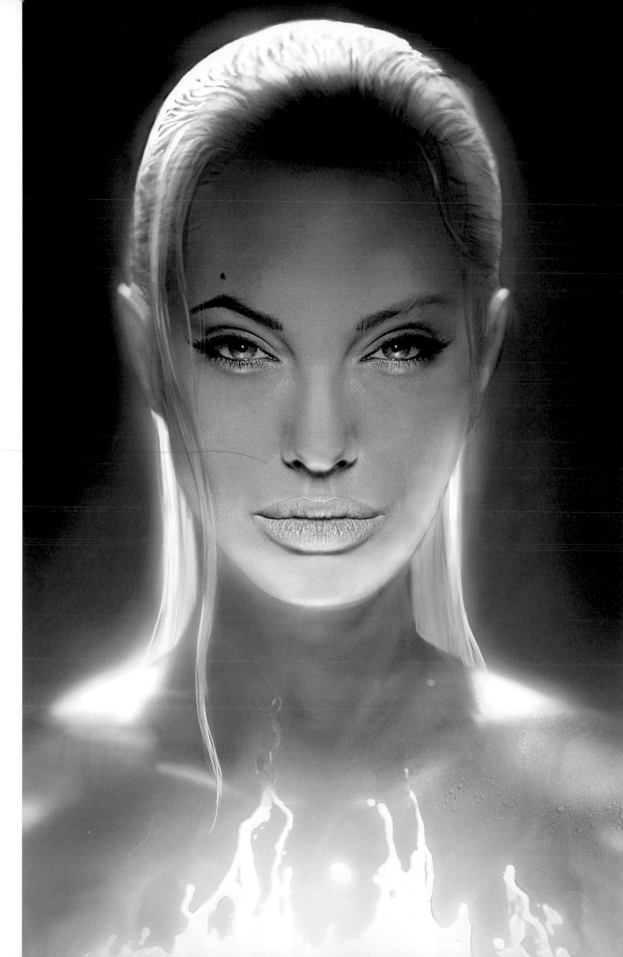

Grendel's mother's gold look development // COLIN FIX // digital

"For Grendel's mother, we had to figure out how to address the fact that she's completely naked," said Doug. "Bob came up with a great idea of 'liquid gold clothes.' This liquid gold would flow off her body, revealing her in a seductive, sexy manner, almost like a virtual strip tease."

CHAPTER

The Era of King Beowulf

"**The** POISON-BREATH OF THAT FOUL WORM FIRST CAME FORTH FROM THE CAVE, HOT REEK-OF-FIGHT; THE ROCKS RESOUNDED . . . STOUTLY STOOD WITH HIS SHIELD HIGH-RAISED THE WARRIOR KING, AS THE WORM NOW COILED TOGETHER AMAIN: THE MAILED-ONE WAITED. NOW, SPIRE BY SPIRE, FAST SPED AND GLIDED THAT BLAZING SERPENT."

∗ Beowulf ∗

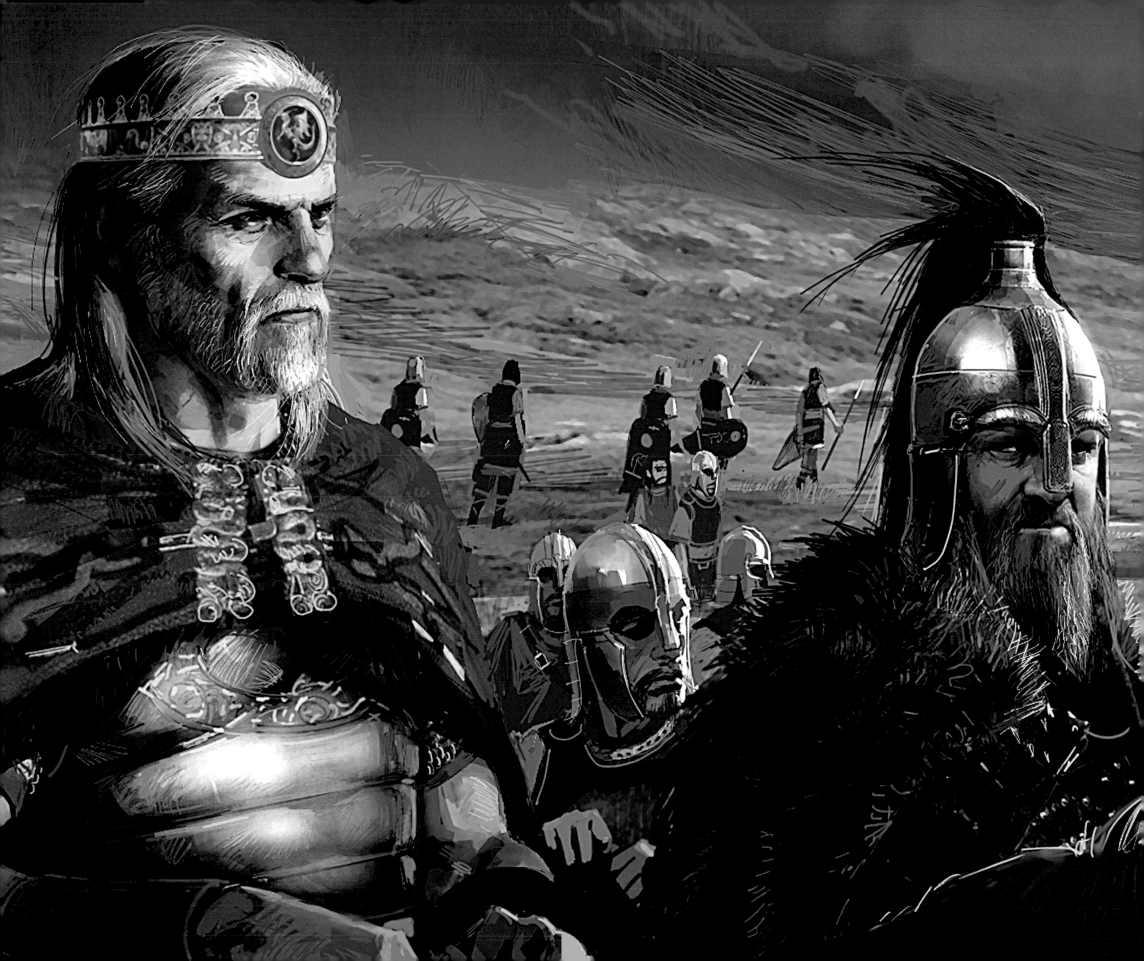

Reflecting the passage of time has always been a challenge for filmmakers. Traditionally, when a character ages in a story, an actor must either undergo heavy makeup, or several actors must be cast to portray the different time periods in a character's life. Environments and living spaces must also reflect time's inevitable changes, requiring either radical redesign of sets or new sets and locations entirely. Such was the challenge on *Beowulf*, as the story jumps some thirty years into the future, from the young warrior's triumph over Grendel and ascension to Hrothgar's throne to Beowulf's old age and the Golden Age of his kingdom. "Thanks to the technology we used on this film, we could take that jump in time and seamlessly transition to another era," Steve Starkey noted. "We could redesign Beowulf's kingdom and age characters without having to cast different actors or apply complicated prosthetics to an actor."

While the era of Hrothgar's rule and Beowulf's youth had been grounded, as much as possible, in historical reality, the timeline thirty years on moved into the fantastical. "In Beowulf's time, things get bigger and grander," Gabbana said. "His castle now has two towers, which reflects his importance as king. We also made the castle bigger, in part, because the dragon [that appears in the last part of the film] is the size of a 747 and it would have looked less dramatic if we kept the castle small."

The aging of characters across the timeline was a challenge to the concept artists. While they could use a character's "young" portrait to build up an aged look, there was no magic dial to "age up" a portrait. "It's all subjective—a lot of painting had to be done for older versions of the characters," Colin Fix explained. "We might find photographic reference of skin texture and liver spots, but it's real difficult to find the exact elements for a certain age to incorporate into an image where you might have a specific lighting setup. So a lot had to be hand-painted."

The old-age design of the warrior king would reflect the corrosive effects of Beowulf's pact with Grendel's mother, the spiritual rot at the heart of a kingdom that, by all outward appearances, was enjoying a glorious renaissance.

opposite
Frisian Battle, wide shot //
DERMOT POWER // painting

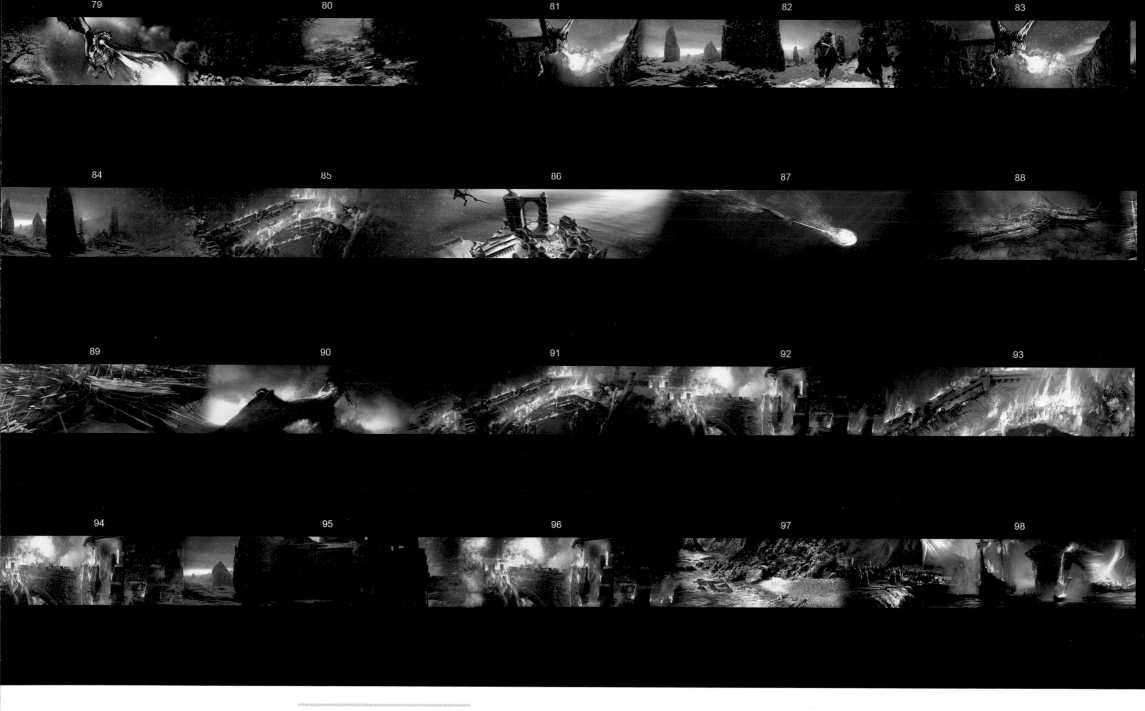

Color timeline // BRIAN FLORA // digital

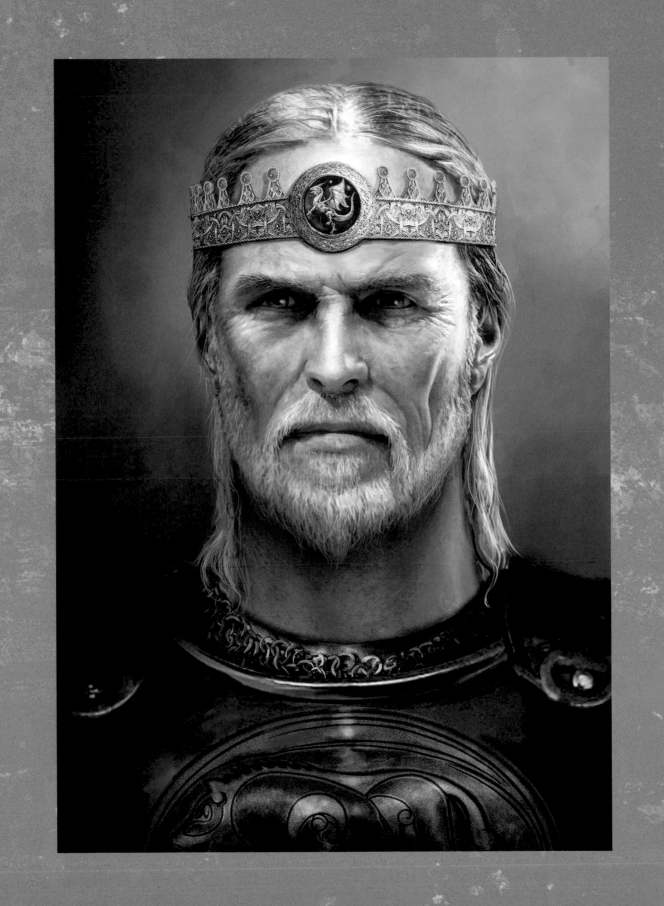

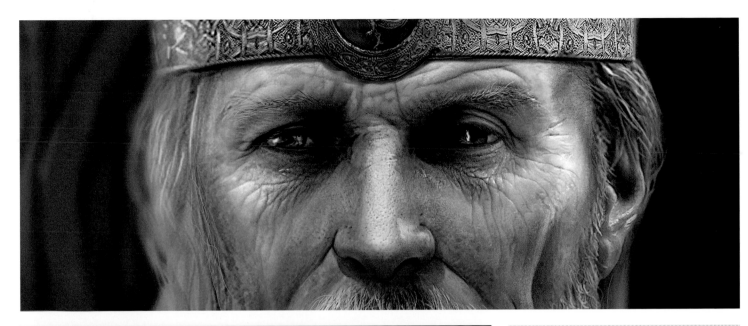

The Beowulf era required a new aesthetic approach, from aging characters to mounting major redevelopment projects at Herot.

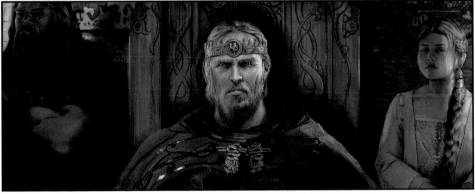

"When it came time for [the art department] to do designs for the old Beowulf, we were told that he was a man with regrets and secrets he wouldn't reveal. He's now a tortured, worn-out guy."

COLIN FIX

top
King Beowulf, close-up // COLIN FIX // key-frame painting

opposite
Old Beowulf final portrait // COLIN FIX // painting

"There are *many* layers to these things—it was a crazy process," Colin Fix noted. "This image started with early concept art, Tony McVey then did a sculpt that was painted on by Randy Gaul, and then Doug asked me to do the finish. I added a little extra detail, a painterly background, with Kurt Kaufman's wolf design on the breastplate."

above
King Beowulf puppet show scene // COLIN FIX // key-frame final

In this DLO key frame, a somber mood seems to have settled over King Beowulf as he watches a puppet show celebrating his own myth. The scene is our first encounter with the king in his old age.

right
Old Beowulf // TONY MCVEY // sculpture

The sculpture that inspired the final portrait design for old Beowulf.

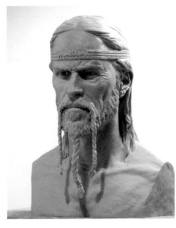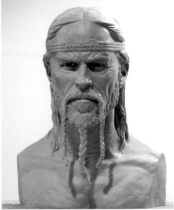

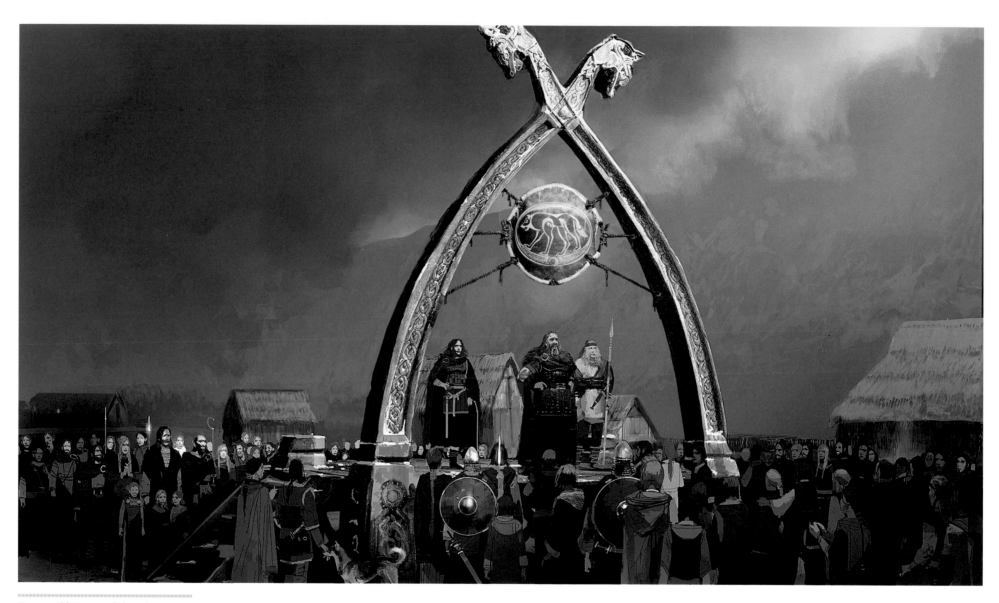

Beowulf Day celebration // BRIAN FLORA
and DERMOT POWER // concept painting

GRENDEL PUPPET
MARC GABBANA
JUNE 28 2005
0101

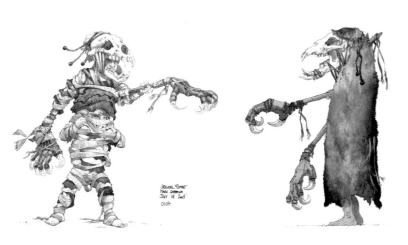

GRENDEL PUPPET
MARC GABBANA
JULY 18 2005
0104

above and left
Puppet show // MARC GABBANA //
concept drawings

right
*Puppet show performer with mead
horn* // JOSH VIERS and COLIN FIX //
scale design painting

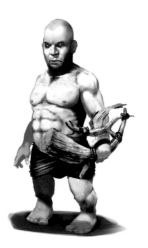

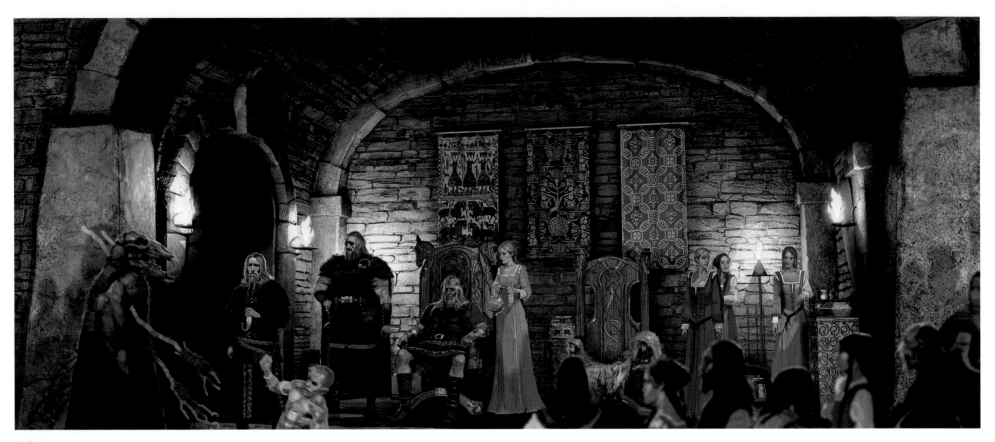

King's throne area, mead hall //
BILL MATHER and DERMOT POWER // painting

𝕭𝖊𝖔𝖜𝖚𝖑𝖋 𝖆𝖘𝖈𝖊𝖓𝖉𝖘 the throne after Hrothgar's suicide and his long rule settles into his own self-aggrandizing mythology. But, always, the curse haunts him, the Faustian bargain eating at his soul. Doug Chiang's idea was that the unseen power behind Beowulf would be so strong that a trace of Grendel's cave would be imprinted in the new mead hall, one of the major redevelopment projects of the Beowulf era. "When Beowulf modifies Hrothgar's mead hall, he subconsciously puts in a gigantic, riblike design," Chiang explained. "This is subtle, but I thought it was important to visually make this connection, to show that in his subconscious, Beowulf is deeply tied to Grendel's mother and the cave."

Mead horn design for puppet show //
JOSH VIERS // concept painting

The puppet show tells the tale of Beowulf's exploits and includes a crude, almost ironic, take on the golden mead horn (the curse of which only Beowulf knows), made with driftwood bound by twine and with a stone set in the dragon's-neck handle to symbolize the red ruby of the king's mead horn.

King Beowulf's mead hall, interior //
BILL MATHER // concept painting

This early take on Beowulf's redesign of Hrothgar's mead hall was deemed too outsized by the director.

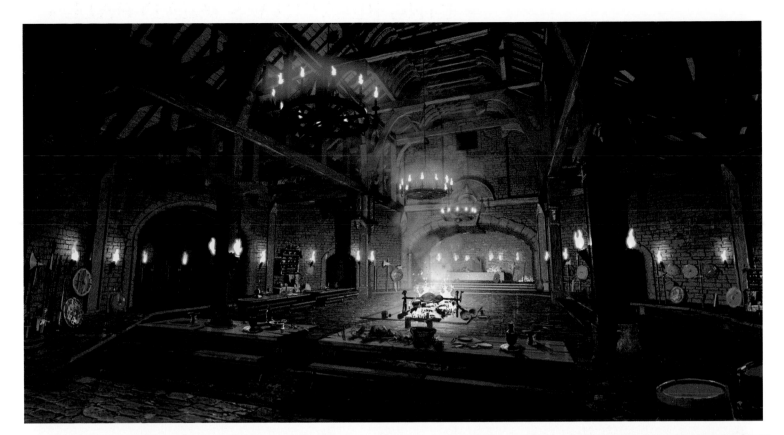

Beowulf mead hall interior //
BILL MATHER and DERMOT POWER // painting

Hrothgar's rustic mead house becomes majestic and fortified in King Beowulf's time. Renovations include a wall built on the left side of the picture, while the reinforced roof reflects the spinal column ceiling of Grendel's cave. Note the muscular figure at the right-hand side of the painting—Power dropped in Sláine, a U.K. barbarian fantasy comics character he has illustrated. Sláine, Mather reveals, is in a foul mood because Beowulf gets his own movie and he doesn't. "Artists like to put in-jokes like this into their work," Mather laughed. "Dermot and I were total comics nerds about this, arguing about whether Sláine could kick Beowulf's ass if they fought each other."

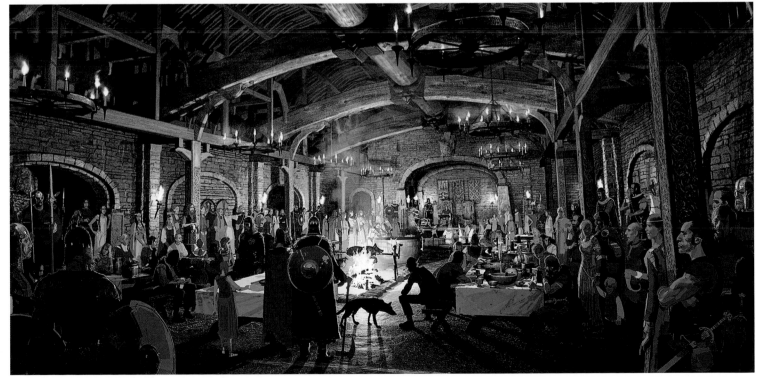

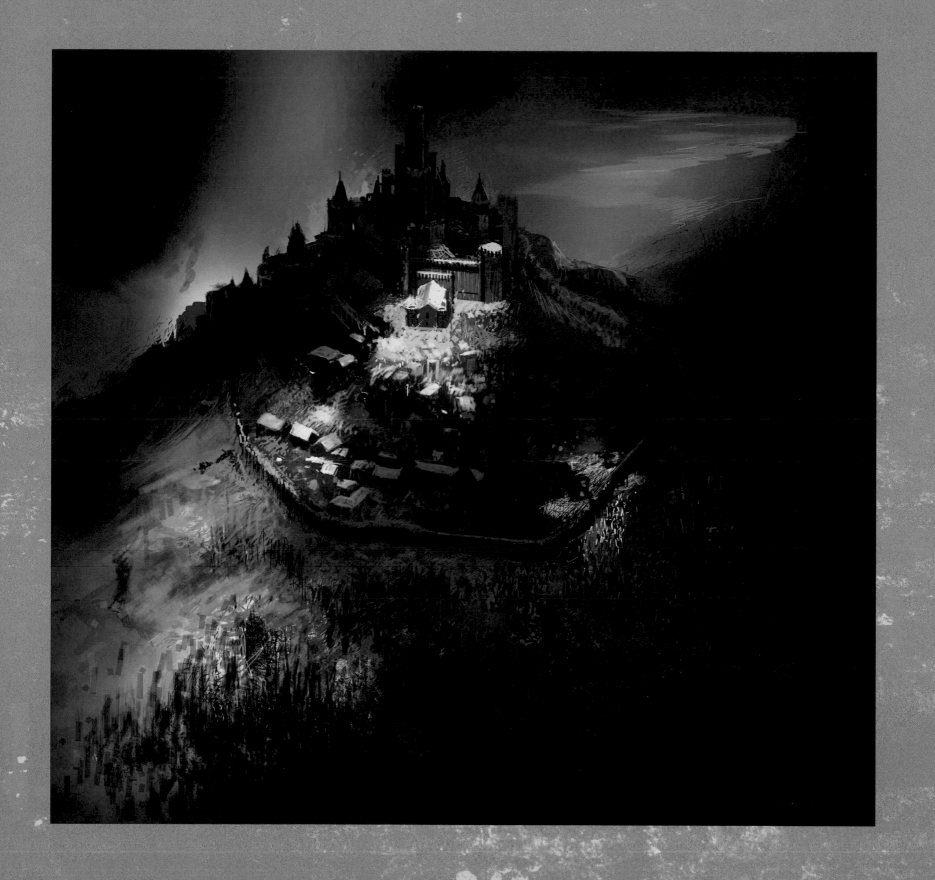

☀ KING BEOWULF'S CASTLE ☀

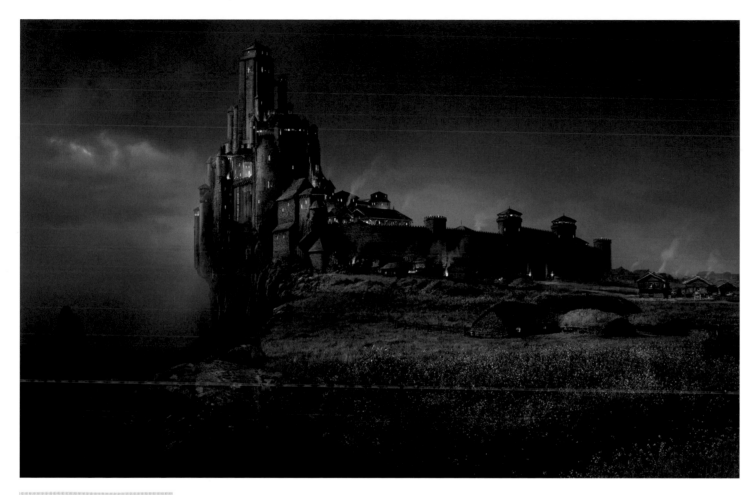

"The Beowulf-era castle gets quite complex. We needed to show how it's grander and more fortified than Hrothgar's castle. Beowulf's castle is almost entirely made of stone, it's larger, and there are now two towers reaching upward. The defensive perimeter has been strengthened. It's all to indicate Beowulf has waged war and conquered his environment. And now, toward the end of his life, he's no longer challenged. He has accomplished everything he set out to do."

PETE BILLINGTON

King Beowulf's castle // MARC GABBANA //
painting

opposite
King Beowulf's castle // BRIAN FLORA //
early concept painting

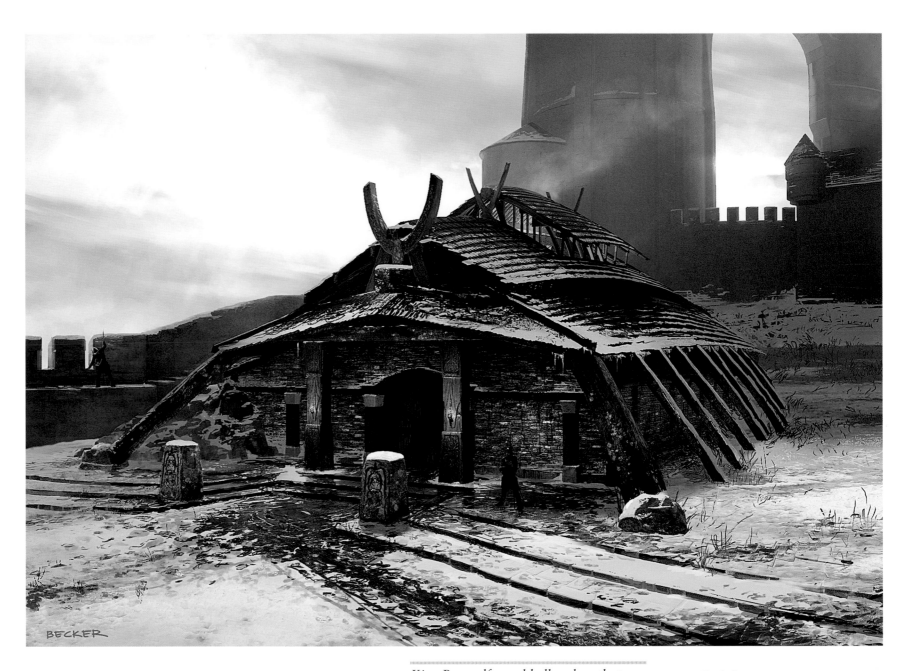

King Beowulf mead hall and castle // AARON BECKER // painting

Becker sums up the new Herot versus the old: "It's like Hrothgar's was the $150,000 home and Beowulf's is the $1.3 million home."

King Beowulf's private quarters used the same model created for Hrothgar's quarters. The challenge was to keep the basic dimensions, but redesign it enough to look like it belonged in the new era.

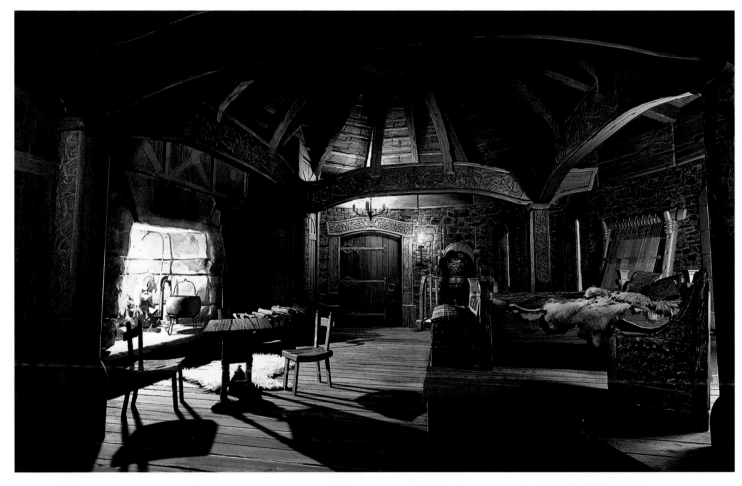

King Beowulf's quarters // BILL MATHER //
painting

King Beowulf's quarters //
MATT DOUGAN // CG model

This three-dimensional model could be rotated to any angle, as Bill Mather would do in one of his concept paintings. "The beauty of 3-D modeling is you can put the camera wherever you want it," Mather noted.

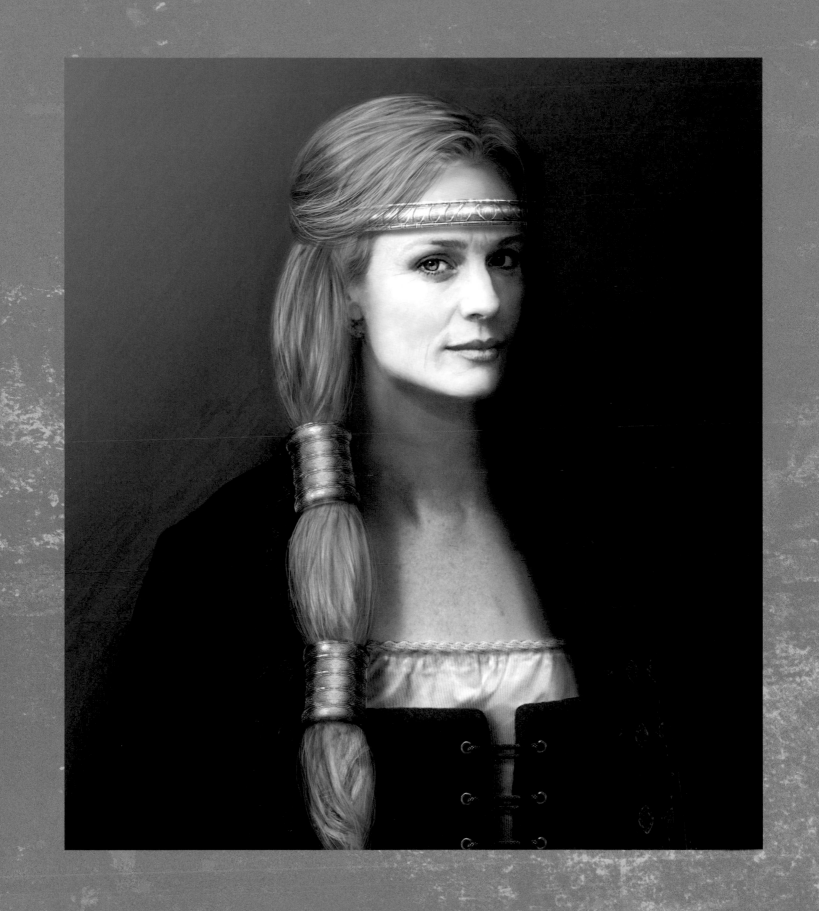

Queen Wealthow // GABRIELLA PESCUCCI //
costume designs

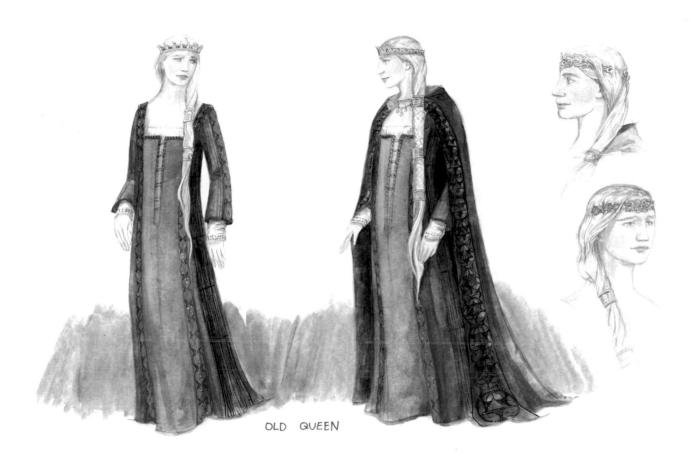

OLD QUEEN

Queen Wealthow // GABRIELLA PESCUCCI //
costume designs

Wealthow grid reference photo // SONY
PICTURES IMAGEWORKS // photograph

"Those grid photos provided reference for the
basic shape of the person, but they weren't
helpful for the artists because the lighting was
so flat," painter Bill Mather said. "We paint
with sculptural lighting, the way light breaks
and describes a form. But there were tons of
pictures of Robin on the Internet, so I had
plenty of reference."

opposite
Queen Wealthow // BILL MATHER and
RANDY GAUL // final portrait

Queen Wealthow is in her early fifties when the
story jumps to the twilight of the Beowulf era.
For his older design portraits, Mather began by
painting different views of Wealthow. Zemeckis
and Chiang then asked him to paint over the
approved "young" portrait, using the same angle
and face for clarity of reference. Wealthow had
to look her age, but still be beautiful.

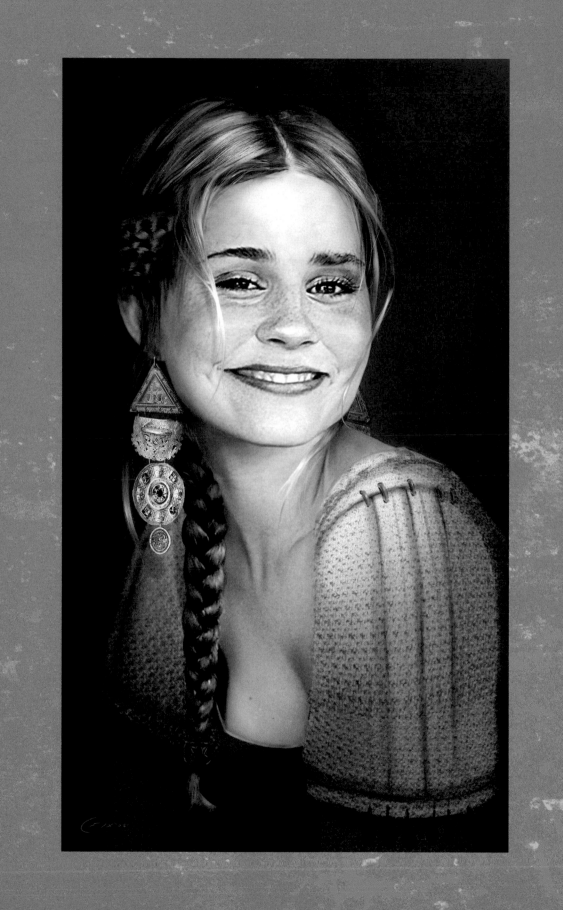

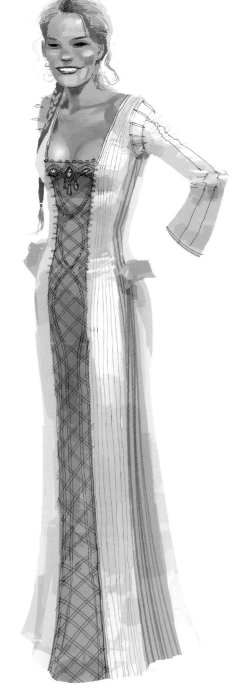

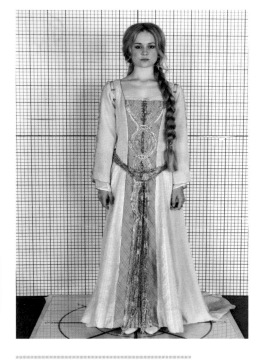

opposite
Ursula // COLIN FIX // final portrait design

A bit of sunshine among the worn-out warriors surrounding Beowulf is Ursula, the king's young mistress, played by actress Alison Lohman. "Ursula does have to have a sexy element, but her character is playful, naive, and cute, very cute," Fix explained. "This final portrait started off with a photo off the Internet of Alison Lohman, but she had short, spiky, and playful hair that didn't fit into the Viking scene, so I had to change her hair and eye color. I painted the costume based on Gabriella's design."

above
Ursula // GABRIELLA PESCUCCI // costume designs

left
Ursula // DERMOT POWER // painting based on Pescucci costume design

Ursula costume and hair photo shoot //
SONY PICTURES IMAGEWORKS // photograph

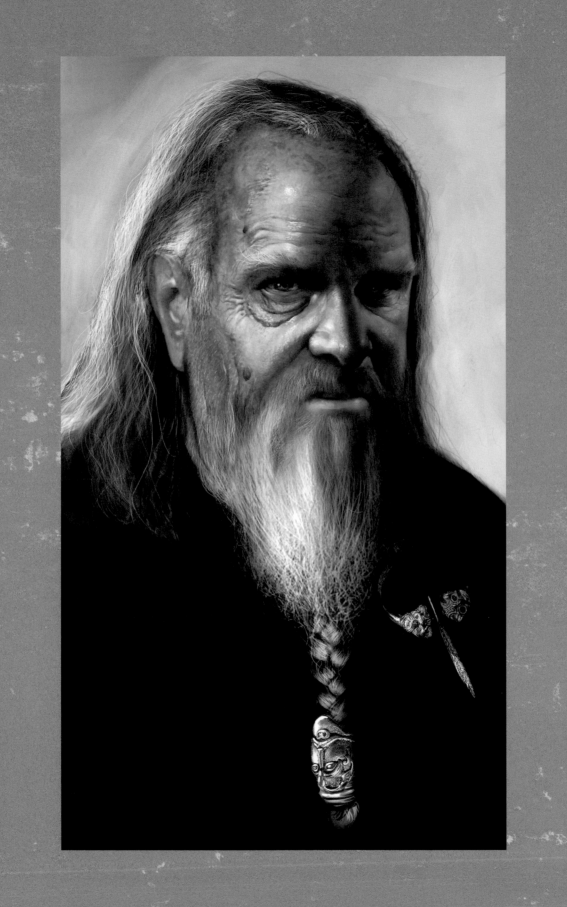

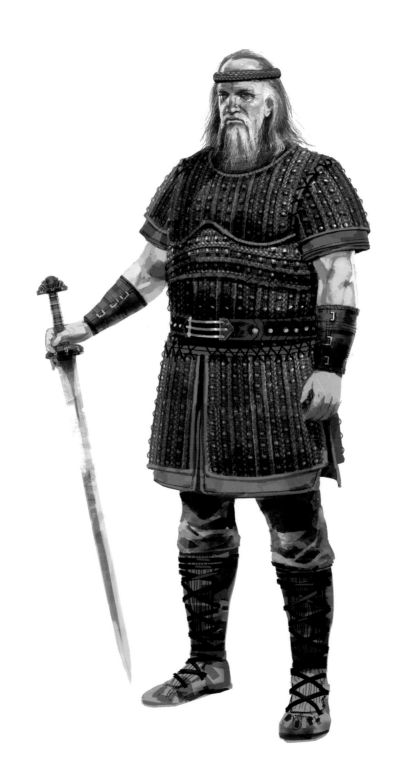

above and right
Wiglaf // GABRIELLA PESCUCCI and
DERMOT POWER // costume designs

opposite
Old Wiglaf // COLIN FIX // portrait

"The idea behind characters in the Beowulf era
is these are old warriors who have scars and
are worn out; they're starting to break down,"
Fix explained. "Doug wanted to age up these
characters with liver spots and wrinkles, but for
Wiglaf he wanted to keep his fiery red hair, but
incorporate a lot of white."

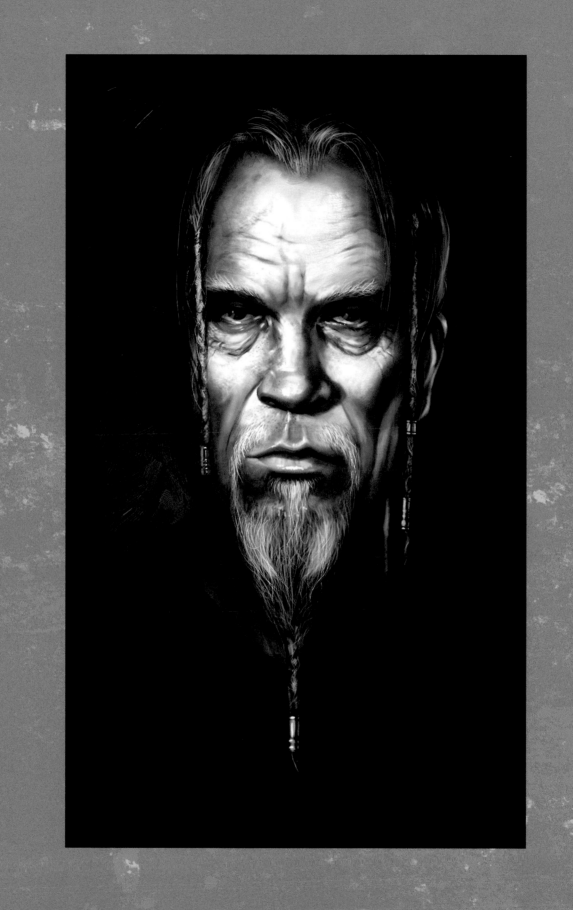

Old Unferth // DERMOT POWER // digital

opposite
Old Unferth // COLIN FIX // final portrait

A rare example of a portrait completed without any photographic elements, with Fix painting entirely in Photoshop and Painter. In his old age, Unferth is no longer the political schemer of the king's court. "Unferth embraces Christianity, so he's far ahead of the game compared to other Vikings," Fix noted. "Now he's kind of an outsider, and mystical, too."

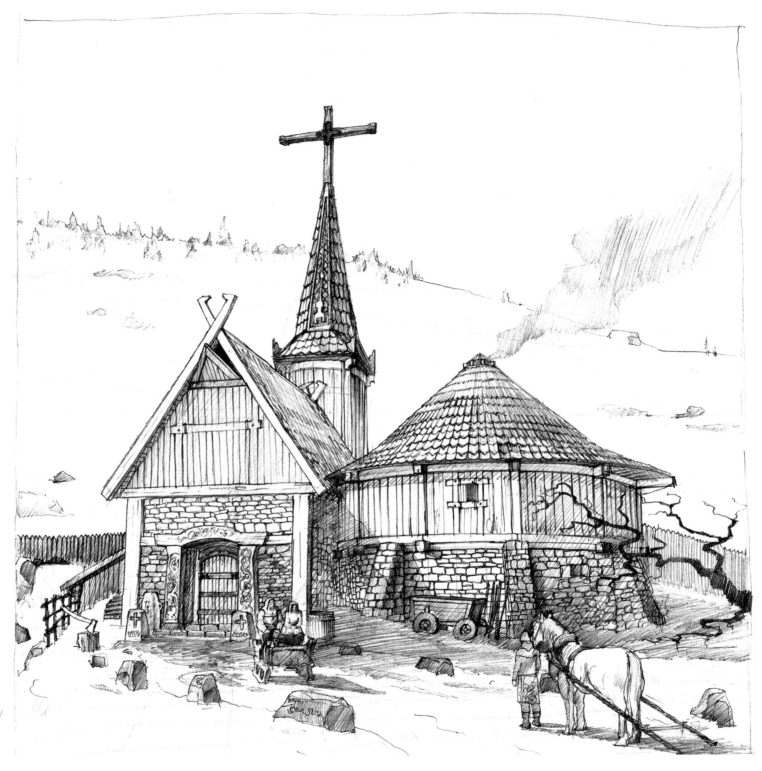

Unferth's compound // KURT KAUFMAN //
pencil sketch

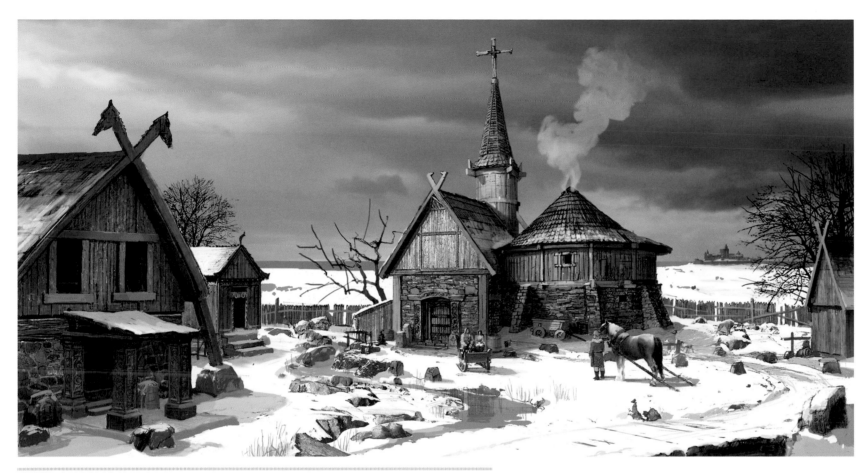

𝕿𝖍𝖊 𝖚𝖓𝖐𝖓𝖔𝖜𝖓 𝖆𝖚𝖙𝖍𝖔𝖗 𝖔𝖋 𝕭𝖊𝖔𝖜𝖚𝖑𝖋 is considered to have been Christian, but other than Old Testament references, there is no mention of Jesus Christ in the poem. The film explores the notion of emerging Christianity through Unferth, who has turned from pagan ways and established his own house in the swampy wilderness of the moor. Unferth's compound is crowned by the cross, symbol of Christ's death and resurrection.

above
Unferth compound // BILL MATHER // painting

This image establishes the compound in relationship to Herot—Beowulf's castle can be seen at right, a black smudge on the horizon. "I liked the fact that I'd been stuck inside the mead hall but here I could go outside," Mather smiled. "I'm from Vermont, which is snow country, and it really resonated with me, painting this snow scene."

right
Broken cross // RANDY GAUL // digital

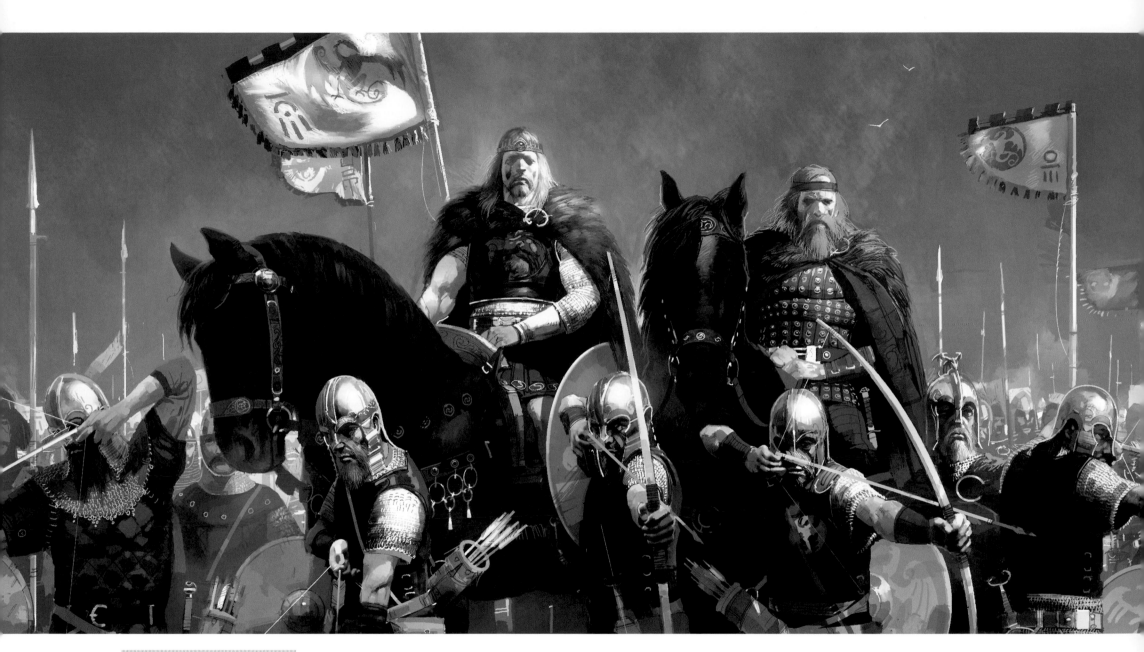

Frisian Battle // DERMOT POWER // digital

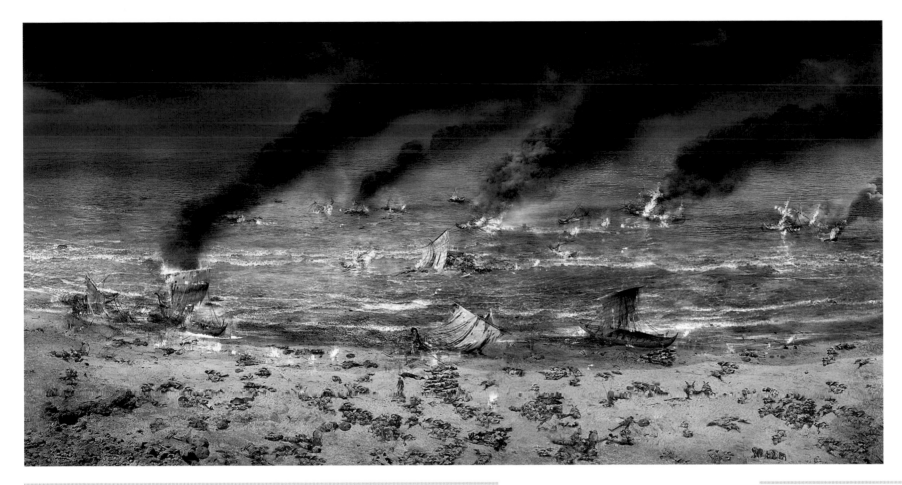

King Beowulf's military supremacy is illustrated in the "Frisian Battle,"
as the art department dubbed this sequence. The poem itself tells how Beowulf's king,
Hygelac, led a war-fleet into Friesland and of the resulting enmity between Frisians and
Geats. In the poem, Beowulf himself brags how he killed the Frisian king with his bare
hands, an incident Gaiman and Avary ironically recall in their script, with old king Beowulf
taunting and then sparing the Frisian leader.

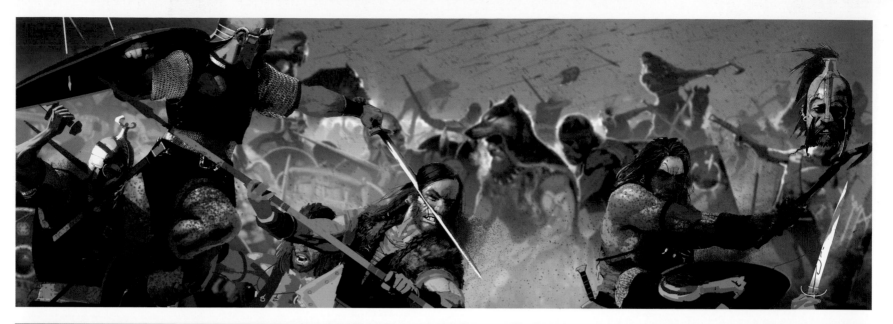

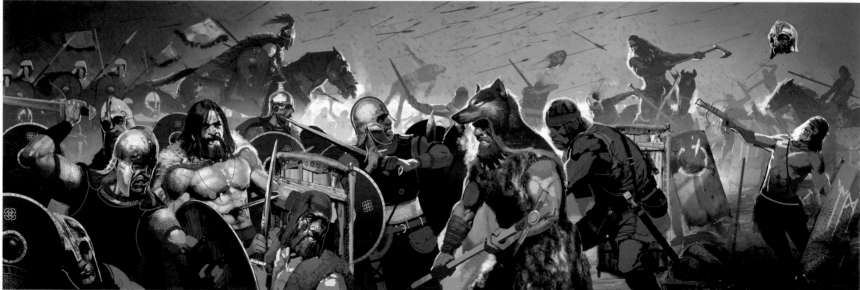

Frisian Battle scene // DERMOT POWER // paintings

"A major question was how to portray violence—how much blood was too much?" Ken Ralston noted. "To give Bob a shot when he had to do the dance of the ratings board, we played with techniques for how to portray violence in the exact same scene with less visceral stuff going on—because in 3-D, those brains spilling out are going to land in your lap! So, Doug did a series of what we called 'violence boards.'"

For these violence boards (which include the production's labels for progressive stages of violence), Power asked Josh Viers to strike what

Viers recalls as an "Oh-God-I-have-an-ax-in-my-face" pose for Power's digital camera. Power scanned in the image and went to work on what Viers calls "the gore studies."

"When Dermot showed me these shots, I felt myself getting a little nauseous—that's the measure of a good illustrator, when you can make a fellow illustrator nauseous," Viers laughed. "When I saw the one with blood on my teeth, that just *spoke* to a part of me."

Dermot Power was given free rein in the Frisian battle scene. Colleague Josh Viers marveled

at Power's ability to perfectly translate into art the images in his head, without reference material. "Dermot is one of those guys who knows not only how to paint someone getting run through with a sword, but how the skin puckers on the blade as it's being pulled out," Viers noted wryly.

opposite, top
Frisian Battle, violence board,
"Little blood" // DERMOT POWER // painting

opposite, middle
Frisian Battle, violence board,
"More blood, dark black color" //
DERMOT POWER // painting

opposite, bottom
Frisian Battle, violence board,
"Extreme 3-D blood" // DERMOT POWER //
painting

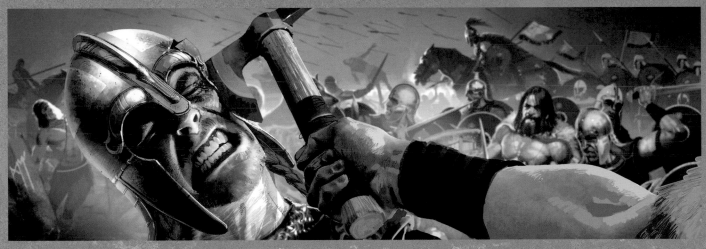

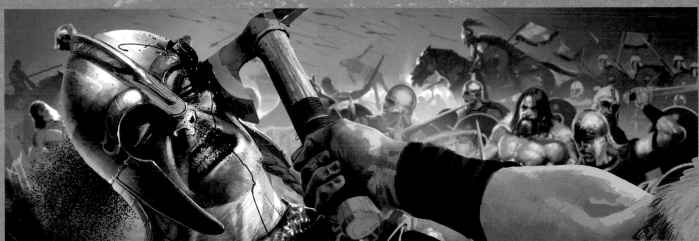

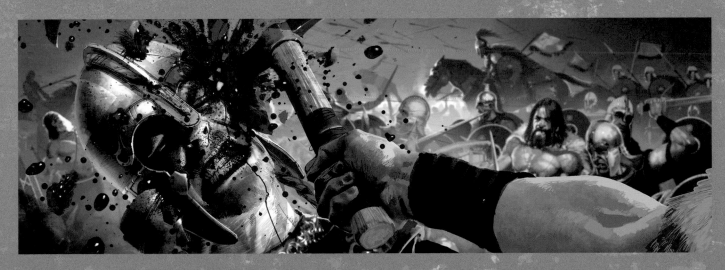

"One of my big fears going into *Beowulf* was, we've seen hundreds of iterations of dragons and Grendel-like monster characters—how do we come up with a new angle? The art department tried to make things historically accurate, and then give the director a design that pushed the boundaries to the fanciful—and then Bob always pushed it to another direction that was fascinating. He had key plot points that started to dictate what a form should look like. For example, a story point was the dragon could go underwater, so that drove the design, which included a rudderlike fan on his tail. Those are the things that guide you in creating designs that actually work. The design work was what made logical sense to fit the story."

DOUG CHIANG

Cave and Golden Boy // DERMOT POWER, RANDY GAUL, and MARC GABBANA // key-frame painting

In this ensemble painting, Dermot Power focused on Golden Boy, Randy Gaul did the background, and Marc Gabbana made some tweaks.

opposite
Golden Boy // COLIN FIX // final painting

This image may seem familiar—it's the same digital model that inspired the full-body design poses for Beowulf and Brecca. "In this image you can see the X on the ground from the reference photo grid when a model posed for the Beowulf body type," Fix explained. "That red blemish on his chest is a slight clue for the viewers, because that's the spot, when he becomes a dragon, that is his Achilles' heel. Doug's direction was to make it look organic, so I poured some India ink on paper and folded it to make a Rorschach splotch and scanned that."

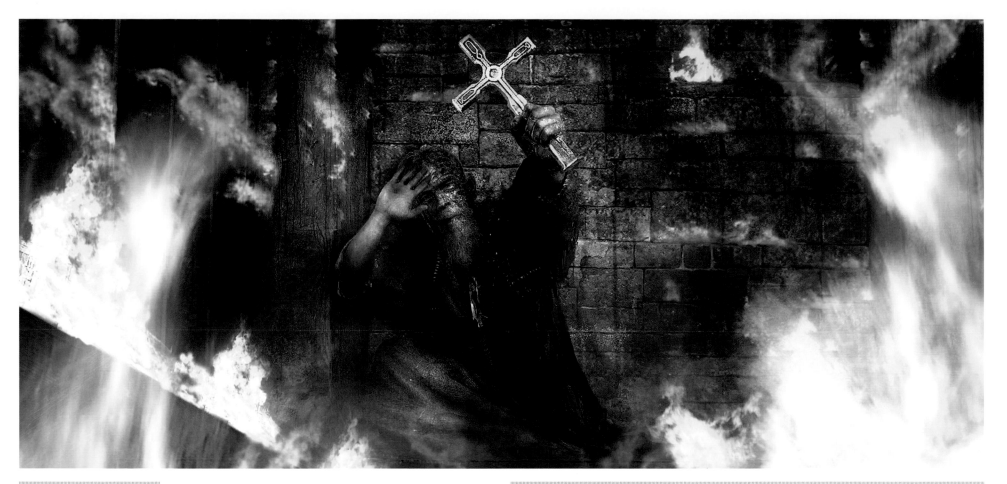

Dragon confronts old Unferth //
RANDY GAUL // digital

In the epic poem, the dragon is a primal force slumbering in a deep barrow, coiled up among the gold and riches that the last survivor of a forgotten civilization once buried. The sleeping dragon guards the treasure hoard until, in King Beowulf's old age, an escaped slave stumbles upon the hidden passageway leading to the store of riches. He steals a single golden goblet, but that's enough to awaken the dragon, who flies into a rampage, leaving destruction in its wake.

In the film, the thief Cain steals the mystical golden horn from Grendel's cave, setting off the golden dragon's first rampage, which results in the destruction of Unferth's compound.

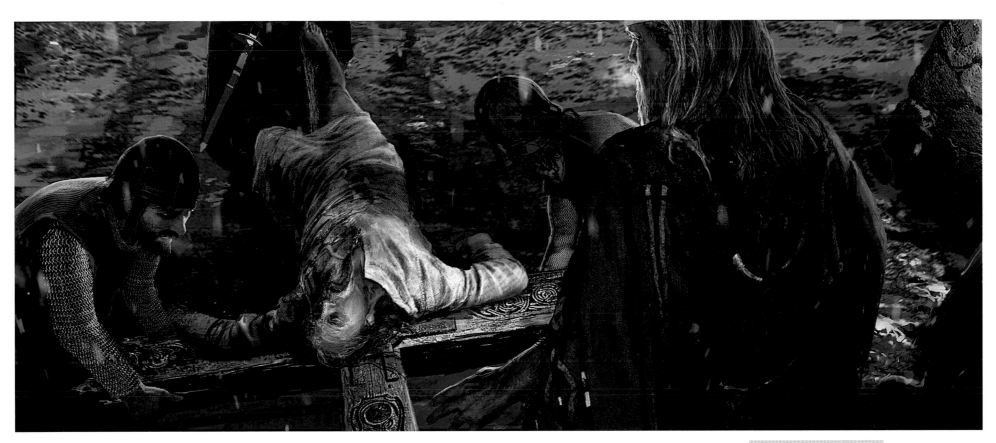

Unferth taken through the gates of Herot // BILL MATHER // key-frame painting

In this key-frame art from the director's layout, Mather dramatically shows Unferth's Christ-like suffering after being burned during the dragon's attack.

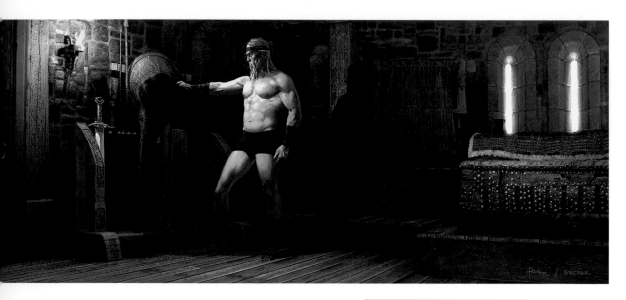

Beowulf in his quarters // AARON BECKER and DERMOT POWER // painting

This scene depicts Beowulf, who, knowing Cain's theft has broken his pact with Grendel's mother, prepares to return to the cave to confront his past. Power painted Beowulf and Becker painted the background.

Final King Beowulf costume design // DERMOT POWER // digital

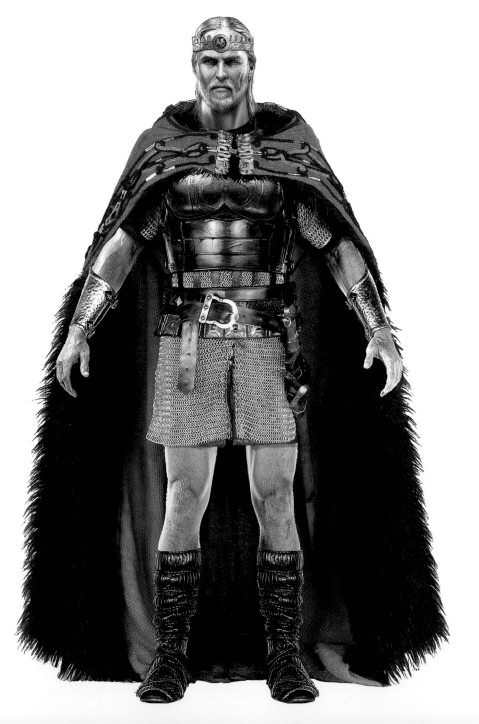

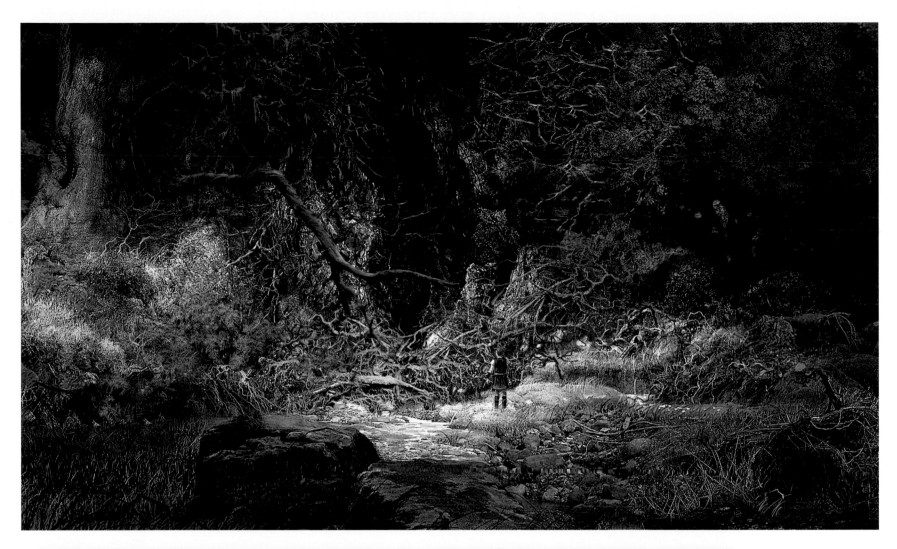

above
Grendel's cave entrance, Beowulf era //
RANDY GAUL // painting

left
Beowulf's return to Grendel's cave //
AARON BECKER // key-frame painting

In the cave, Beowulf encounters his son, the spawn of his tryst with Grendel's mother. "Golden Boy," as the production dubbed him, retains that golden skin when he undergoes a metamorphosis into a fire-breathing dragon.

✳ DRAGON DESIGN ✳

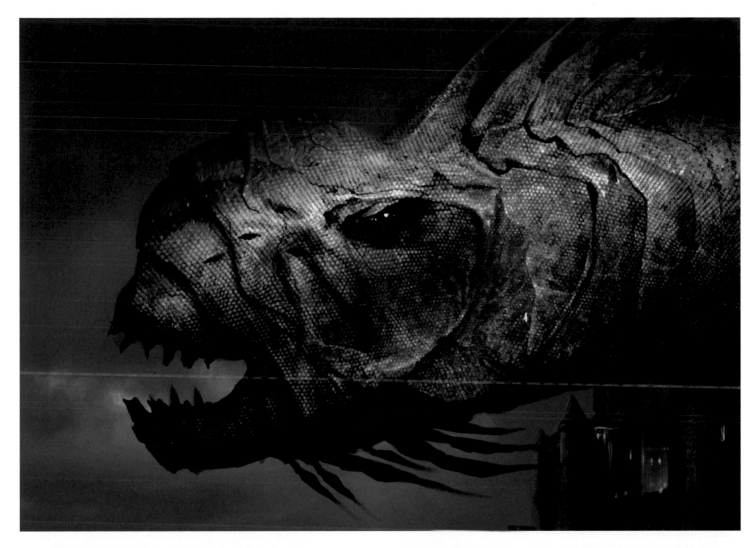

𝕹eil 𝕲aiman cites the climactic battle between Beowulf and the dragon as emblematic of the difference between the live-action film he and Avary envisioned and what their idea ultimately became under Robert Zemeckis. "In our live-action dragon battle they were going to fly around a bit while hacking at each other, more or less. In this, Bob said the dragon fight was going to be the last five minutes of the movie and had to be amazingly cool."

While writing the epic battle between Beowulf and the flying dragon, Gaiman had Beowulf riding the back of the fire-breathing dragon, then diving underwater together and swooping over cliffs. At one point, Gaiman worried that his writing was turning into an expensive flight of fancy for the production. "I phoned Bob and told him I was getting a bit carried away and I might be going over budget. There was a pause at the other end and Bob said, 'Neil, there's nothing you can possibly write that won't cost me more than a million dollars a minute to film. Just keep writing.'"

Doug Chiang himself set the pace for the dragon design, with his own artwork inspiring concept studies by Terryl Whitlatch and Josh Viers. The 2-D paintings would come together in the dimensional form of a Tony McVey sculpture. "Doug's concept art took a direction I had never seen before in a dragon design," Viers said. "Things like exaggerated proportions and large head shapes were so different from the long snout and beady eyes of the standard dragon."

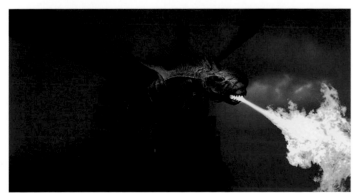

Dragon design // TONY MCVEY // sculpture

This dragon sculpture measures two and a half feet from wingtip to wingtip. Note the rudderlike fan on his tail, an element that allowed the dragon to swim underwater.

Dragon, various views // TONY MCVEY // sculpture

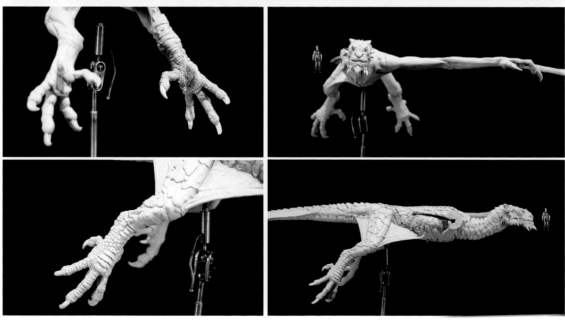

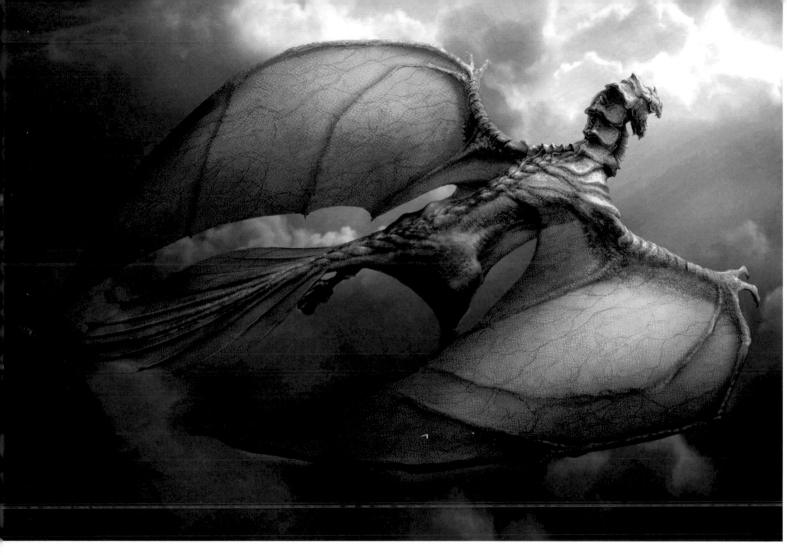

left
Flying dragon // RANDY GAUL // painting

below, left
Dragon anatomy // TERRYL WHITLATCH //
pencil sketches

below
Dragon design // RANDY GAUL // painting

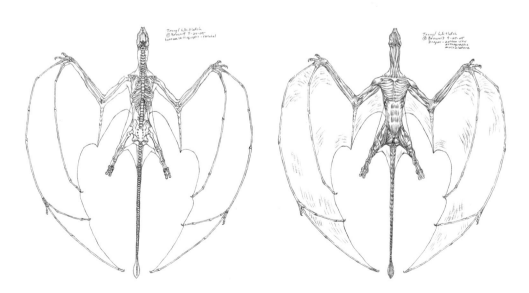

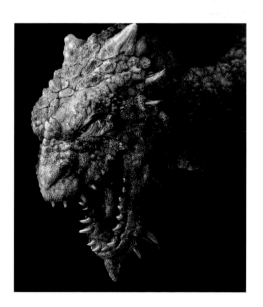

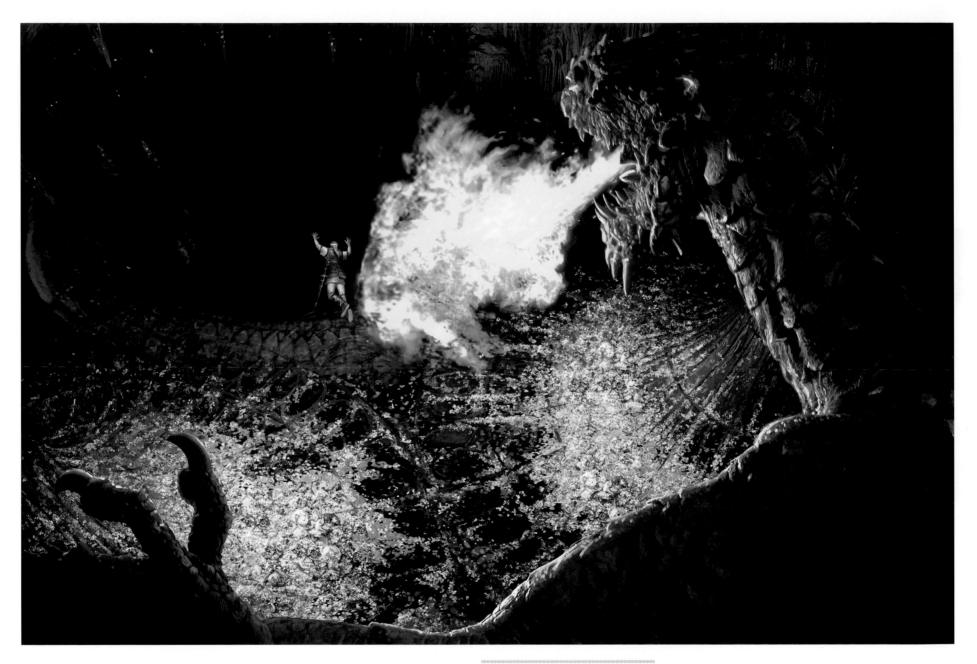

Dragon attacks King Beowulf // MARC GABBANA // digital

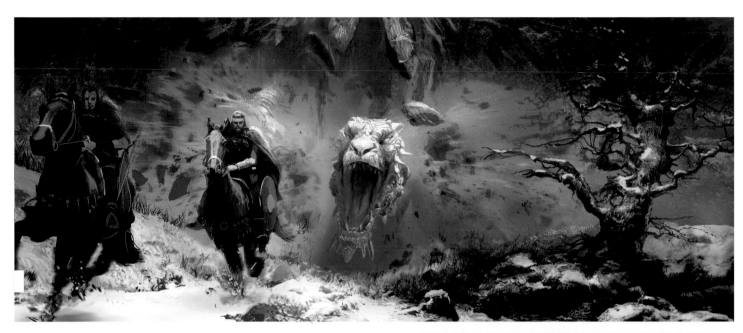

Dragon attack // BRIAN FLORA // paintings

Brian Flora first did a clean version of the dragon exploding from its cave as Wiglaf (in front) and Beowulf gallop away. Flora then created a second version to show the director what the scene would look like with the dragon breathing fire. "As a matte painter I usually get to do many of the wide, establishing shots, so it was fun and exciting to do a key story moment where there's action happening. I even made a little miniature of the cave entrance. I bought green foam at a crafts store, cut a shape based on the most current artwork [of the cave entrance], and used baking powder for snow. I photographed that and then painted on top. I did the whole image, including characters and horses. I'd never painted horses before, so I asked Dermot Power about horses because he's such an expert at human and animal anatomy. Everyone crossed over a bit in our art department. I'd ask about anatomy; someone would ask me about getting mood and lighting."

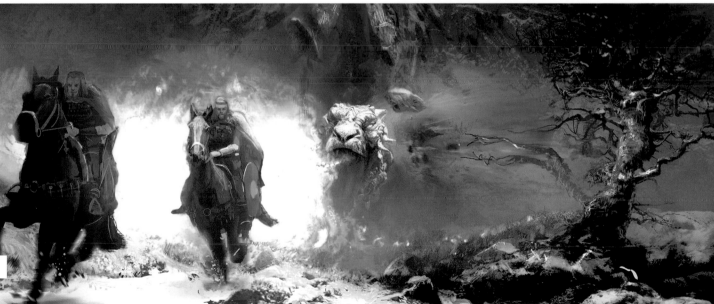

"Roger and I started off writing a low-budget action movie that was going to be small, cheap, and hastily made about cold, wet, dirty people. Now, we have this huge, amazing thing filled with animated people and Anthony Hopkins as Hrothgar and Angelina Jolie as Grendel's mother. It's like nothing one would have imagined. It became its own thing, which, I guess, is the best thing about movies. At one point, all I knew of what the film was going to look like was seeing rough-cut footage with faceless, Xbox kinds of characters and video of live actors with dots on their faces. I realized this could be the best film in the world or one of those amazing disasters people talk about in hushed voices. But I loved the sheer vitality of it. I remember watching Bob pull together a scene where Beowulf and the dragon are in the surf. He liked the scene, but he didn't like what the waves were doing. So, he changed the ocean waves. I think that's what a director wants. You get to be God."

NEIL GAIMAN

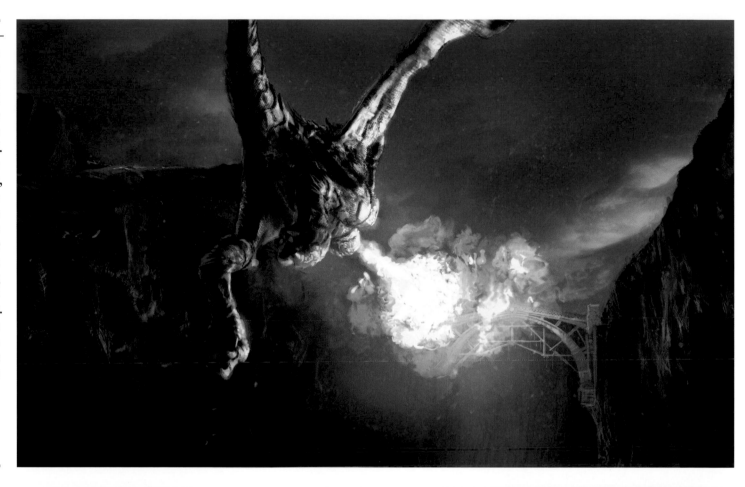

above right
Dragon attack // BRIAN FLORA // painting

Production designer Chiang requested this image to see how the dragon's fire might interact and visually read against the canyon walls (note King's Road Bridge in the distance).

right
Dragon attack // BRIAN FLORA // painting

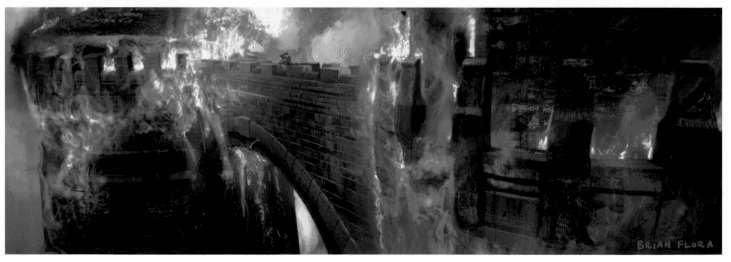

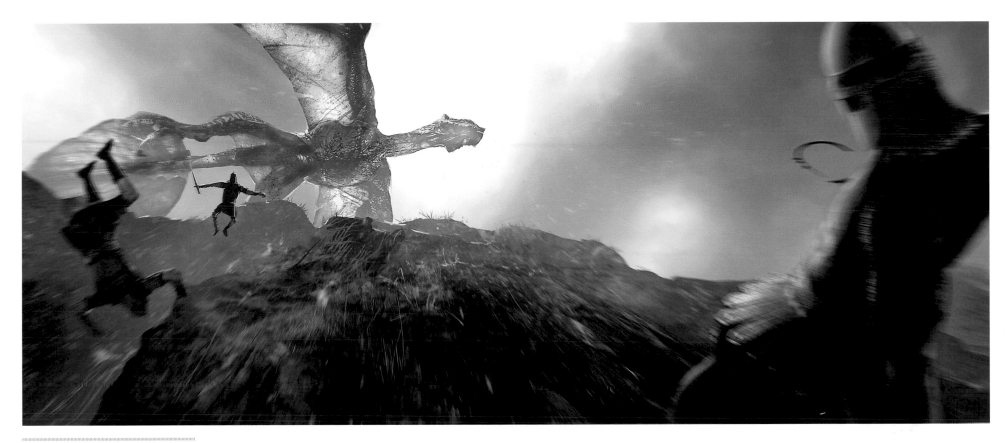

Dragon attack // JOSH VIERS and
BRIAN FLORA // painting

pages 150-151
Dragon attacking Beowulf's army //
BRIAN FLORA // digital

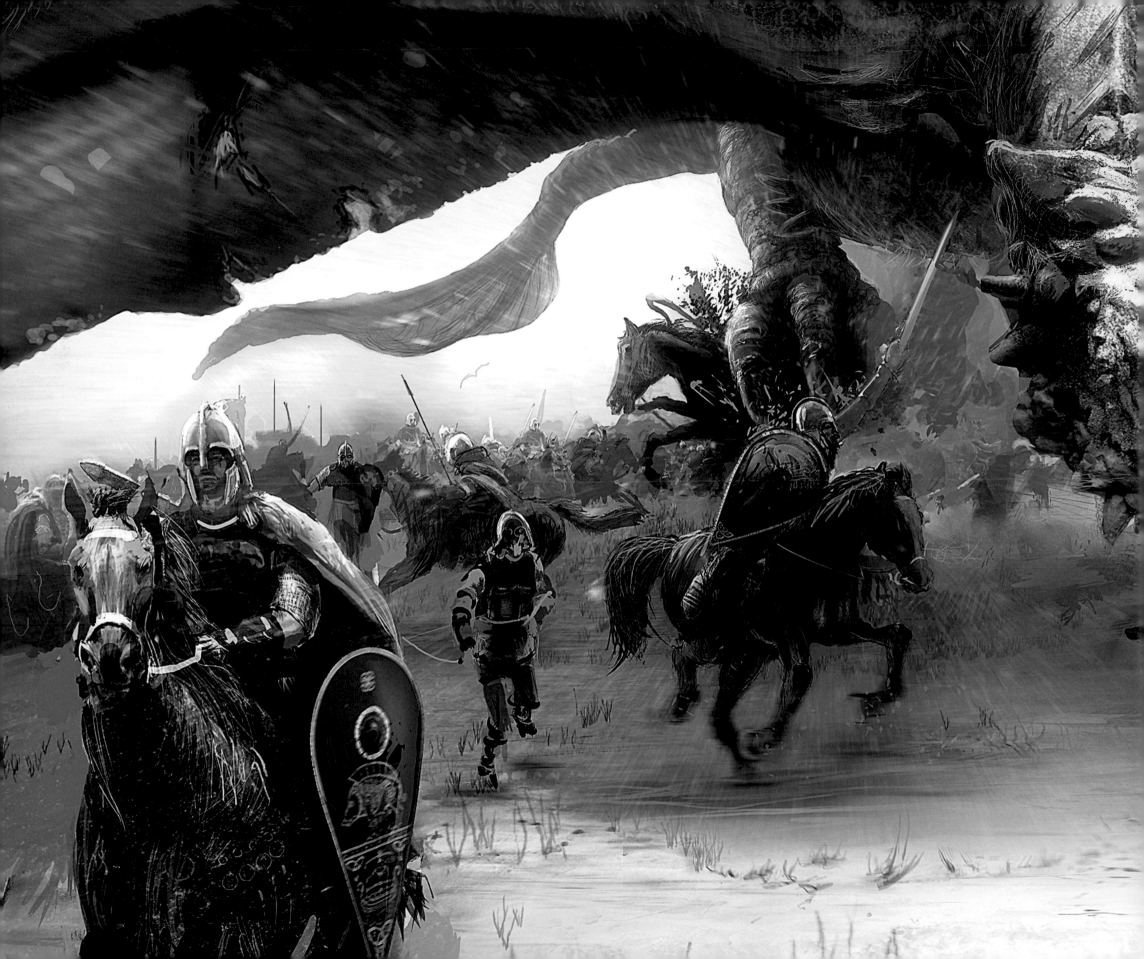

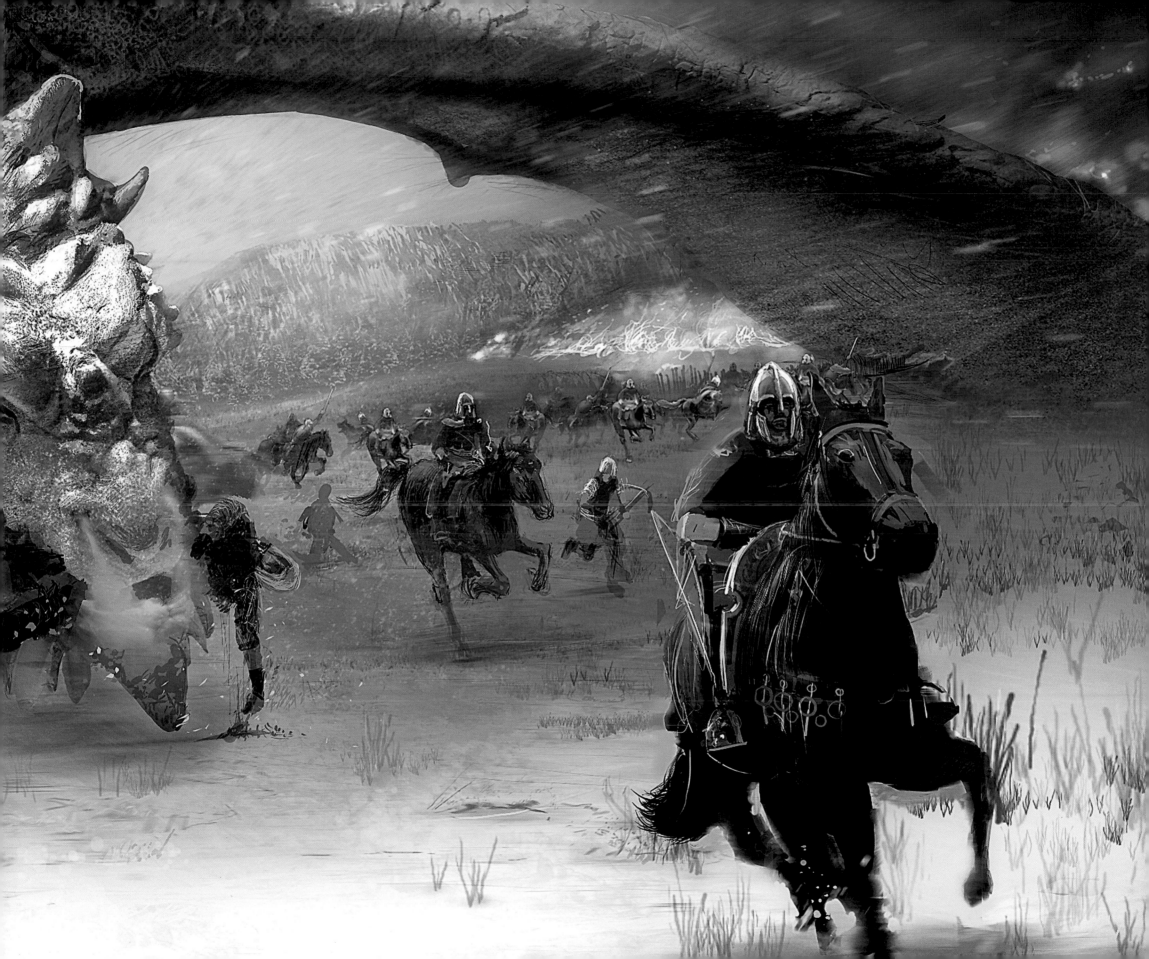

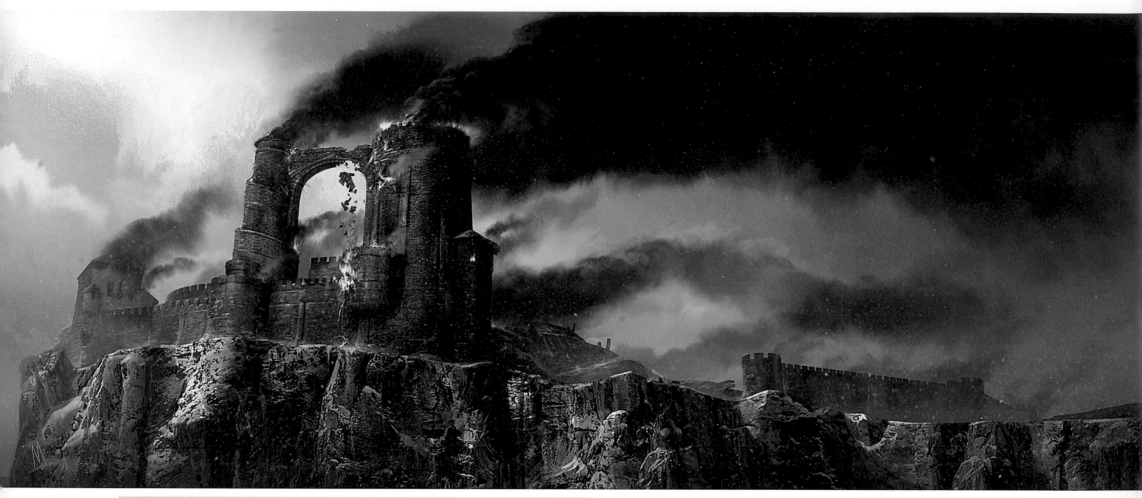

In the poem, Beowulf slays the dragon, but dies from his wounds. His death leaves a dark future for a kingdom now vulnerable to enemies who have been biding their time. "People have been arguing about the meaning of the ending to *Beowulf*, where Beowulf goes to fight the dragon and insists on going alone," *Beowulf* expert Hagen observed. "His retainers, who are supposed to be defending him, run away. It is only Wiglaf, the loyal one, who stays. The Anglo-Saxon ethos was you don't desert your lord, everyone is bound to fight with him. You don't leave the battle before your lord and if he dies, you die. Wiglaf predicts the doom of their society because not only is the powerful leader dead, but the others did not step up and display the proper heroism."

In the poem, Beowulf's funeral pyre is stacked high with war shields, armor, and helmets, the blaze sending up a dark cloud of wood smoke like a heavenly offering. For the movie, there was the cinema-friendly idea of setting Beowulf out to sea in a burning ship.

above
Beowulf's castle ruin // MARC GABBANA //
digital

opposite
Dragon attacks Beowulf's castle //
KURT KAUFMAN // final painting

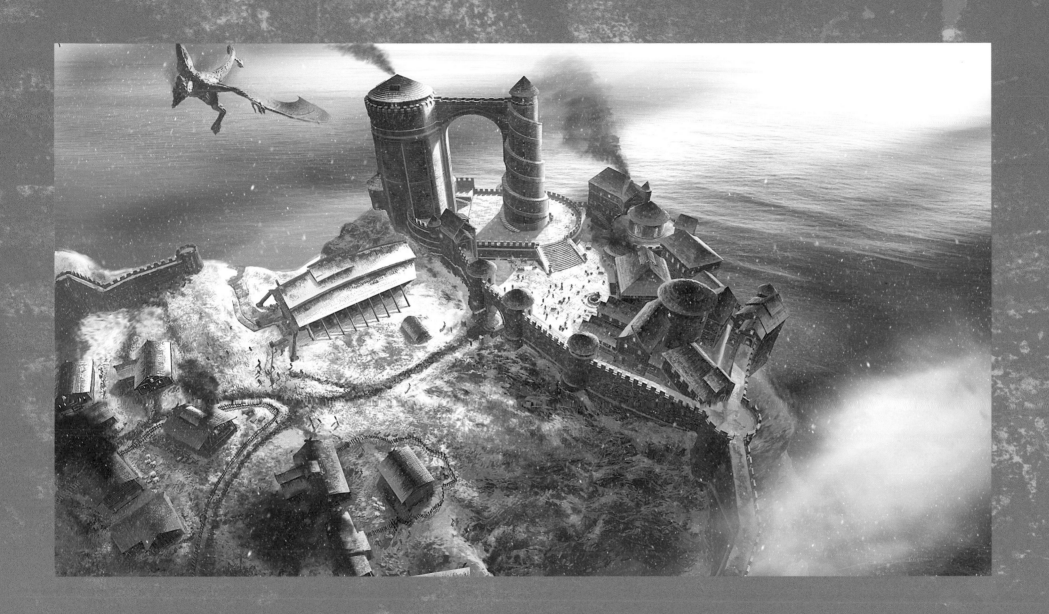

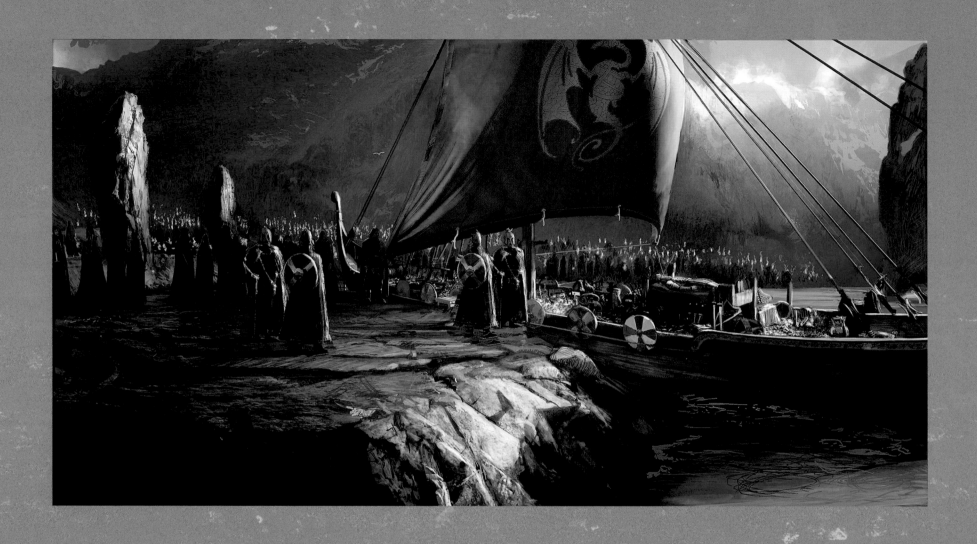

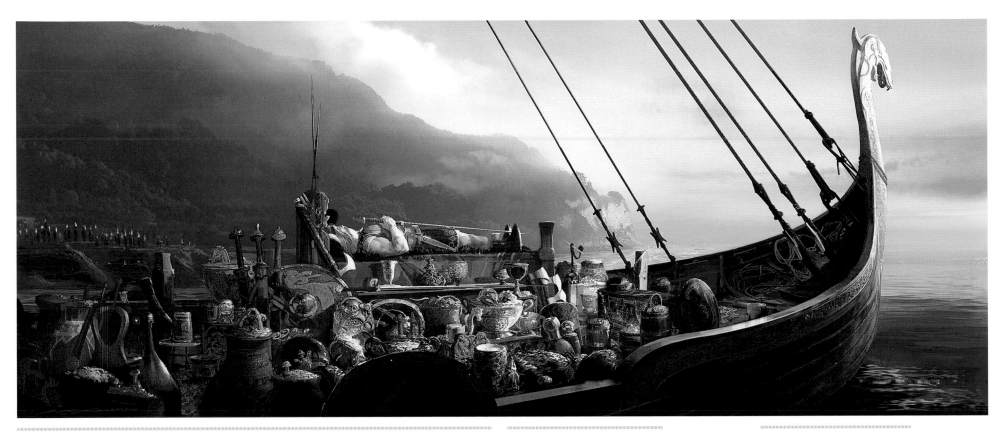

"𝕿raditionally, you see the funeral boat on fire, or flaming arrows shot into the boat—the problem is we discovered that happens in every bad Viking movie," Pete Billington said. "So, we looked for a creative solution to solve the end."

Doing research, Doug Chiang came across a curious tradition that had begun at Yosemite during the Depression as a summertime promotional stunt dreamed up by someone who had a hotel concession at the park—a waterfall of fire that would rain over the sheer 3,000-foot rock face at Glacier Point. Zemeckis was skeptical, but soon embraced the idea. Supervising art director Norm Newberry credits the director's respect for his production designer's instincts and felt he helped reinforce the concept for the director—Newberry himself had actually witnessed the legendary event on boyhood trips to Yosemite.

"They'd truck in ten-to-twelve-foot-long chunks of cedar bark from the logging companies and stack them atop Glacier Point," Newberry recalled. "Around 5:00 P.M. they'd start a bonfire and by nighttime had a huge pile of glowing red embers. It was a big event, and everyone would walk out into the valley to watch this. About 9:00 someone would shout: 'Let the fire fall!' Then, steel rods pushed the mass of red-hot embers over the edge. They seemed to fall in slow motion, this glowing, pulsing, red waterfall effect. After the firefall, everyone on the valley floor walked back through the forest to camp, feeling a lot of camaraderie."

Beowulf funeral // BRIAN FLORA // painting

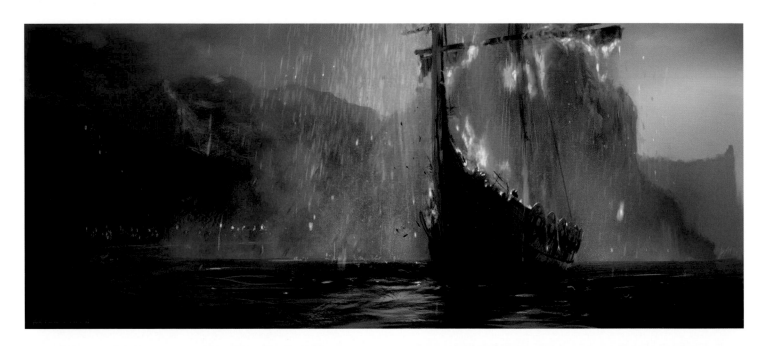

Beowulf funeral // MARK SULLIVAN //
painting

Beowulf's funeral boat sails under a stone
archway where fire rains down and consumes
the ship.

"I think the last words of the poem sum up
Beowulf very well. Translated, they read:
'He is kindest to his people and most eager
for praise.' That can be a good thing
or a bad thing. It depends on
your perspective."

KARL HAGEN

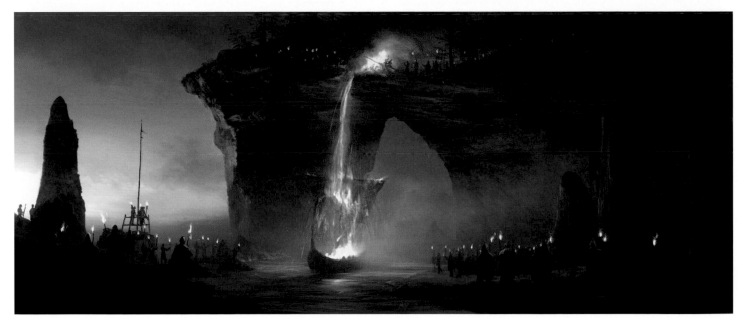

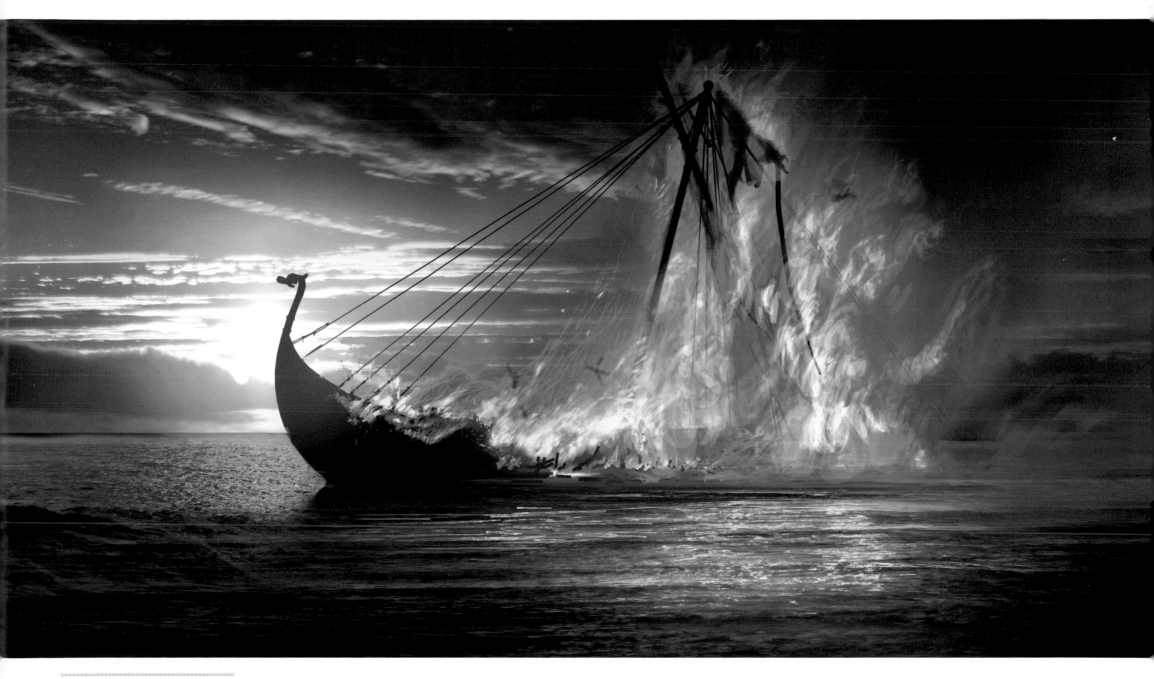

Beowulf funeral // BRIAN FLORA // painting

❋ NOTES ❋

Beowulf quotes are taken from Project Gutenberg, a volunteer Web site that makes e-books available to the public—may its renown spread throughout the land! The opening quote from Seamus Heaney is taken from his *Beowulf* translation (New York: Farrar, Straus and Giroux, 2000). Comments from actors and some of Steve Starkey's quotes are from the production's electronic press kit (edited for continuity). *Sandman* history is from Neil Gaiman's 1989 essay, "The origin of the comic you are now holding" (*Sandman* #4).

❋ ACKNOWLEDGMENTS ❋

Thanks to Bob Zemeckis, who motivated everyone involved in the project with his tremendous spirit.

Steve Bing and Shangri-La supported the vision of the filmmakers to pursue their dream.

Neil Gaiman and Roger Avary inspired all of us with their daring screenplay.

Doug Chiang, for his artistic leadership and for selecting from the hundreds of pieces of artwork, and all the artists at Ice Blink, without whom this book would not exist.

Invaluable to this process was Erin Collins, who coordinated visual material and also facilitated the logistics necessary for writing this book.

Risa Kessler and our friends at Paramount supported us when we thought that this book might not happen.

And, of course, many thanks to Jerome Chen and Sony ImageWorks for presenting these pieces of art beautifully on the big screen.

Thanks also to those who helped make connections, including Lorraine Garland, assistant to Neil Gaiman; Michelle Minyon for Ken Ralston; Danielle DiMarco for Jerome Chen; and Lauren Miller and Will Sherrod, assistants to Steve Starkey.

May an exalted place at the king's mead table be reserved for Mark's agent (and Beowulf fan), John Silbersack.

On the Chronicle side, a big Viking-sized huzzah for Sarah Malarkey, Matt Robinson, Doug Ogan, Evan Hulka, Brooke Johnson, Beth Steiner, and Marc English Design.

A brimming mead-horn toast to all!

—S.S. and M.V.

✶ BEOWULF ART CREDITS ✶

PRODUCTION DESIGNER	Doug Chiang	ASST. ART DIRECTORS	Jackson Bishop
SUPERVISING ART DIRECTOR	Norm Newberry		Andrew L. Jones
COSTUME DESIGNER	Gabriella Pescucci		Jim Wallis
ART DIRECTOR	Greg Papalia		Todd Cherniawsky
CG ART SUPERVISOR	Pete Billington		Mike Stassi
SET DECORATOR	Karen O'Hara		
PROP MASTER	Michael Gastaldo	CAD / MAYA SET DESIGNER	Scott Herbertson
ART DEPT. PRODUCER	Erin Collins Butler	1ST ASST. COSTUME DESIGNER	Massimo Cantini Parrini
		2ND ASST. COSTUME DESIGNER	Flora Brancatella
CONCEPT ARTISTS	Aaron Becker	ASST. PROP MASTER	Greg Benge
	Marc Gabbana	ASST. SET DECORATOR	Andrea Fenton
	Randy Gaul		
	Brian Flora	MODEL MAKERS	John Duncan
	Kurt Kaufman		Trevor Tuttle
	Bill Mather		Jason Mahakian
	Mark Sullivan		Tony Bohoroquez
	Vladimir Todorov		
	Josh Viers	PRE-VISUALIZATION ARTISTS	Ryan Heuett
	Terryl Whitlatch		Sathyan Panneerselvam
			Justin Mettam
CHARACTER ARTISTS	Colin Fix		Matthew A. Ward
	Dermot Power		
		STORYBOARD ARTISTS	Phillip Keller
CONCEPT SCULPTORS	Robert Barnes		Dan Sweetman
	Tony McVey		Simeon Wilkins
CG ARTISTS/TDS	Young Duk Cho	ART COORDINATOR	J. Virdone
	Matt Dougan	ART ASSISTANT	Roel Banzon Robles
	Zac Wollons	RESEARCH ARCHIVIST	Greg Bossert
		RESEARCHERS	David Craig
			Jason C. Brown

"**Each** OF US ALL MUST HIS END ABIDE IN THE WAYS OF THE WORLD; SO WIN WHO MAY GLORY ERE DEATH! WHEN HIS DAYS ARE TOLD, THAT IS THE WARRIOR'S WORTHIEST DOOM."

* Beowulf *